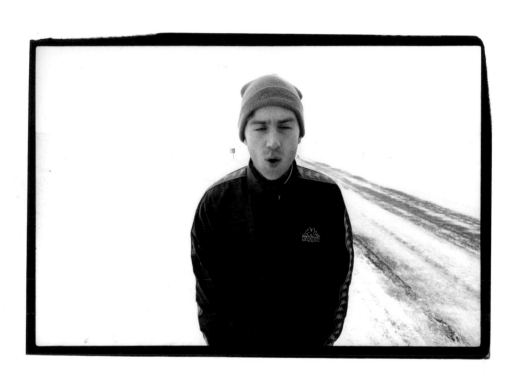

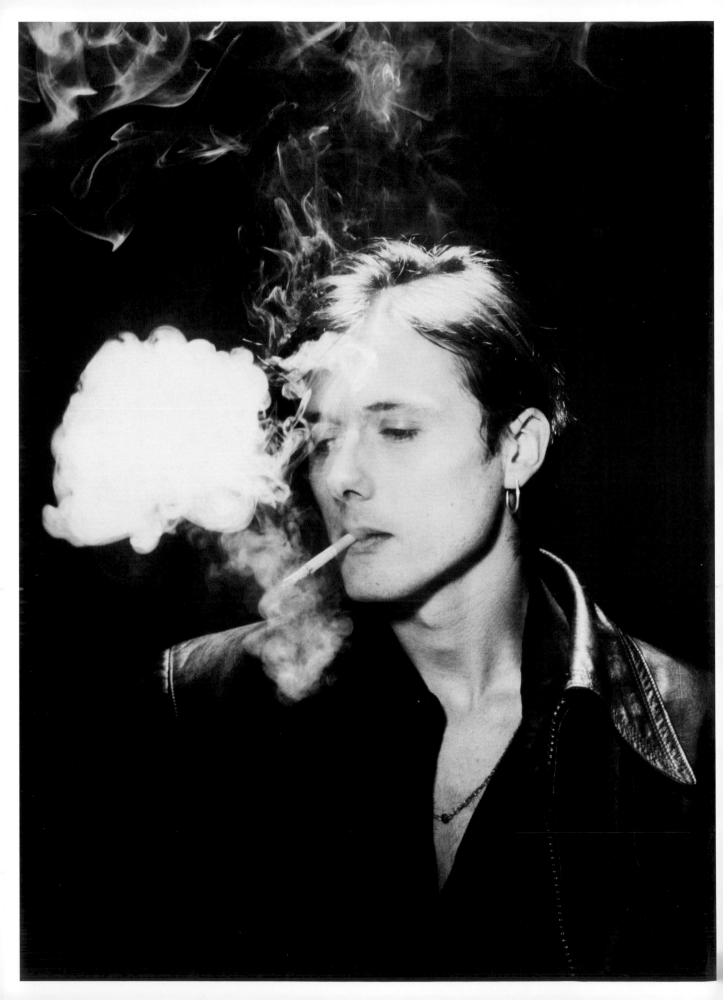

While We Were Getting High

Britpop and the '90s

Photography by

Kevin Cummins

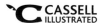
CASSELL ILLUSTRATED

Contents

Introduction
Kevin Cummins

On 15 July 1961, the *Daily Telegraph* published a jazz feature by Philip Larkin under the header "Cool, Britannia". The comma here is crucial.

Just over 35 years later, "cool Britannia" became one of those meaningless expressions beloved by ad execs who thought it defined the zeitgeist – but more importantly, they thought it defined them. In the mid-1990s anything and everything British was cool. Celebrity mockney chefs: cool. Lads' mags: cool. Tony Blair: cool. The Spice Girls: cool. Ladettes: cool. New Labour: cool. Except none of it was cool. It was just another way of marketing a certain type of Britishness to the masses. Britpop was a term I was uncomfortable with, and I wasn't alone.

In April 1993 *Select* magazine dropped a photo of Brett Anderson over a backdrop of a Union Flag, using the coverline: "Yanks Go Home! Suede, St Etienne, Denim, Pulp, The Auteurs and the Battle for Britain". They were reducing the standard of the once lofty music press to the level of red-top, flag-waving patriotism.

Brett was furious. His songs were documenting the world around him, illustrating its cheapness and failure, not about Britishness in all its perceived glory. Suddenly Britpop became a movement and flag waving became the norm. Newspapers and magazines love a catch-all expression, and thus the term "Britpop" was born.

Most British bands distanced themselves from the term, but they were fighting a losing battle. All the UK bands we featured in *NME* over a period of three to four years would be asked about their Britishness. They weren't asked about the elements of toxic masculinity, misogyny and racism that many commentators – and musicians – were uncomfortable with. If any publication defined the zeitgeist it was *Loaded*. They'd championed the birds, booze, football, clubbing and casual drug use culture from issue one in May 1994. Uncool Britpop was designed for them; for men who should know better. And so it went on…

At *NME*, I like to think we distanced ourselves from the more laddish end of the spectrum. We concentrated on the musicians and their music, and some great music came out of this period. I wanted to shoot serious portraiture and consequently I felt we gave the bands the gravitas they deserved. Of course, it was difficult to do this when commissioned to shoot an on-the-road piece with Oasis – it was hard enough to stay alive. Similarly with Blur. Both bands lived life to excess. It was exhausting but a lot of fun, too.

I usually define my job as 10 per cent photography and 90 per cent hanging around hotel lobbies waiting for the band to turn up. It's kind of ironic that the photo of Liam on page 107 was taken while I was sitting in a hotel lobby in Newport, Gwent, and when he eventually turned up he was perfectly framed by the door with "The Oasis Bar" sign above his head.

Twenty-five years on and it's difficult to separate Britpop from today's political climate. The symbolism of the Union Flag is more loaded and exclusivist than ever. Was Britpop a precursor to the Brexit mentality? It's hard to truly know, though I suspect a connection somewhere along the way. I am delighted that four very different protagonists of the era – Noel Gallagher, Brett Anderson, Sonya Aurora Madan and Martin Rossiter – answered my questions about Britpop and its legacy, openly, honestly, and with insight.

When it came to making the selection of photos for this book, I found it more difficult than for any of my previous books. Britpop isn't easily definable. I took to Twitter to ask fans if certain bands could be considered part of the genre. Several musicians joined in to deny they were ever part of Britpop. I realized I had to go with my own instinct. I've kept it reasonably fluid, but the Manics were never considered part of this genre, neither was Primal Scream, much as I'd like to have included them. I'm sure many of you won't agree with the complete edit, but I hope you will agree that it's a lovely, strong set of photographs. If you don't, I'm sure you'll take to Twitter to let me know.

1991

Blur, Studio, July

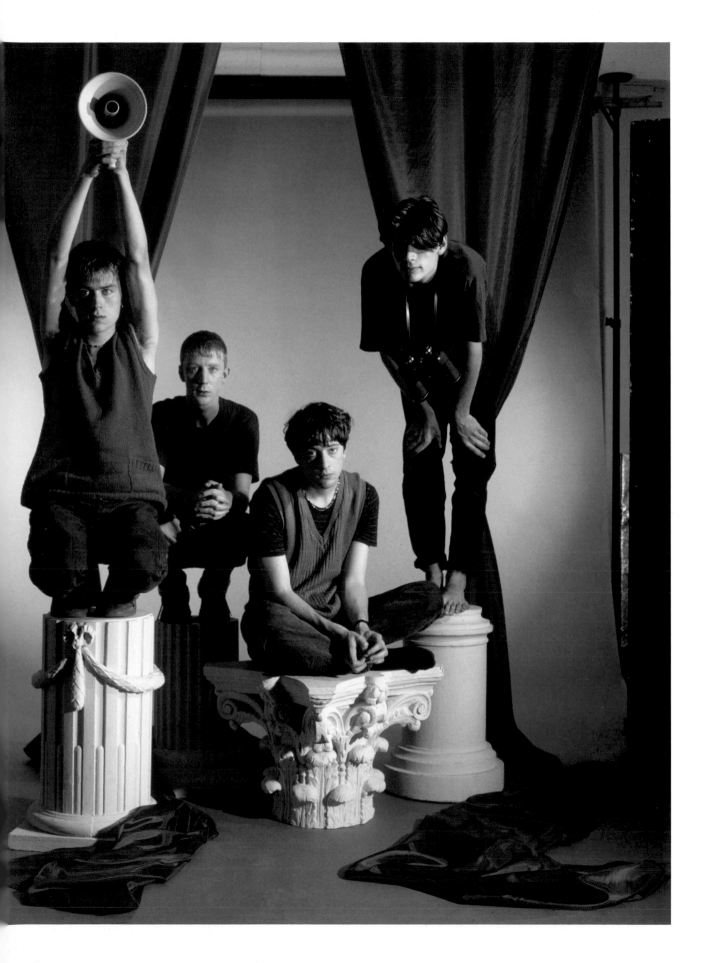

The Charlatans, Cheshire, January

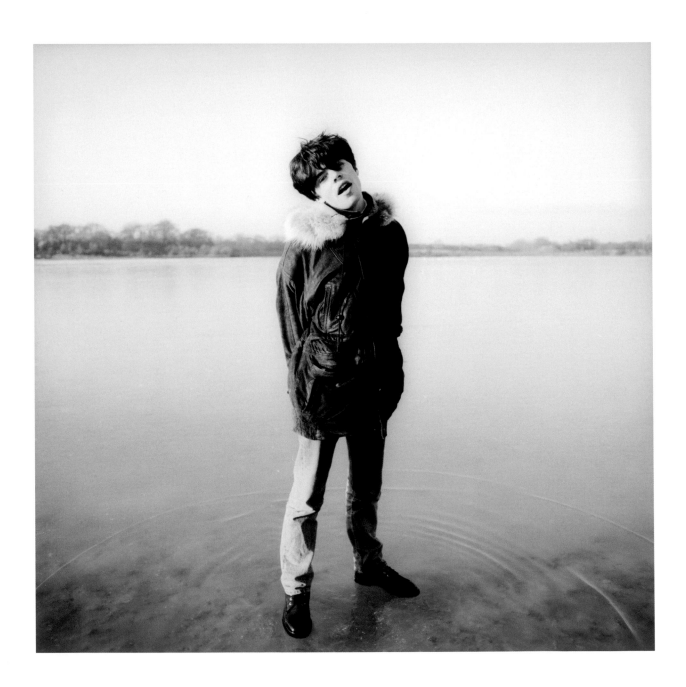

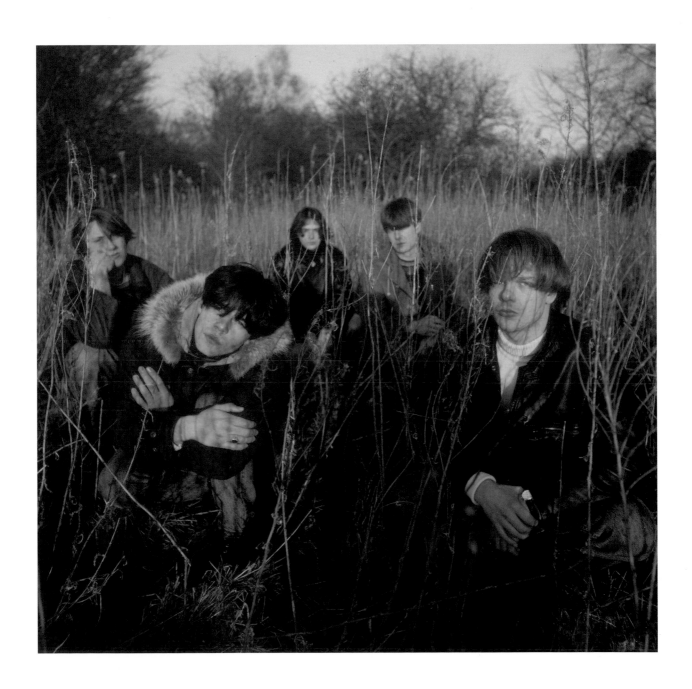

Miki Berenyi/Lush, Studio, October

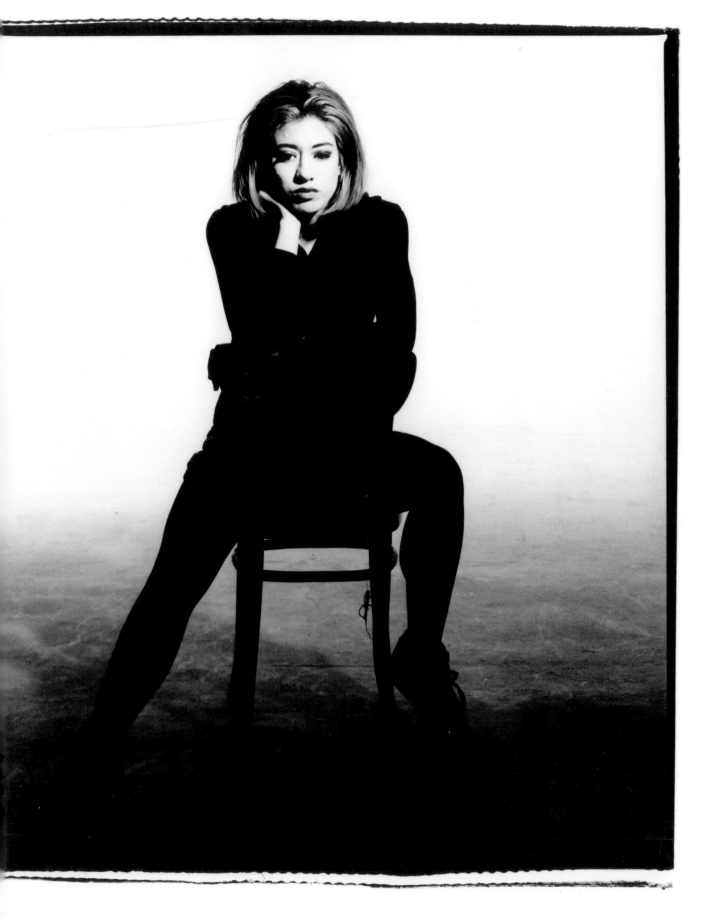

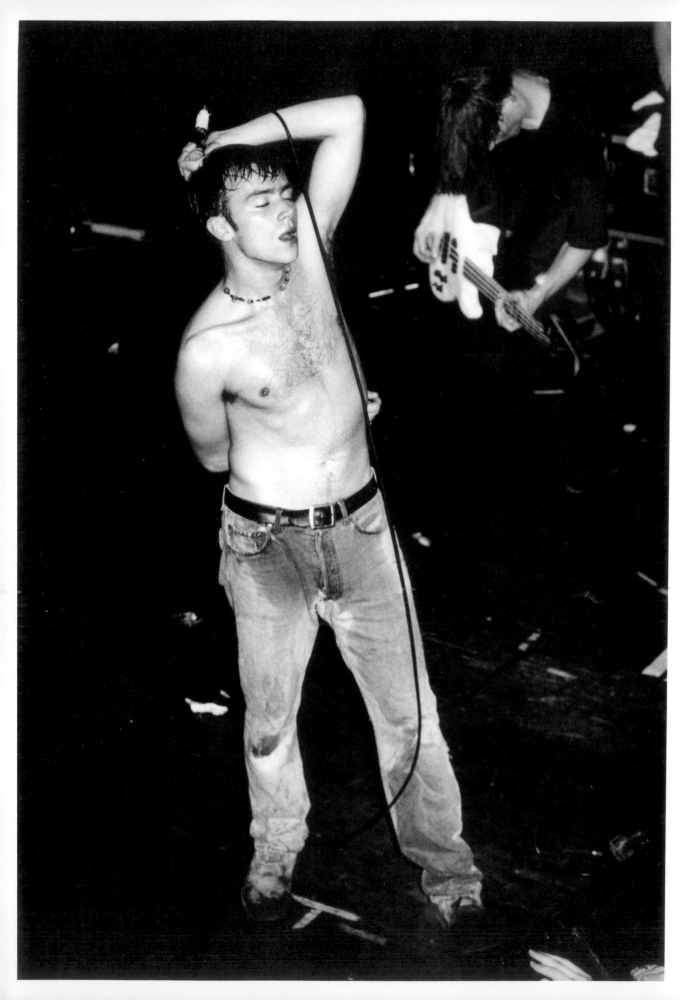

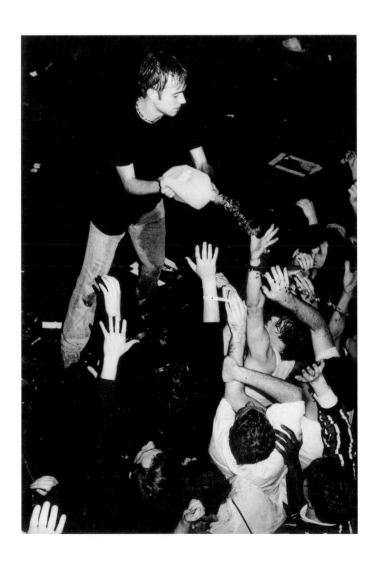

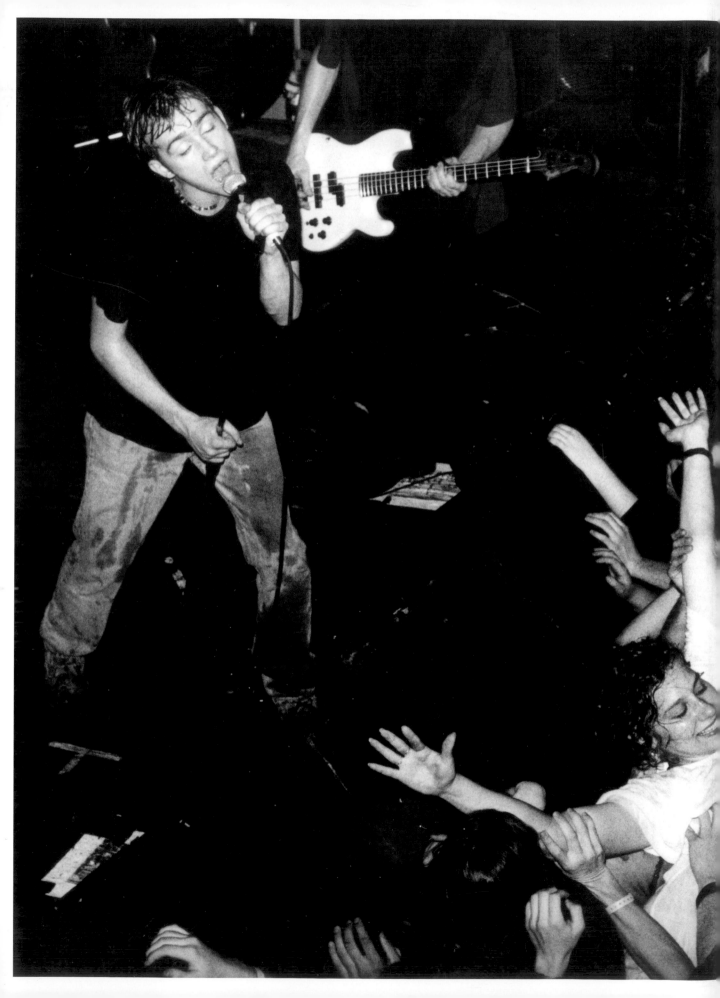

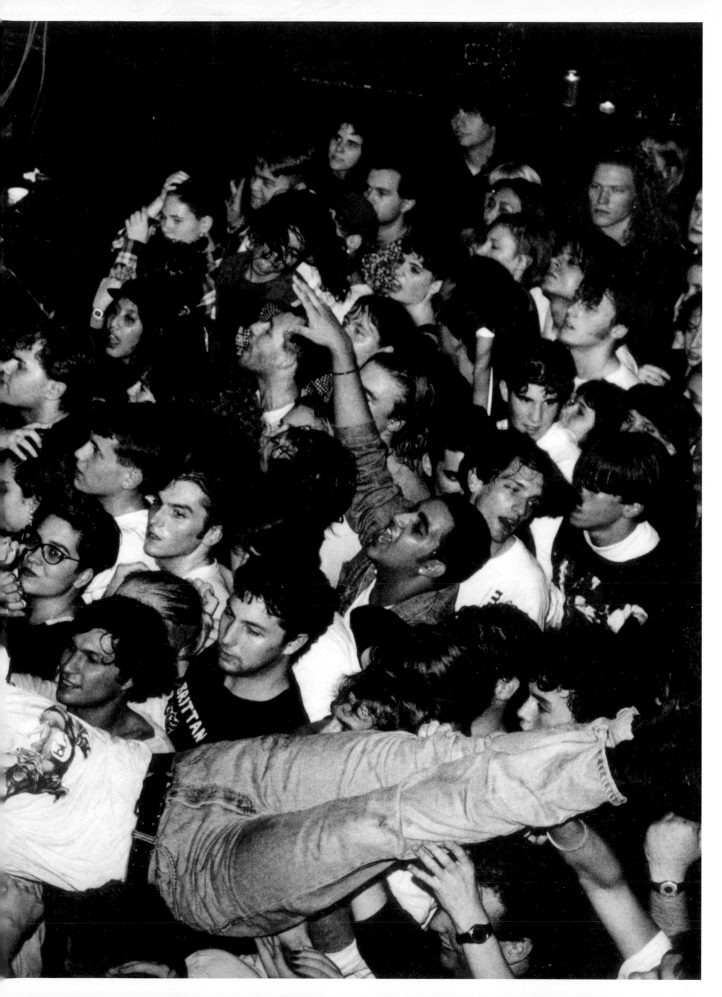

Blur, Studio, December

Every year for the *NME* Christmas
issue, we'd choose a theme –
favourite TV programmes, films
and so on. This year it was favourite
album sleeves. Blur chose *Queen
II*, but a few days before the shoot,
Freddie Mercury died. We were often
accused of insensitivity, but thankfully
my editor backed down on this
occasion and the band decided to
do Blondie's *Parallel Lines* instead. In
the studio, I spent four hours cutting
and preparing the backdrop from
memory. Then my stylist, Dilly, arrived
with the album sleeve and we realized
that the picture of Blondie was just cut
out and dropped in onto the parallel
lines. Meanwhile Damon was getting
into the role, having his chest hairs
covered in talc to tone them down
and his legs shaved. He would only
shave them below the knee for some
reason, but despite this the photo
still works brilliantly. Years later I
photographed Debbie Harry, who
told me she (and the band) adored
the photo and I told her about Damon
only shaving below his knees. "Oh, tell
him I only do that too," she said. "See,
it's more authentic than you thought."

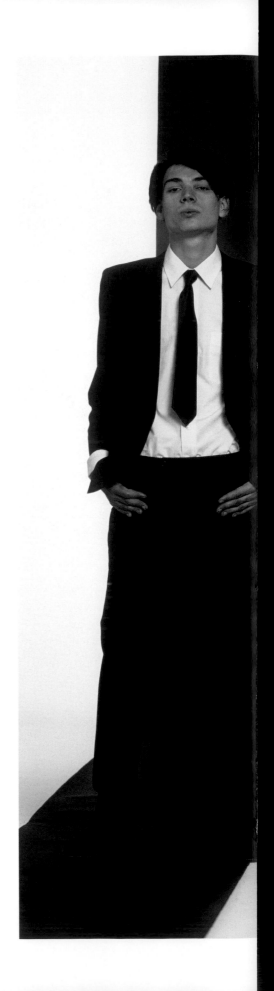

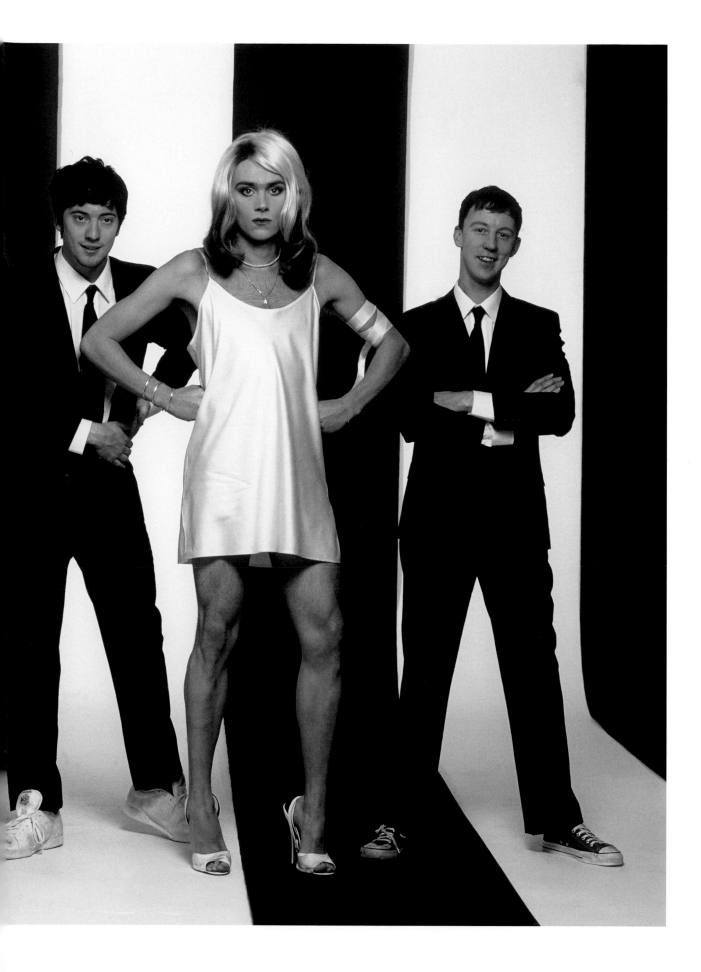

1992

Tim Burgess/The Charlatans, Montreal, June

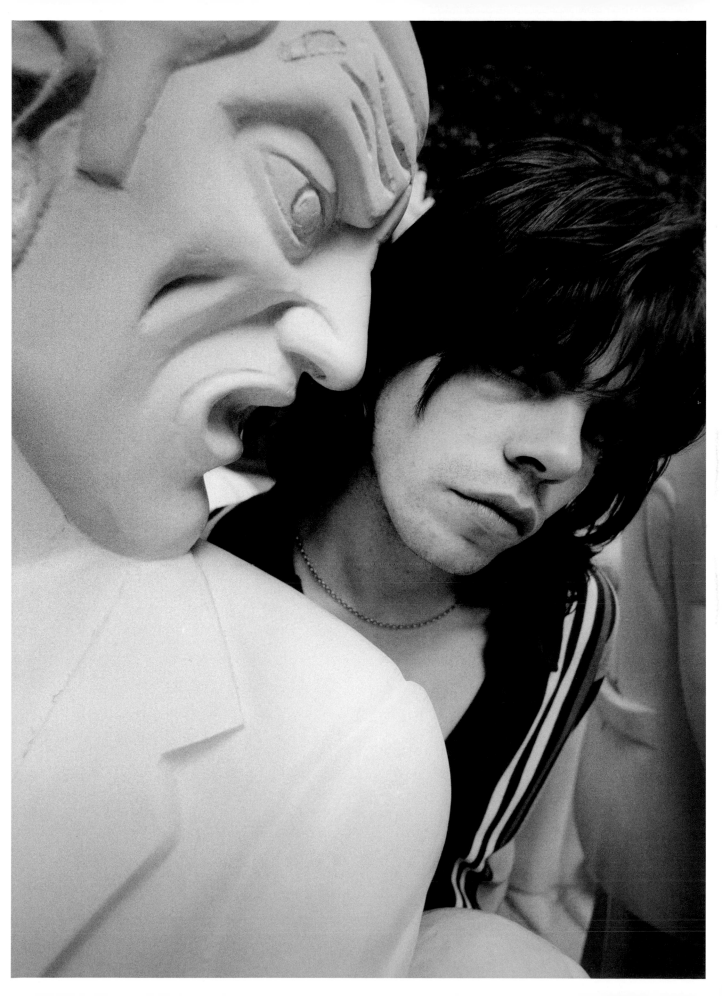

Lush, Studio, January

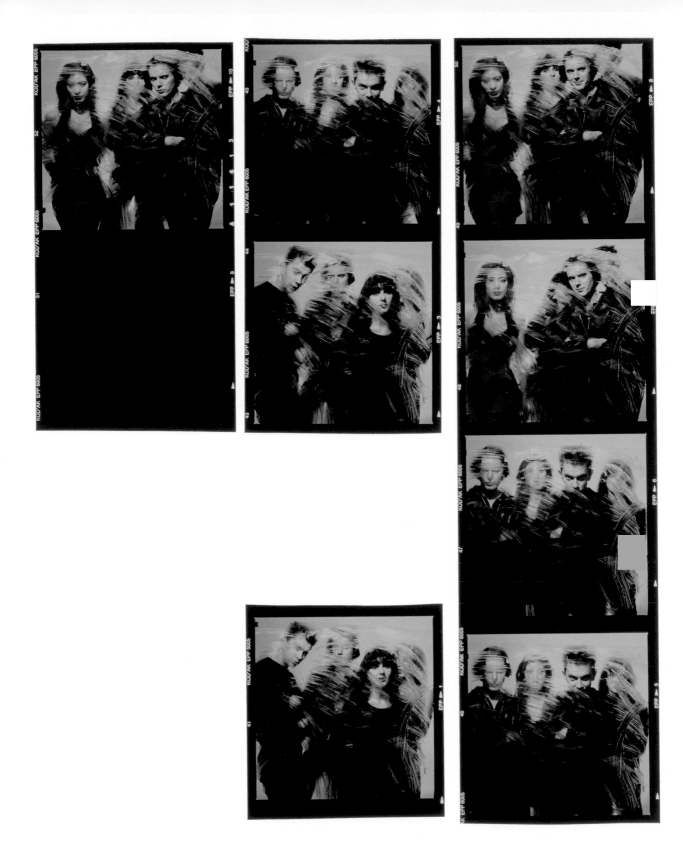

Blur, Tokyo, February

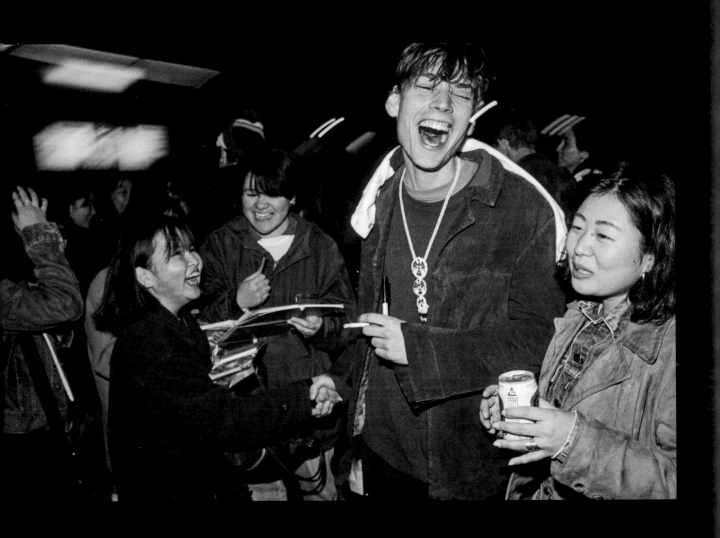

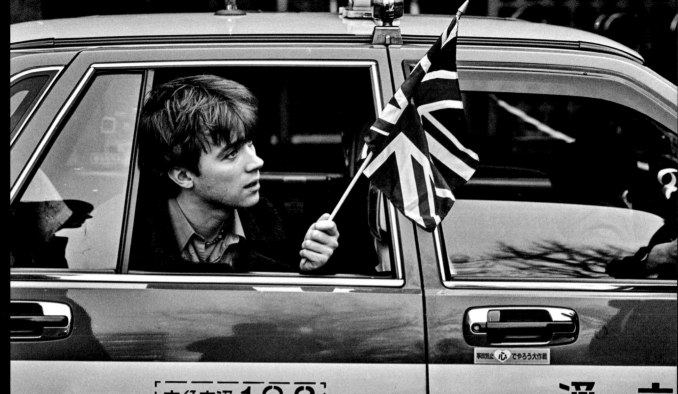

"Look, I know why people resent me. It's because I'm confident."

Damon Albarn, Blur, *NME*, 27 April 1996

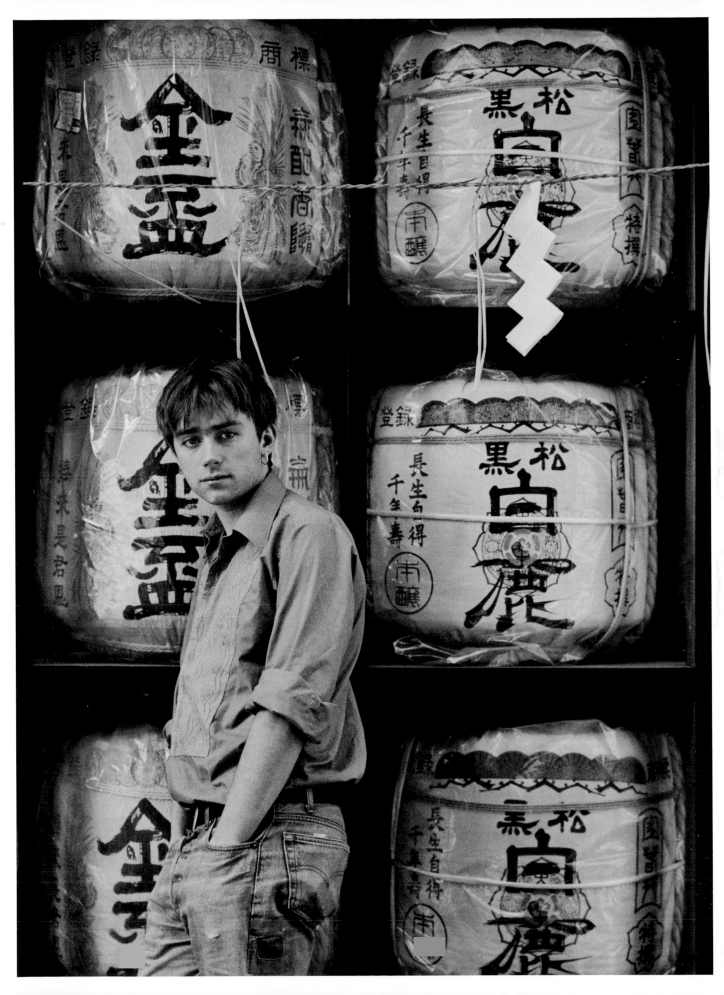

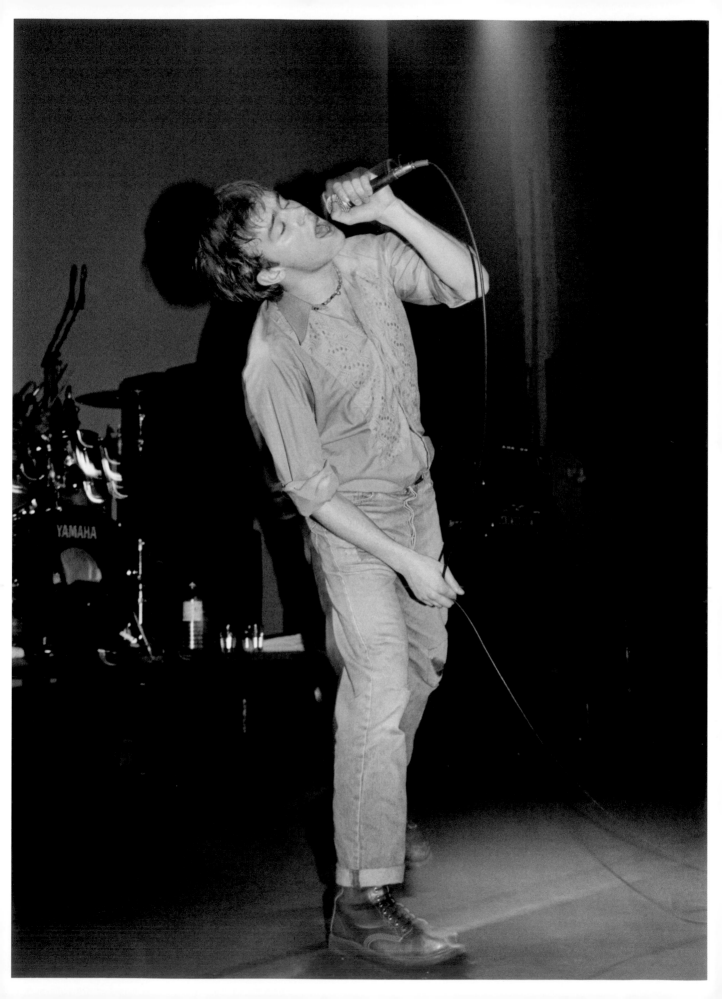

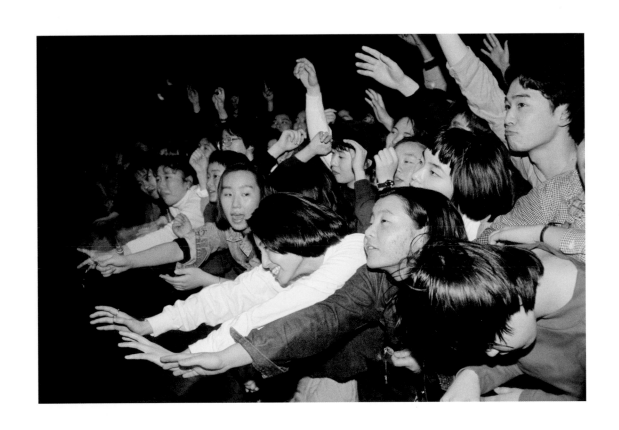

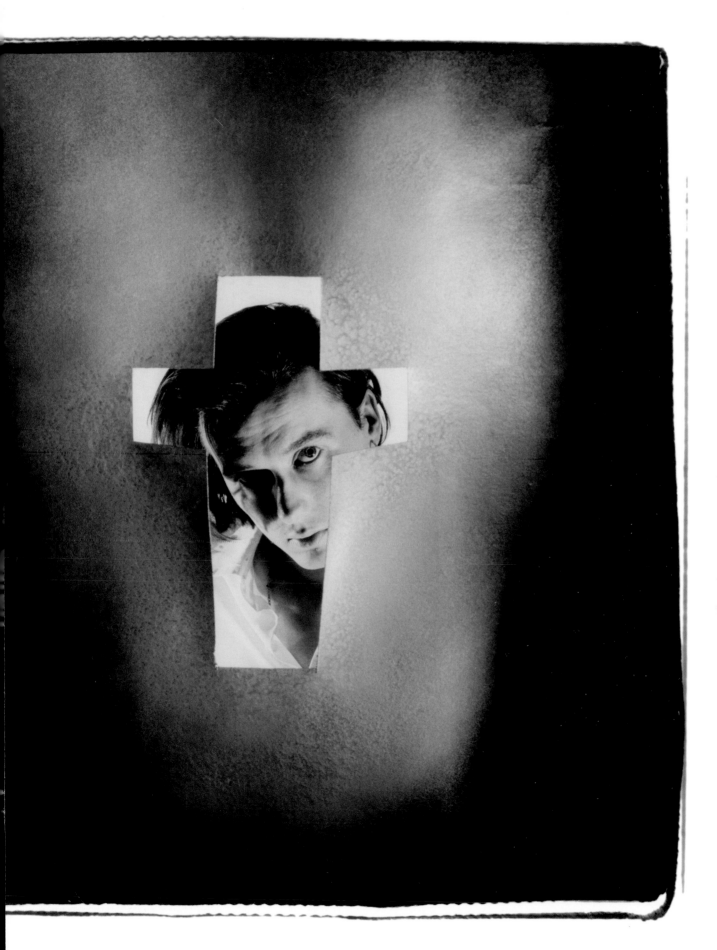

In Conversation
Brett Anderson, Suede

It's 25 years since Britpop – how do you look back on that time?

My view of the era is complex. I think like all movements it started off with good intentions. When we were writing those songs in 1991 it felt thrilling and against the grain, but what began as a frank documentation of life as a poor, white, marginal man living in rented rooms in London – and which was in broader terms an exciting rejection of American cultural imperialism – soon became a jingoistic, beery cartoon when the money moved in. It happens to all cultural movements. The original inspiring ideas become a cheapened victim of their own success once the imitators and the hangers-on spot an opportunity.

Has it aged well?

I think it's aged terribly. The faint whiff of nationalism and misogyny, the *Men Behaving Badly* and *Loaded* culture that was part of the ugly zeitgeist it began to embody is so at odds with modern concepts of gender fluidity etc, that it feels clumsy and almost anachronistic now.

Did it feel like you were all part of a scene?

Subjectively no, but I'm aware that others would of course see it differently. As soon as we saw a scene developing we made *Dog Man Star*, which is possibly the ultimate anti-Britpop record. It was an album about disintegration, isolation and internationalism, which we made at a time when our contemporaries were waving their flags and celebrating a kind of fantasy parochialism, a chimera of nostalgia.

Did you feel any kinship with other indie artistes of the time?

I suppose the Manics were the only other band who had a similarly sour and askance view of the whole thing. They toured with us in Europe in 1995, and it did feel that both bands were somehow happily exiled from it all.

Do you feel that lumping bands together under the Britpop label was enhancing or demeaning for you and for the other bands?

Labels and movements are necessary in that they provide heft. They are simplistic and a little clumsy and no one thinks they really do them justice as individuals, but the media need to file things like this as it makes everything easier to wield and to categorize.

Your previous relationship with Justine Frischmann was used to imply there was a close-knit scene. Did that irritate you?

When you are in the public eye there are two versions of yourself – the person and the persona – and the same can be true of the nature of a relationship. It's interesting that Justine and I had a completely self-contained relationship, prior to either of us achieving any sort of success, that was of course private and personal. And then that relationship was somehow wrestled from us and viewed and assessed publicly in retrospect. Yes, I do think its very existence implied a sort of cliquey coterie and maybe I'm deluding myself by protesting that there wasn't.

Did you or the band have any problem with your first *NME* cover, when I shot you on your own through a cross to mock the idea of you as rock deity, rather than using a band shot?

To be honest it's not my favourite shot you ever took of us or me but, aesthetics aside, no, a band will naturally acquire a focal point and one face is easier for the public to process than four. You'd have to ask the others how they personally felt about it.

What do you think set Suede apart from the other bands of that era?

A pig-headed and self-sabotaging urge to not be like other bands. That was the whole point of Suede, to be an antidote.

Why do you think other bands were caught up in the hedonistic, *Loaded*-style birds, booze, drugs, rock 'n' roll and football lifestyle?

I think it allowed a powerful, almost Dionysian urge to transgress and indulge primal, base instincts. It achieved an almost mob-like mentality, as if everyone was lost in a huge cultural football chant, the madness of the crowd abdicating personal responsibility. It indulged a childish personal and cultural revisionism, a return to a hazy *Dad's Army* sort of world that never really existed. These were extremely compelling forces to which many succumbed.

Do you think the era is forever tainted by the nationalistic use of the terms "Britpop" and "Cool Britannia", or do you think it was able to reclaim the Union Flag and celebrate a great period for British music?

The use of the flag is interesting. It's fascinating how something that loaded can be interpreted completely differently depending on the context. Look at how Morrissey's use of it at that Finsbury Park gig in 1992 was seen as nationalistic, whereas Geri Halliwell's and Noel Gallagher's use later in the decade was viewed as patriotic. It's an indication of the blithe optimism of Cool Britannia that people managed to get away with waving flags. It's an indication of how different the political climate is today that exactly the same act would now be viewed as deeply troubling.

Most eras of music are remembered for songs that live on forever. Do you think Britpop has this too?

I'm still too close to it to say. It's always my least favourite things that seem to become really popular and zeitgeist-defining, so I'm probably the wrong person.

Was Britpop the epitome of white male privilege?

I don't want to become too curmudgeonly, but I can't help but say yes. I do now view its core politics as anachronistically patriarchal and, actually, borderline toxic. But I'm proud that Suede stood up to that and through our songs discussed issues of androgyny and gender fluidity in a climate of such overt misogyny. Our stance now feels strangely modern. As John Peel once said about prog, "I was right then and I'm right now".

Did you ever consider Britpop as a backlash against all the great social advancements that had happened up to that point?

I think every movement is a reaction to the cultural climates that precede it. I suppose the politically correct era of the 1980s was bound to mutate into something less woke, to use the modern vernacular. It's the nature of how pop culture works, a cycle of birth and rebirth.

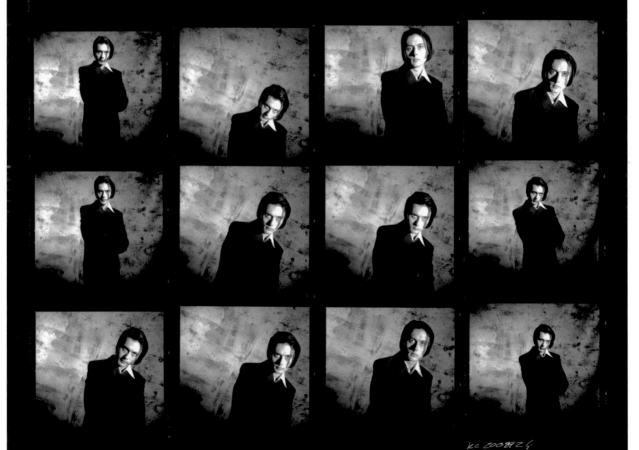

kc 200892 4

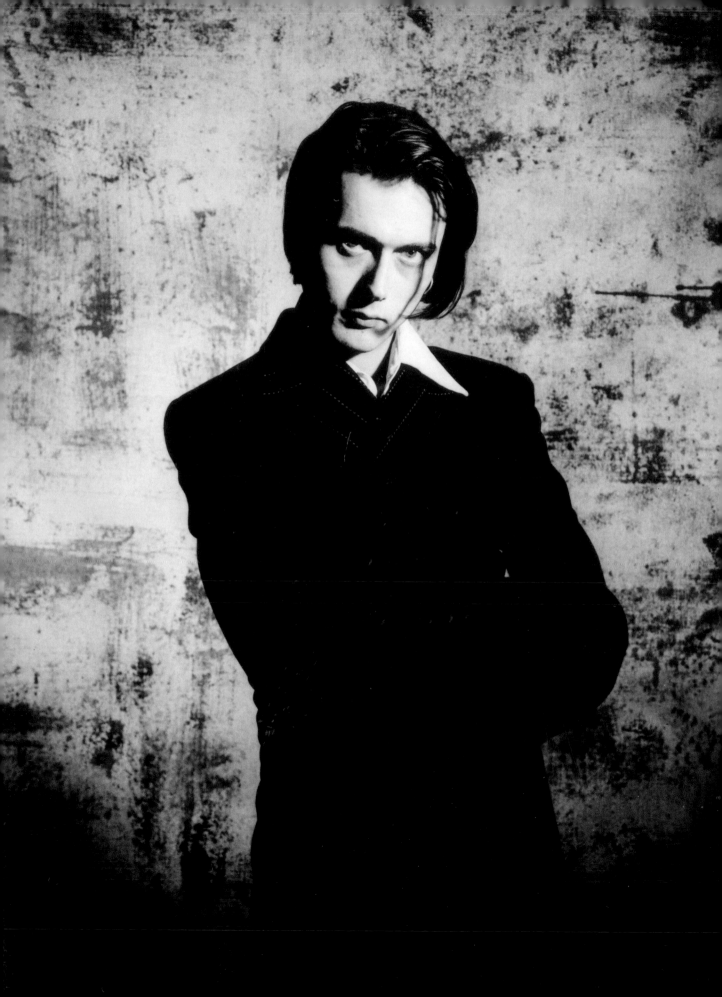

Sarah Cracknell/St Etienne, Studio, September

This is from a session to promote a Heavenly
Records compilation of Right Said Fred songs
to raise money for the Terrence Higgins Trust. St
Etienne's contribution was "I'm Too Sexy". What
better way to promote safe sex than to blow up
condoms in giggly schoolkid fashion, which clearly
is what we did here.

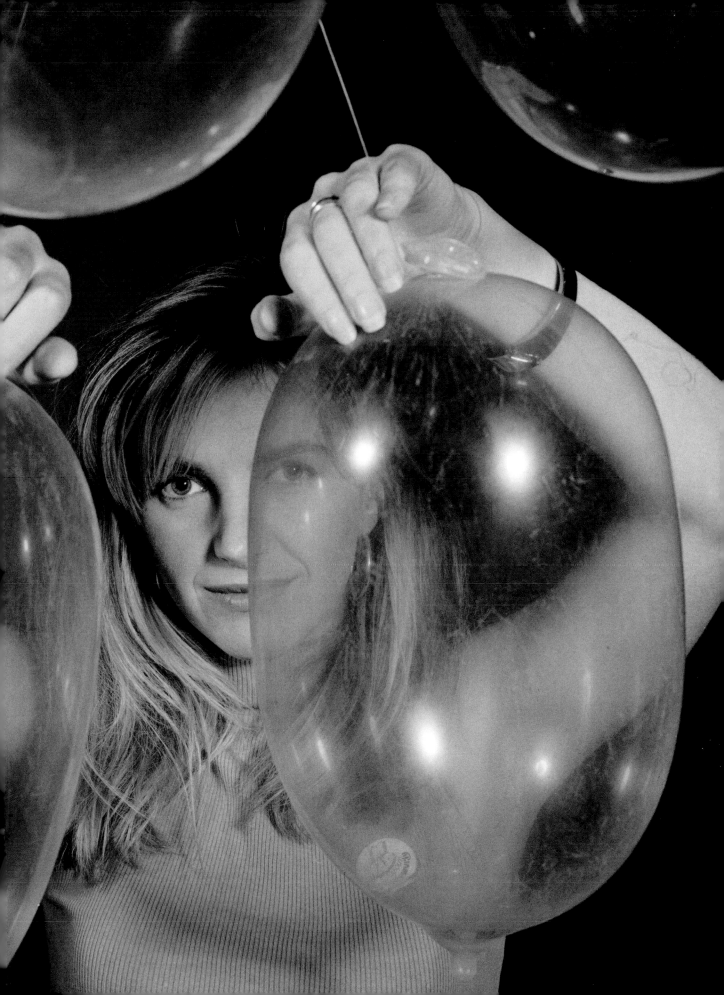

Chrissie Hynde and Brett Anderson, Studio, September

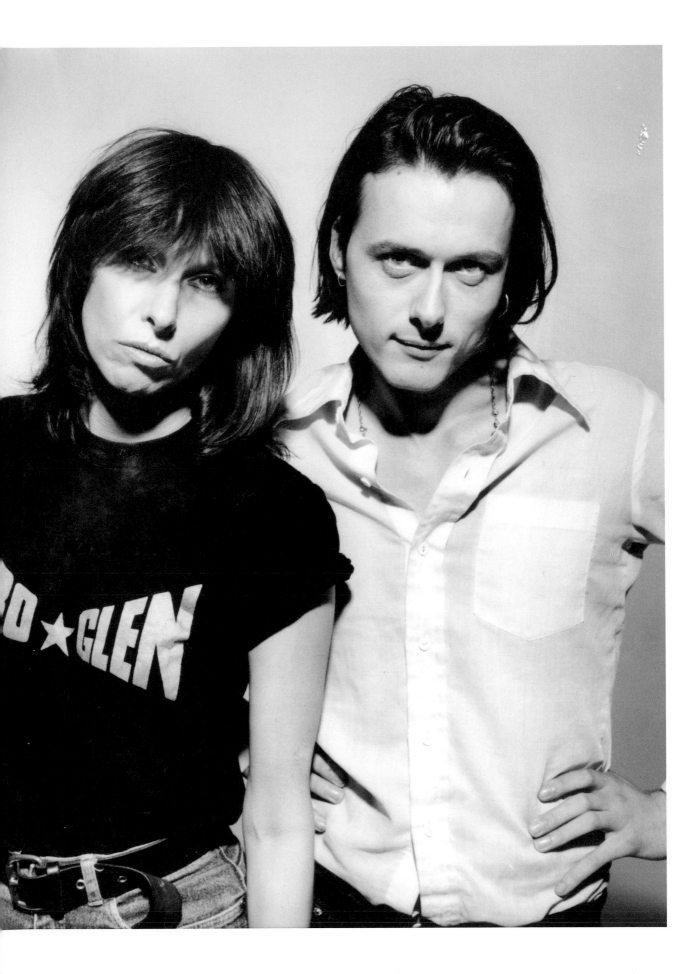

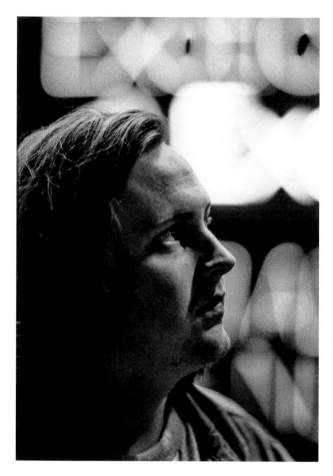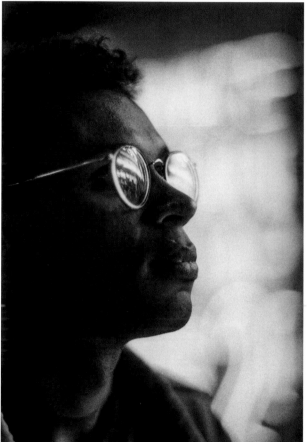

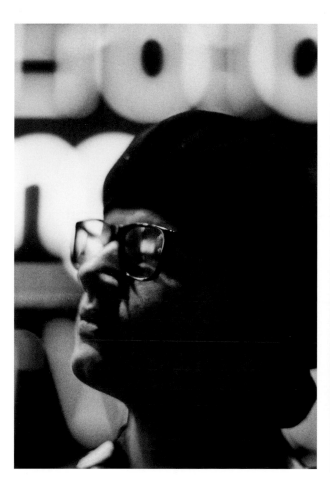
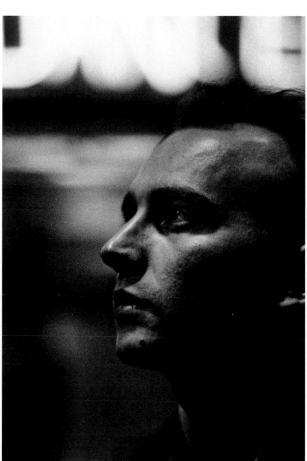

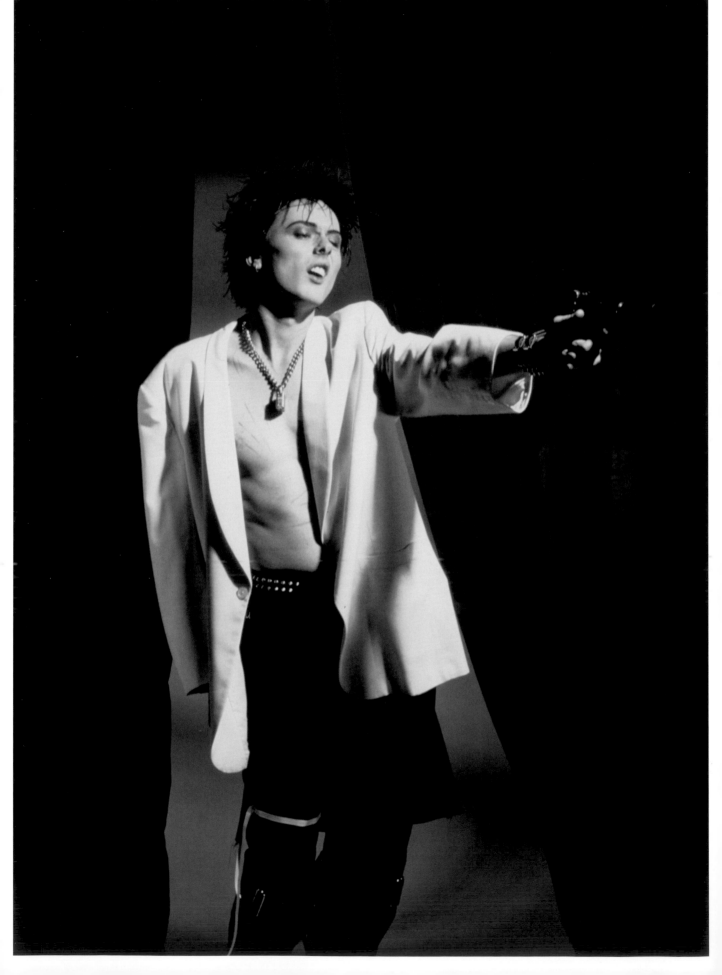

Brett Anderson/Suede, Studio, November

This was for an *NME* Christmas issue. Brett made a great Sid from *The Great Rock 'n' Roll Swindle*. We even gave him chest scars for added authenticity. I've no memory of him actually singing "My Way" in the studio but I'd like to think he did.

1993

Brett Anderson/Suede, Studio, February

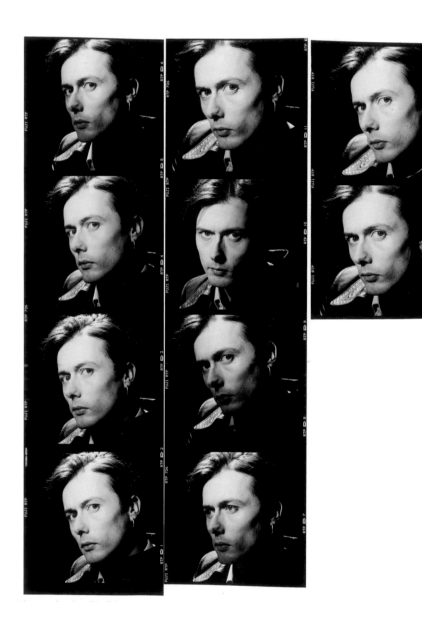

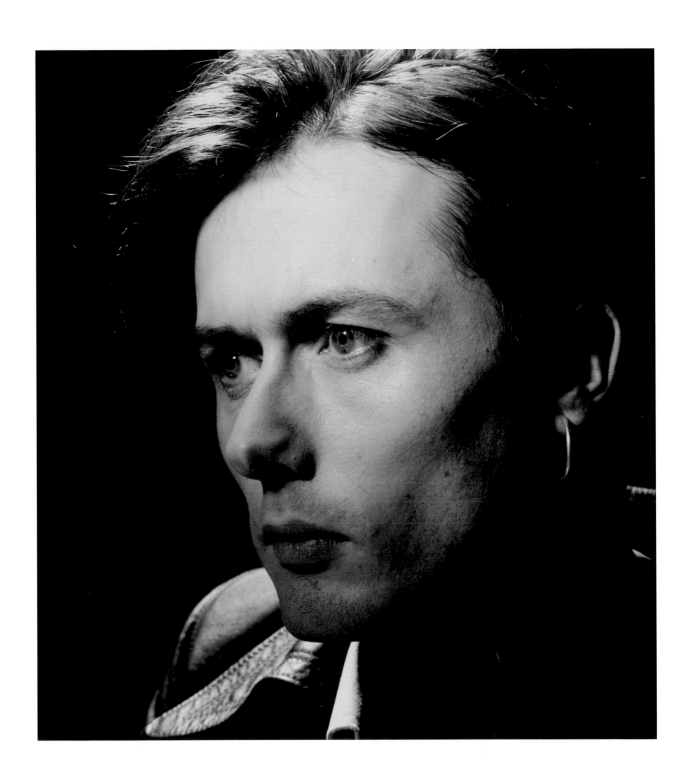

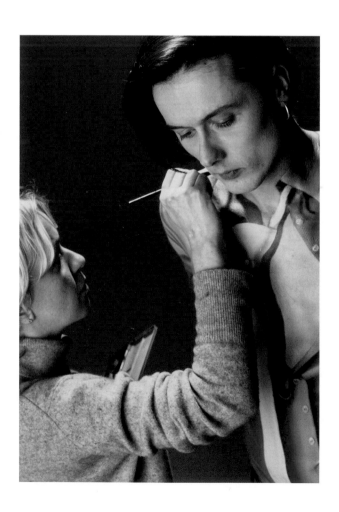

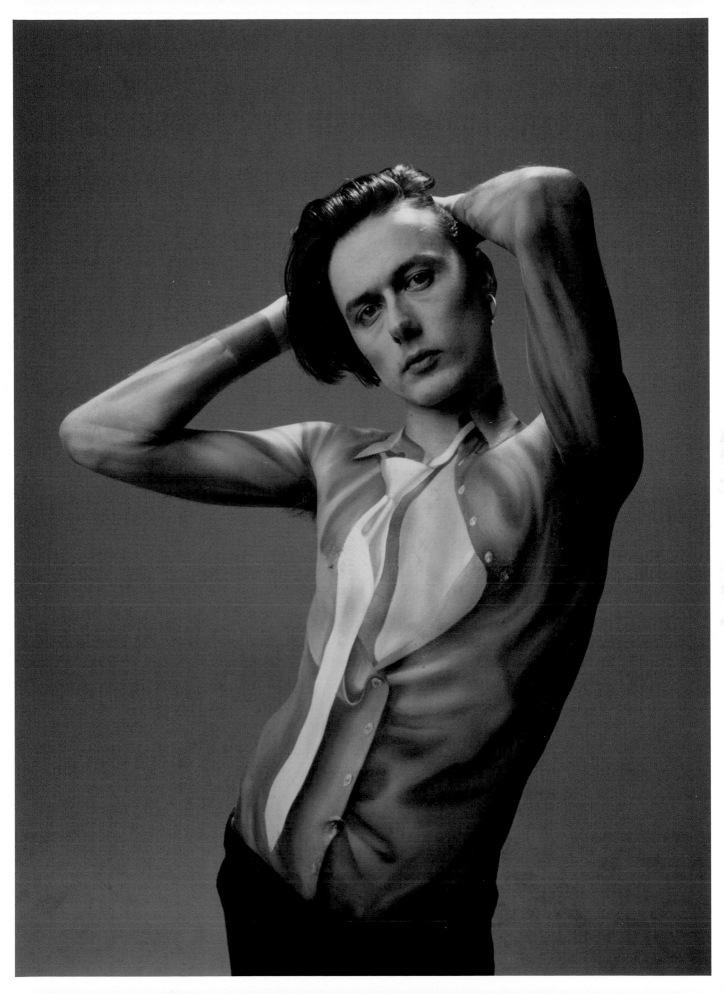

"There's a side of me that has a real yearning to do something like Pink Floyd, that isn't traditional Suede at all."

Brett Anderson, Suede, *NME*, 20 February 1993

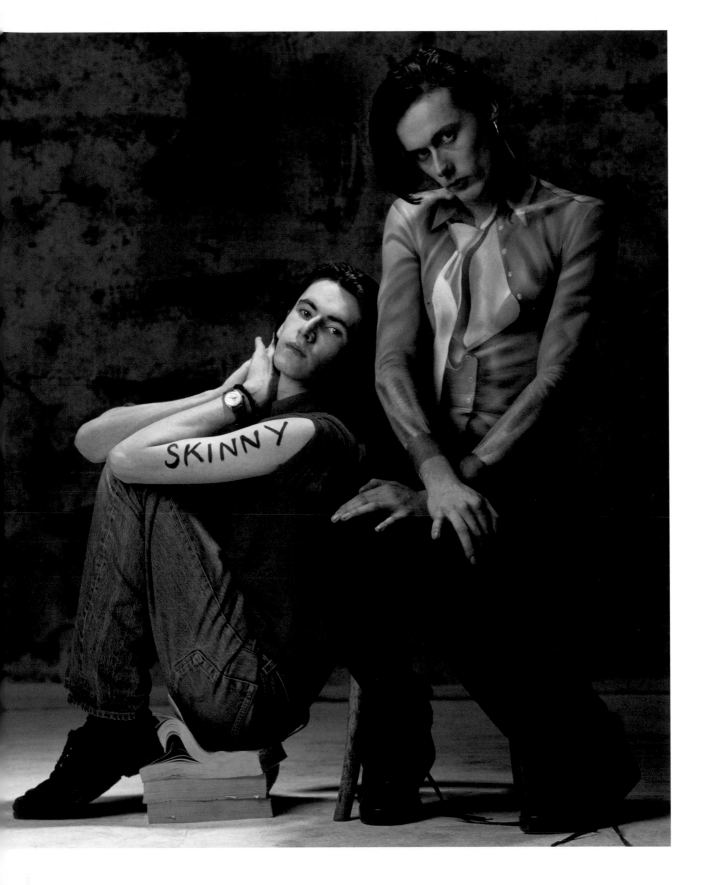

Bernard Butler/Suede, Studio, February

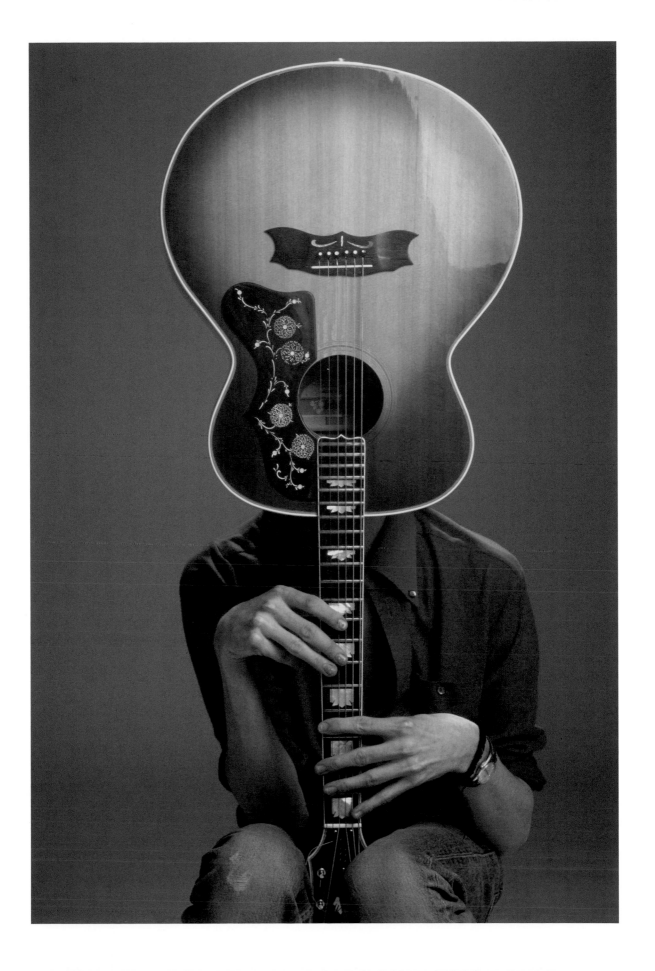

Blur, Clacton-on-Sea, March

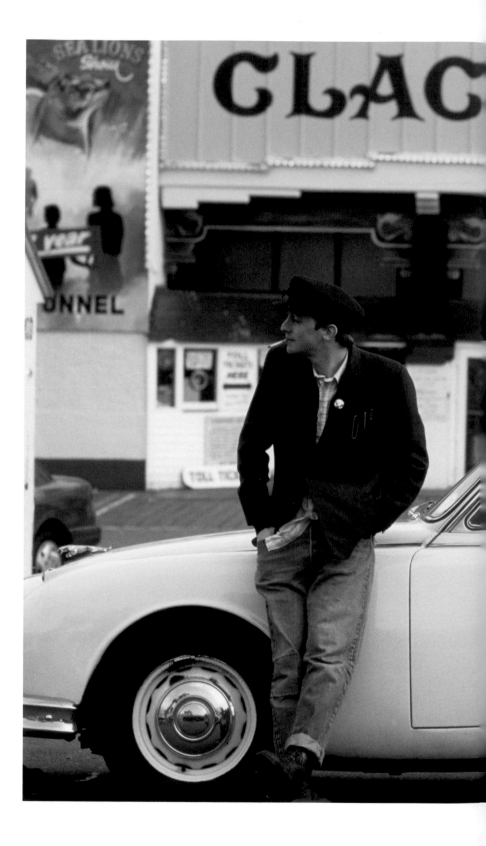

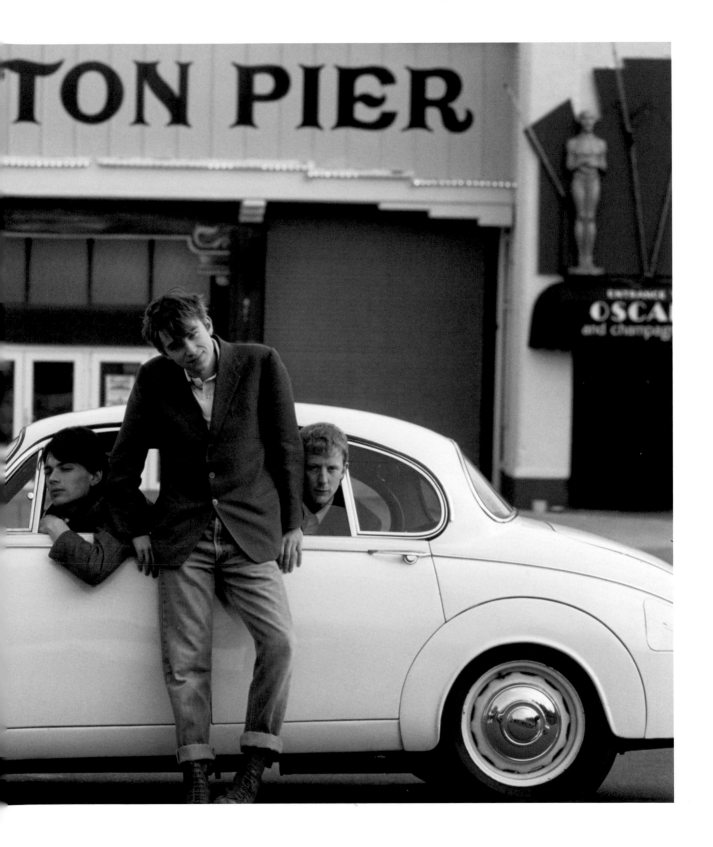

When I shot the *Modern Life is Rubbish* photos with Blur, the idea was to travel in 1960s vintage cars to the coast and do a kind of mod-style Clacton day out. Before we'd even left London, one of the cars overheated and we had to have it loaded onto the back of a car-carrier. The band and I caught the train and met the car owners there. We couldn't move or drive the cars, which had to be shunted into position for the pier shot, so there was no real variety in the pictures. We were sitting around wondering how to flesh it out for a cover feature, when Damon produced the spray paint. I found a derelict wall and shot individual portraits using one word for each of the band, but it still didn't feel strong enough for a cover. Then, as we walked back to the cars, we noticed a council painter putting the finishing touches to the seawall. It was at least 45m (150ft) of pure sky-blue paintwork. As soon as he was out of sight, Damon got to work, spray painting "modern life is rubbish" across the wall. I hastily shot a couple of rolls of film and that was job done. The following day's local paper was full of the act of vandalism, but sadly there were no witnesses. However, when the *NME* published the following week, no witnesses were needed. I believe EMI had to pay for the repaint job. To this day I feel sorry for the guy who painted the wall, but on the upside he helped make a truly iconic photo.

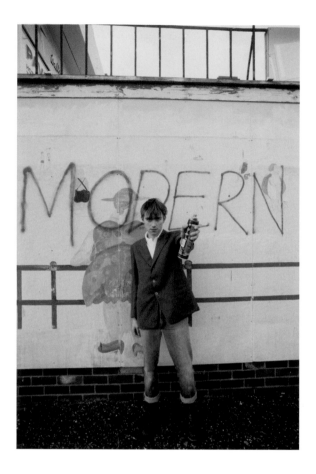

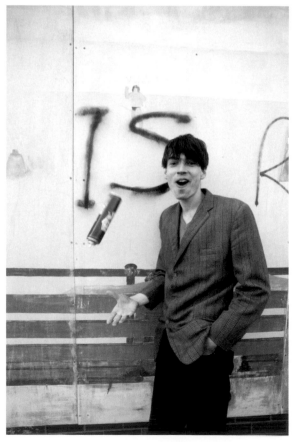

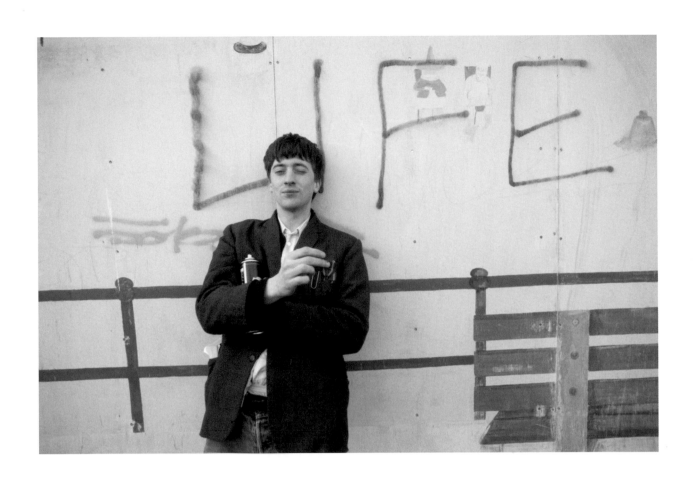

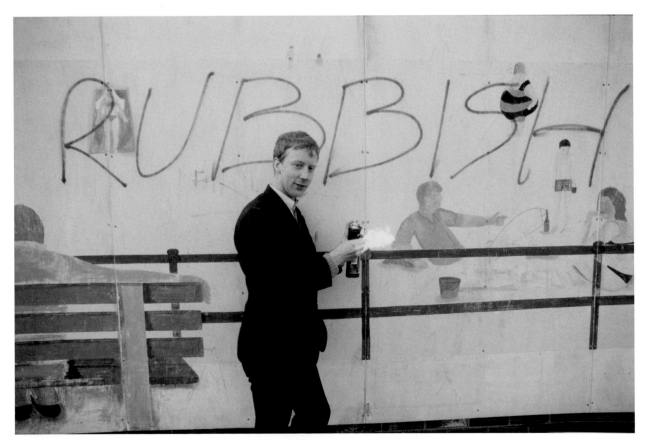

Dodgy, London, April

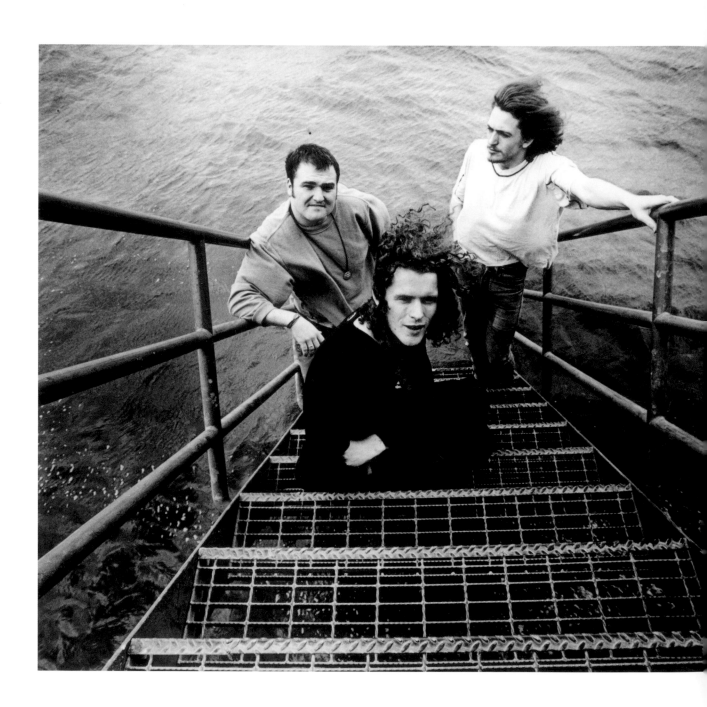

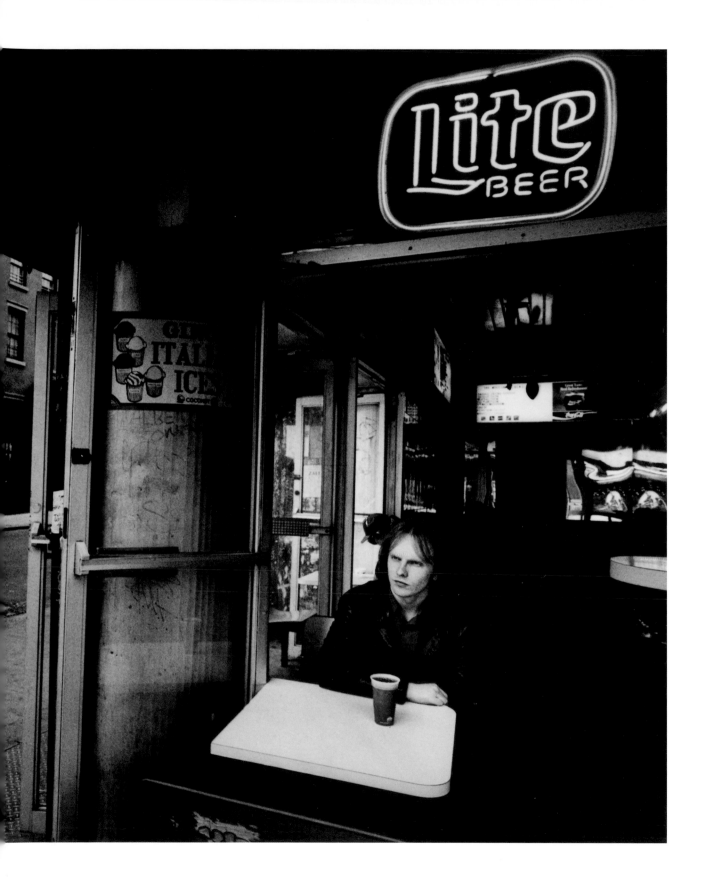

Richard Ashcroft/The Verve, Studio, May

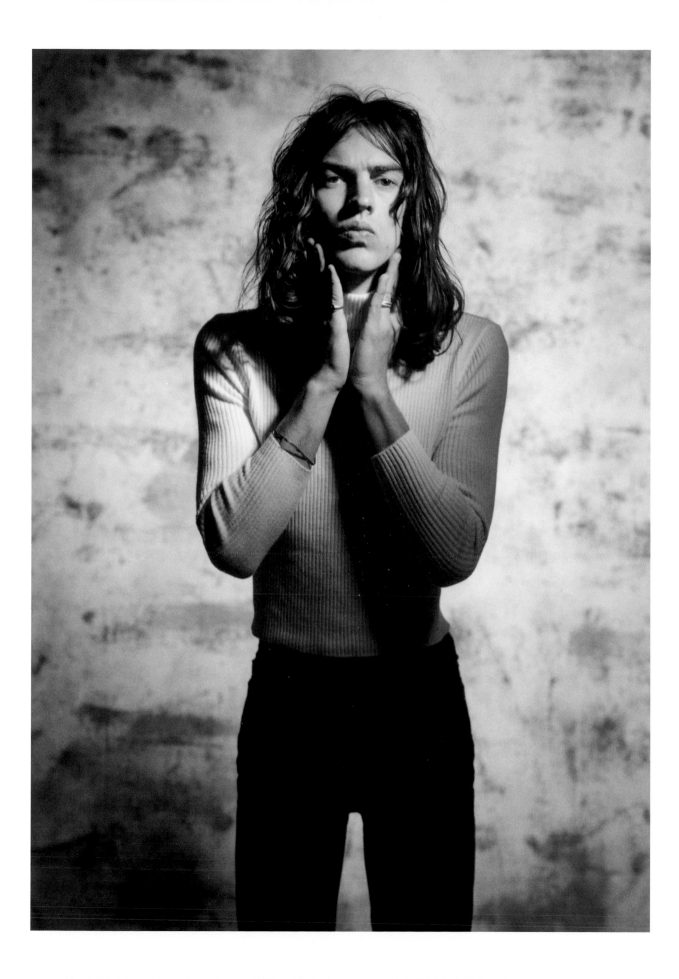

Heather Small/M People, Paris, June

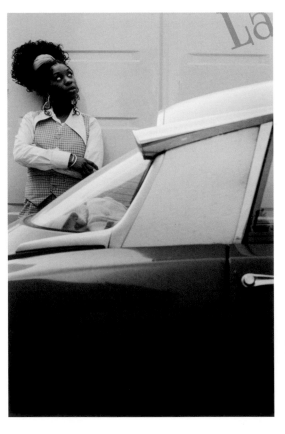 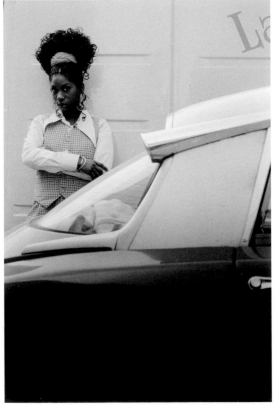

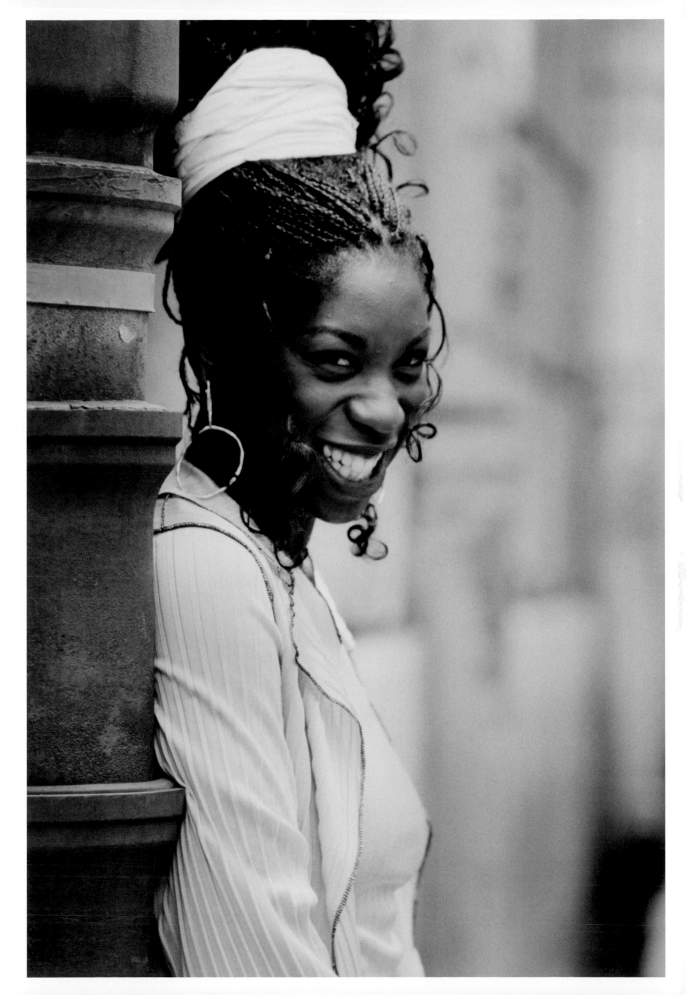

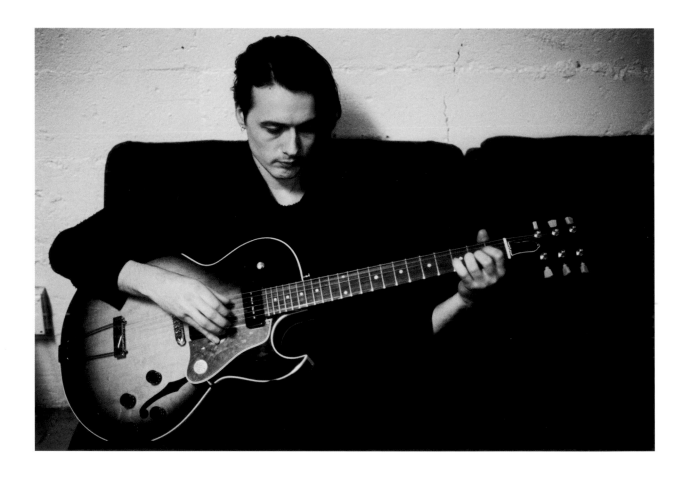

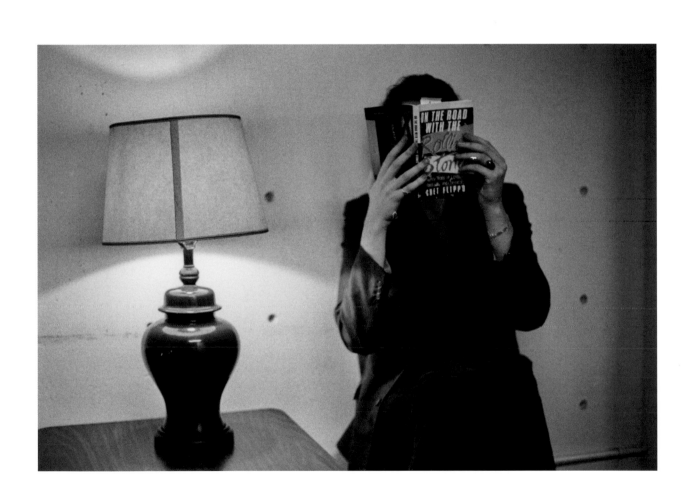

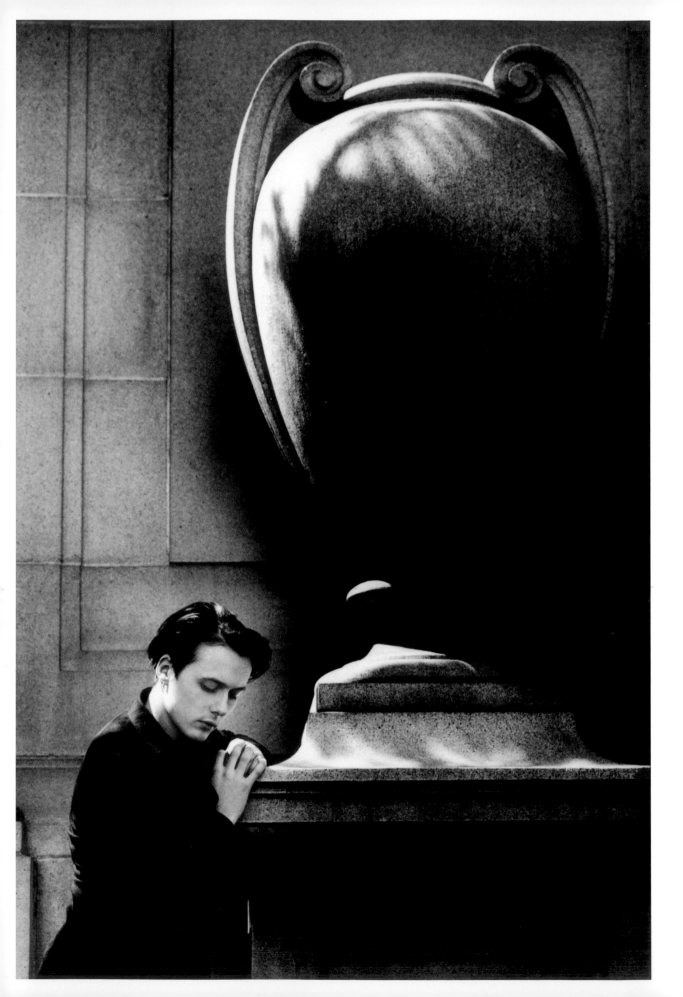

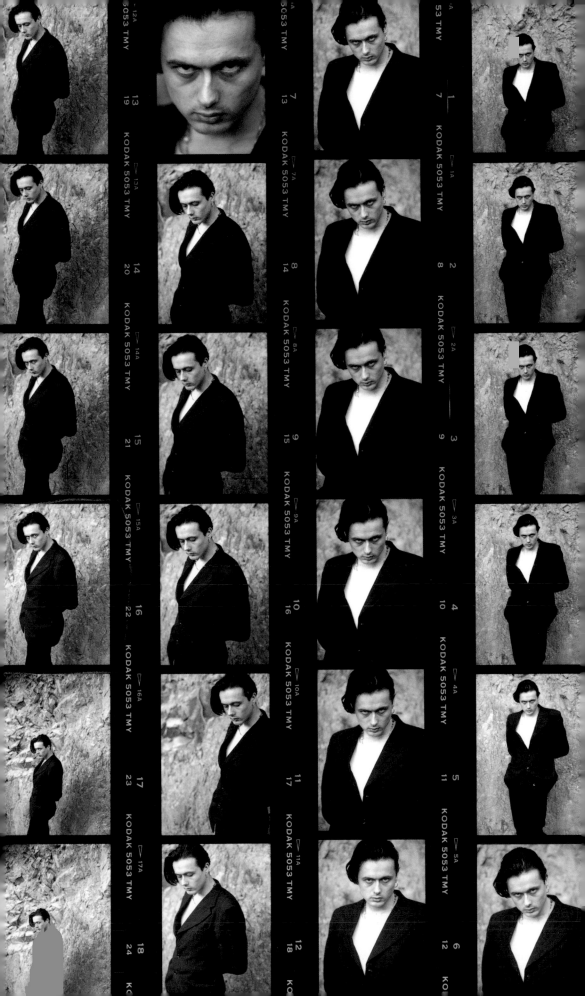

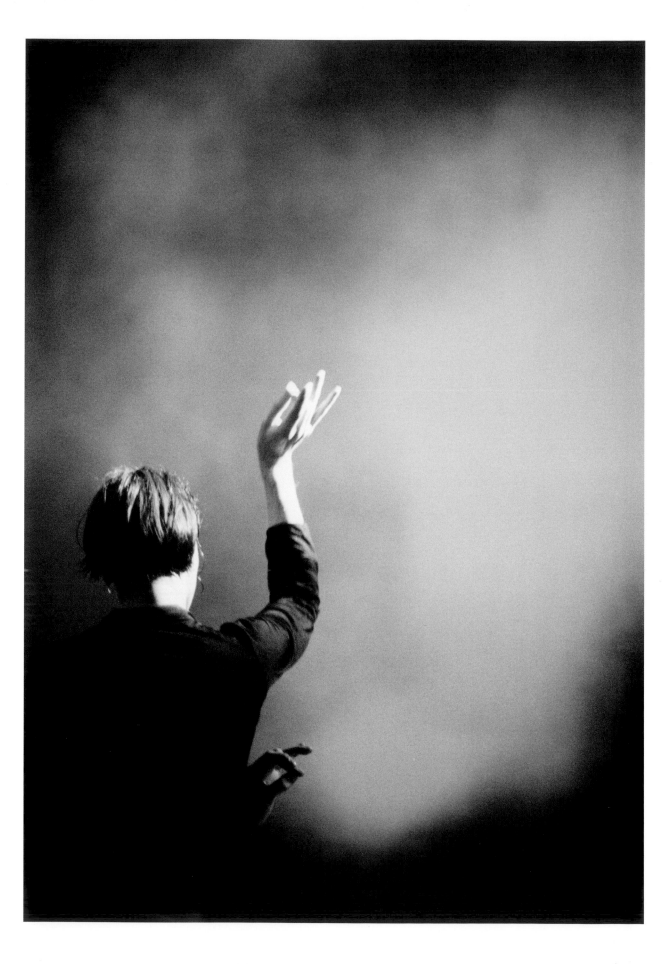

"They trampled all over the corpse of Morrissey – put that in the *NME.*"

Suede fan after a gig in San Francisco, *NME*, 26 June 1993

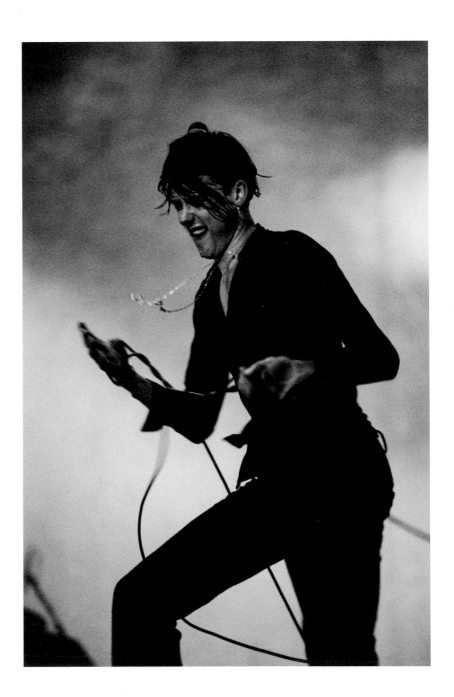

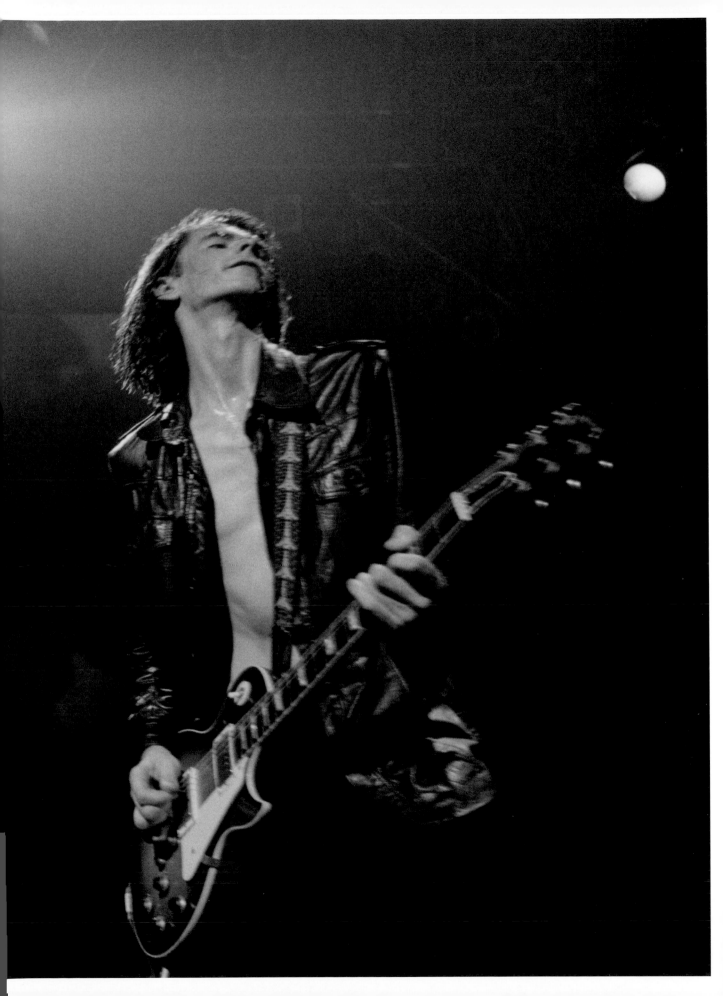

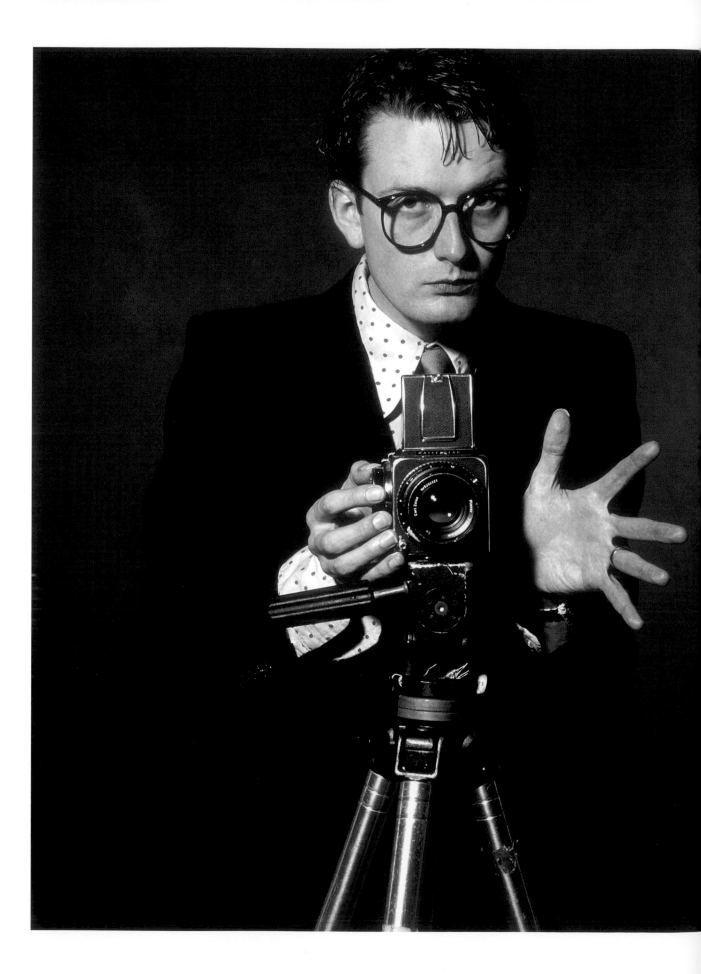

Jarvis Cocker/Pulp, Studio, November

Here Jarvis Cocker recreated the cover of *This Year's Model* by Elvis Costello for an *NME* Christmas feature.

Jarvis, *NME,* 25 December 1993: "It was quite a cathartic experience. When I was younger I worked in a fish market – it was around the time that 'Oliver's Army' was in the charts and people were always telling me I looked like Elvis Costello because of my National Health glasses. I've also been compared to Harold Lloyd, Rolf Harris and Buddy Holly (someone even compared me to Roy Orbison when I was in the pub the other day). To be him in that pose was a useful experience in coming to terms with being called Elvis Costello and I've become a stronger and better person for it. *This Year's Model* and *Armed Forces* are the best stuff he's done. More interesting than the stuff he went off to do. The background is a very nice shade of brown."

Justine Frischmann/Elastica, Studio, December

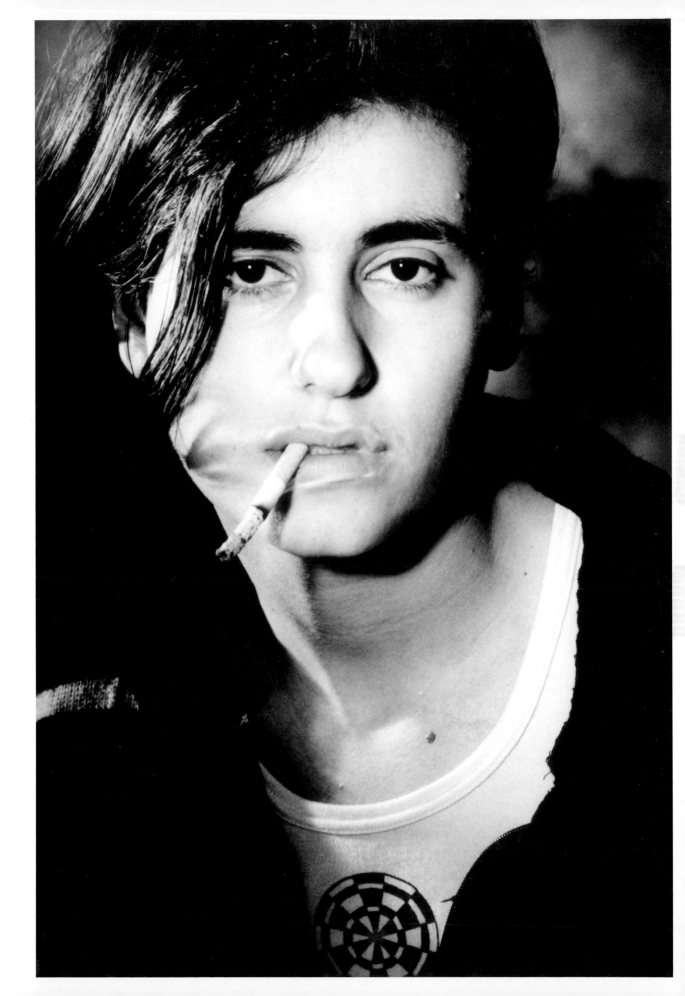

1994

The Charlatans, Brighton, January

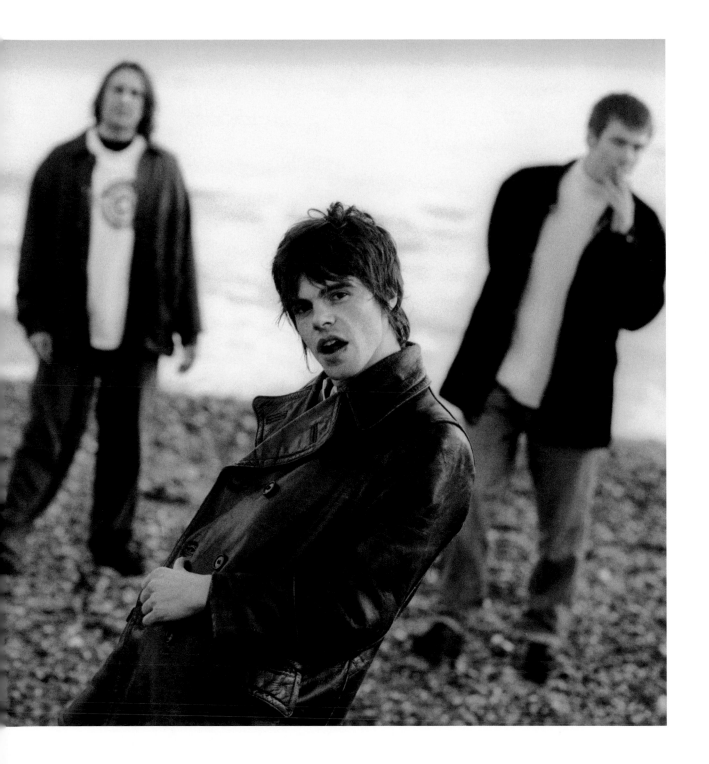

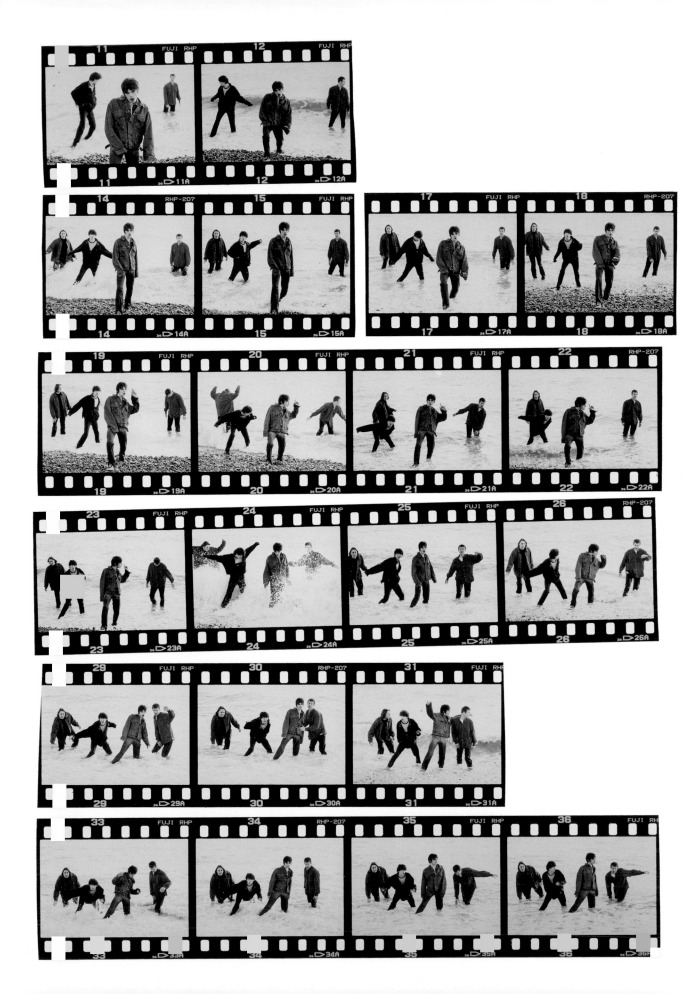

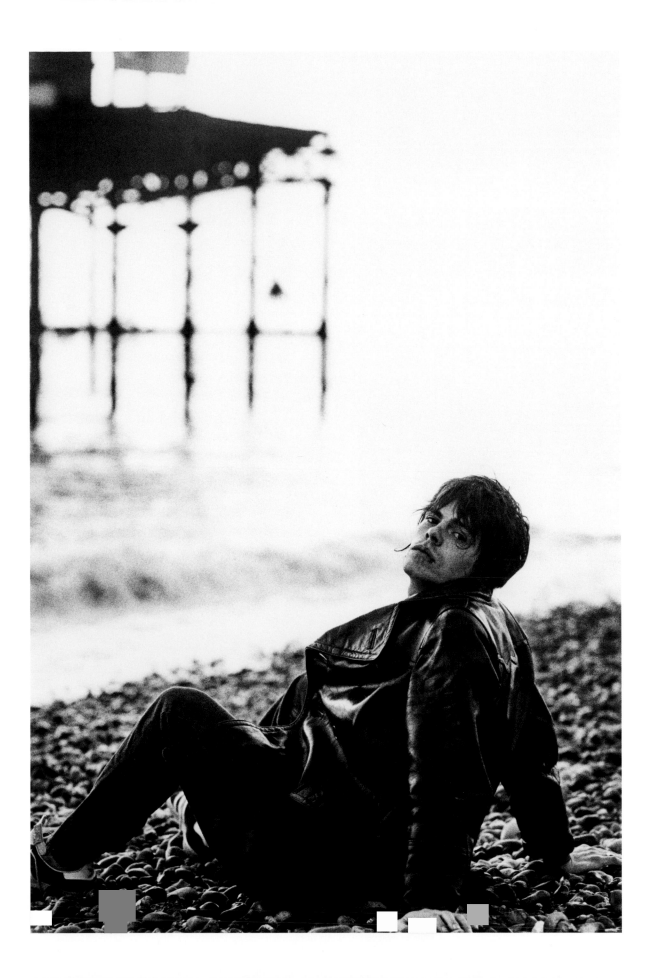

Justine Frischmann, Thom Yorke and Brett Anderson,
The Brat Awards, London, February

"If you took us away, there'd be a huge
blistering gap there. And I don't think
it'd be a particularly interesting musical
climate either."

Brett Anderson, Suede, *NME*, 14 January 1995

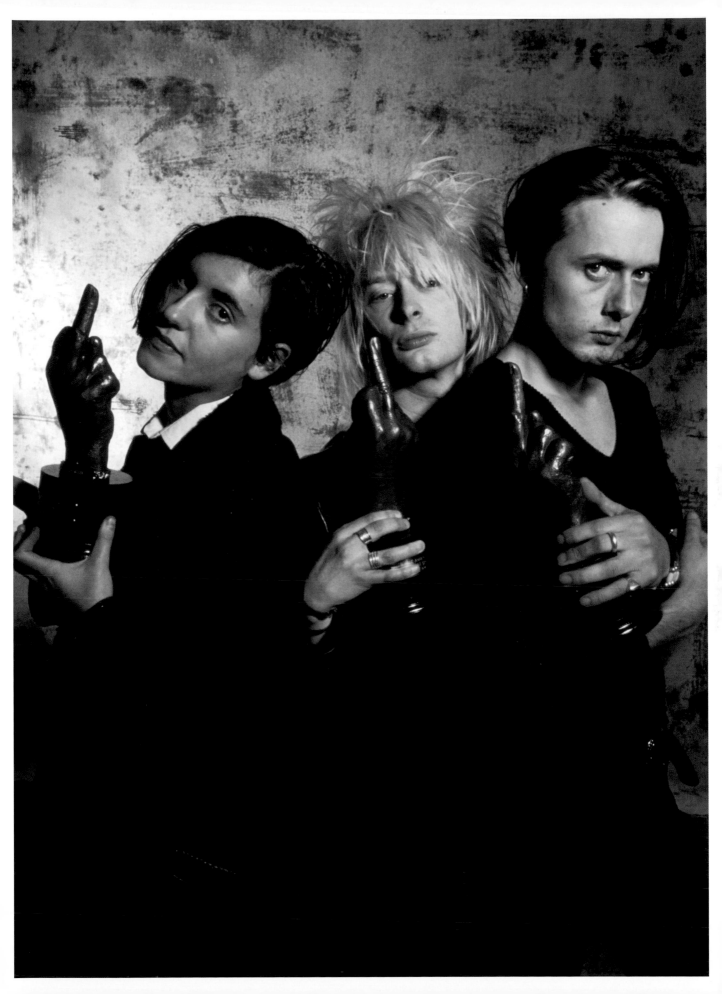

"**Every scene needs someone to articulate it, and some people are always going to hate us for that, but there would not be Britpop without us.**"

Damon Albarn, Blur, *NME*, 27 April 1996

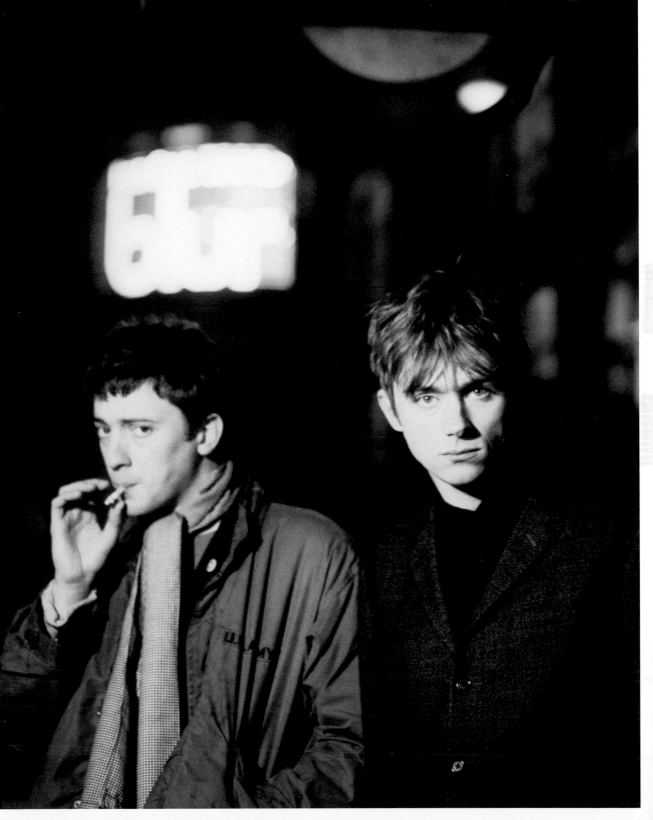

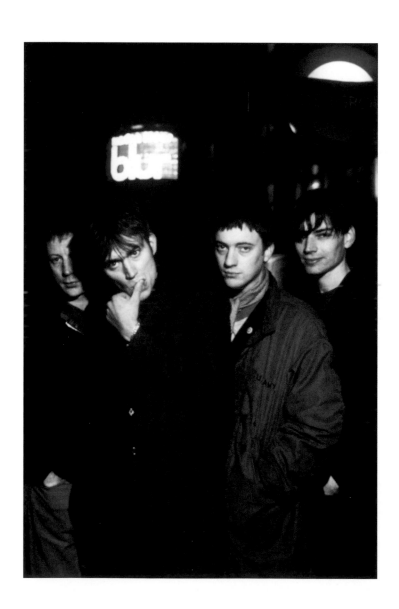

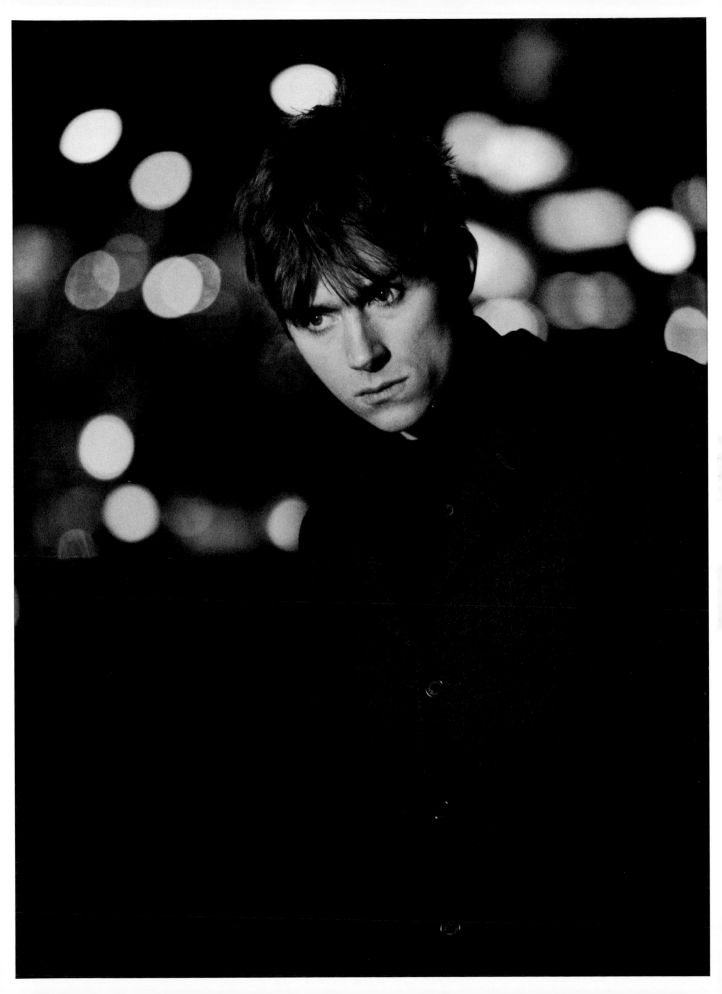

St Etienne, Glastonbury, June

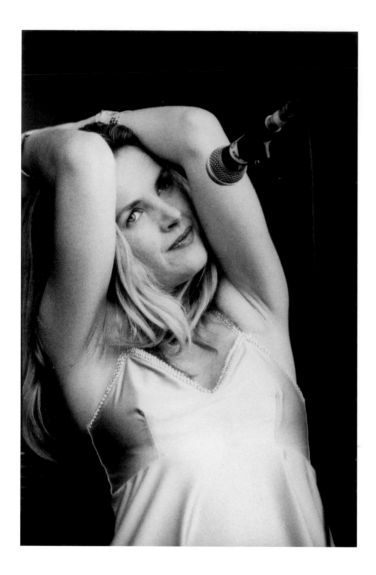

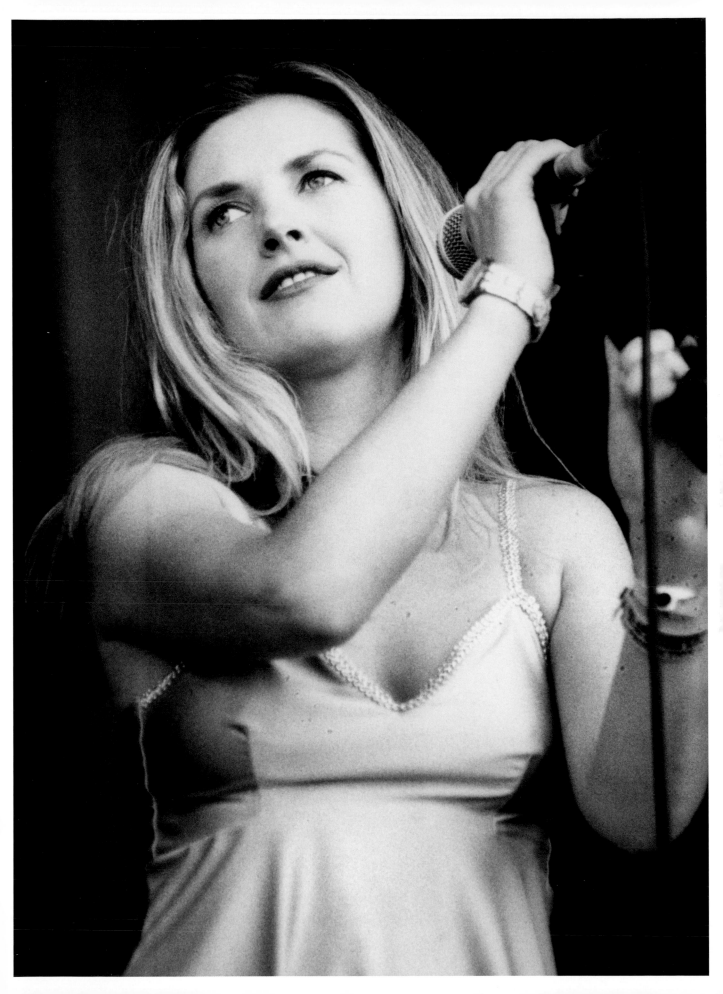

Oasis, London, February

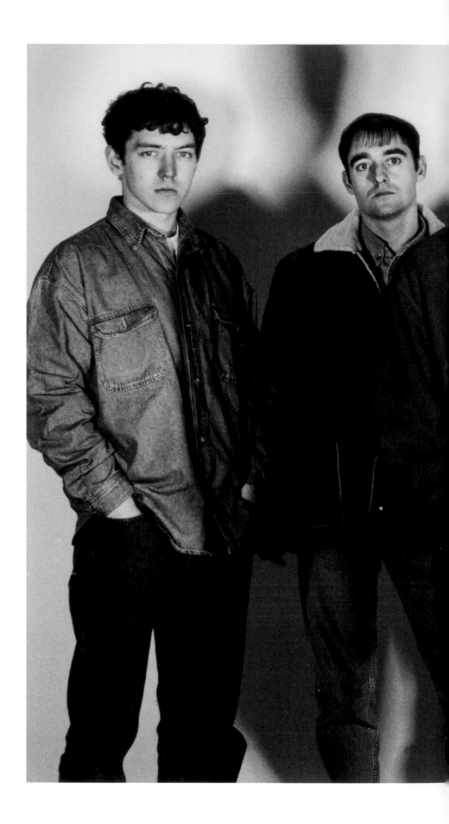

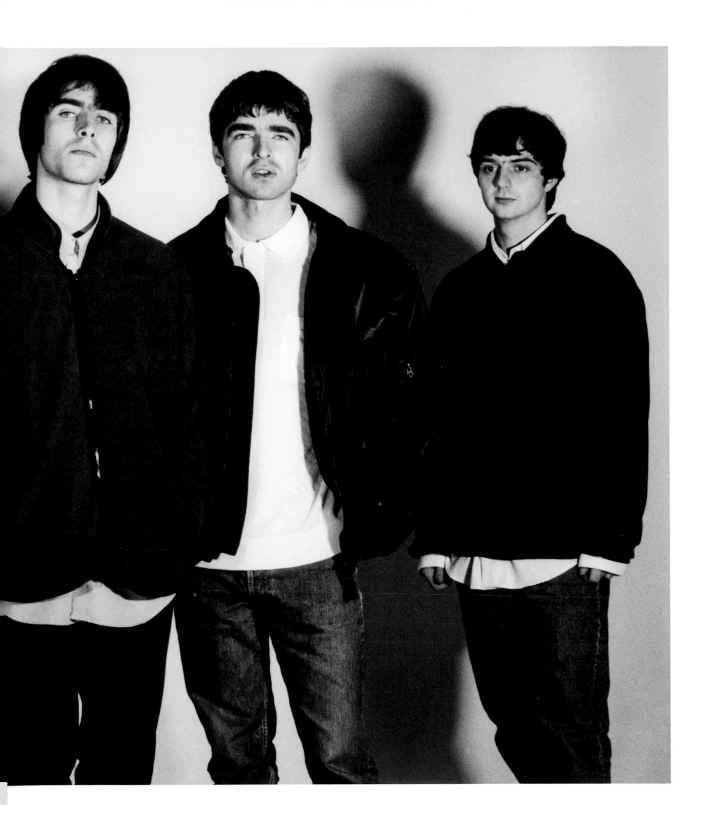

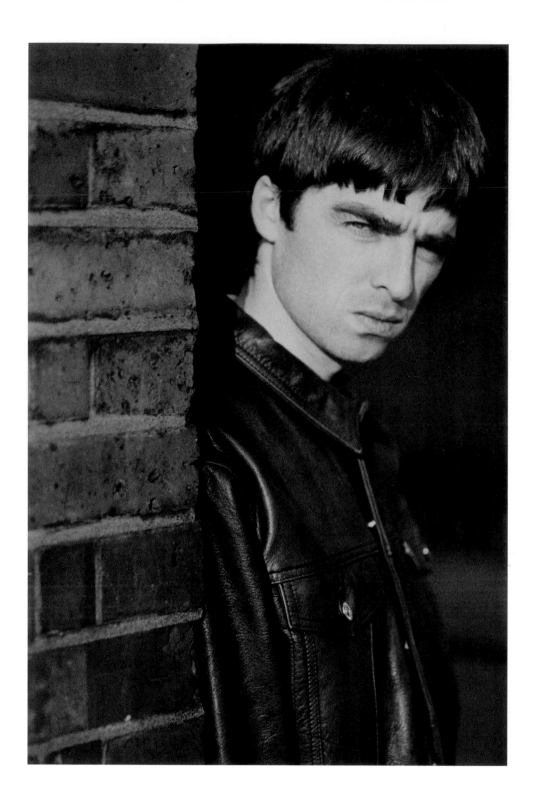

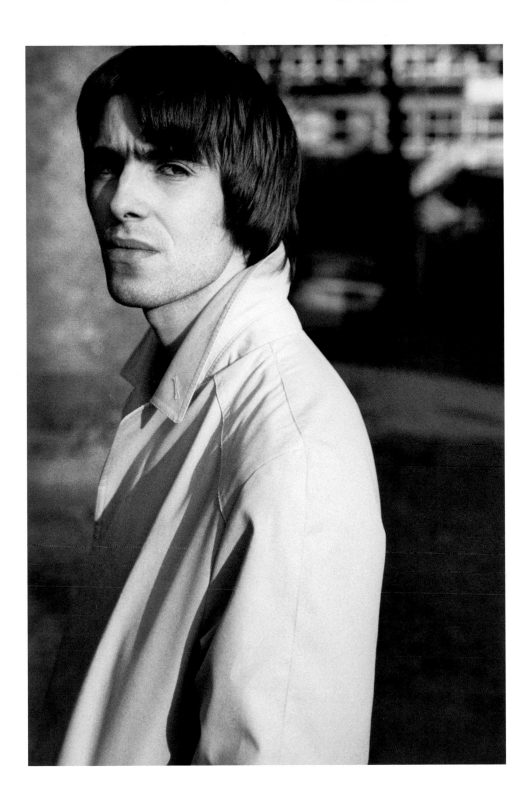

Oasis, London, March

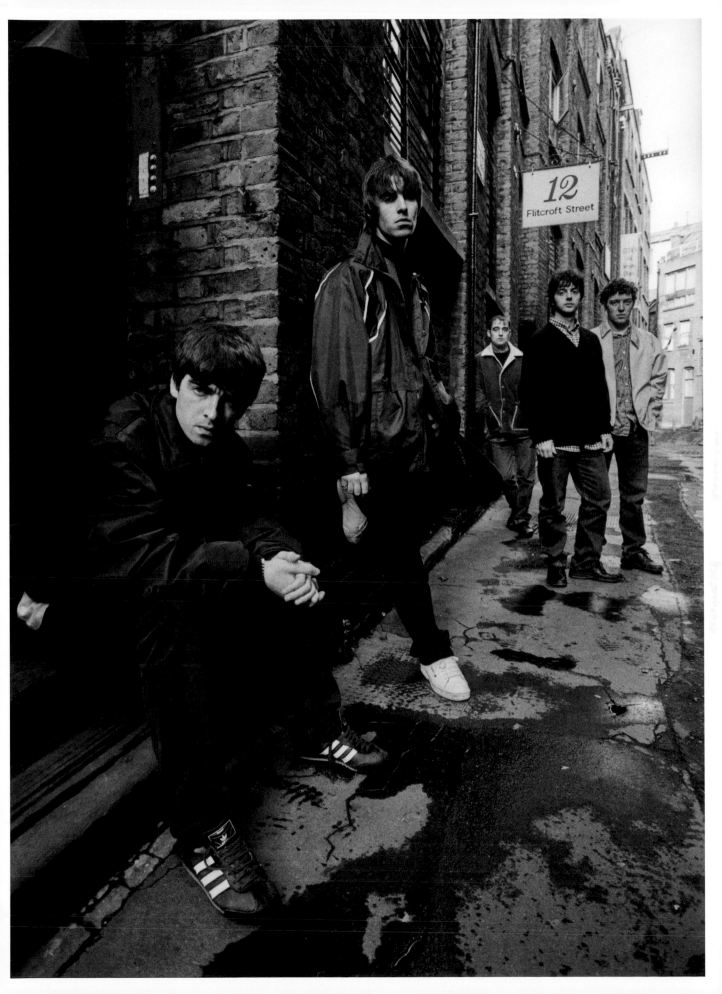

"If you took a kid from the Bronx and a kid from Brixton who probably have absolutely nothing in common, well the one thing they'd have in common is they'd own a copy of *...Morning Glory.*"

Noel Gallagher, Oasis, *NME*, 17 February 1996

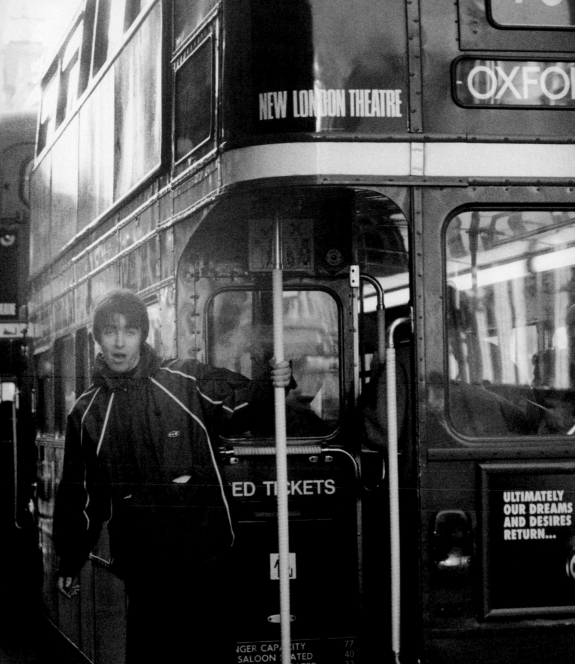

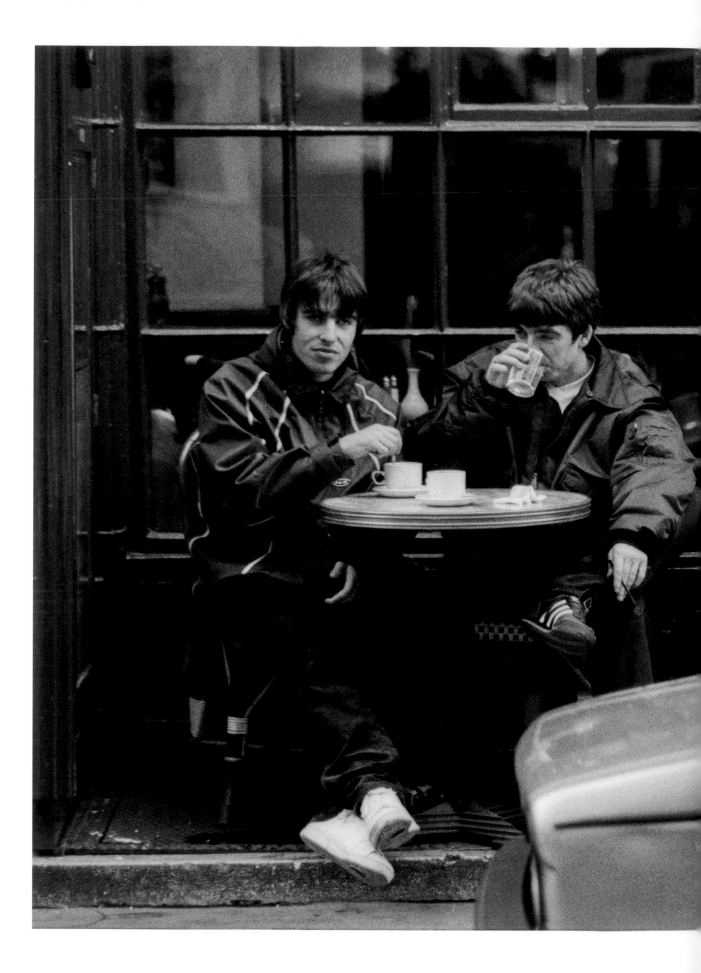

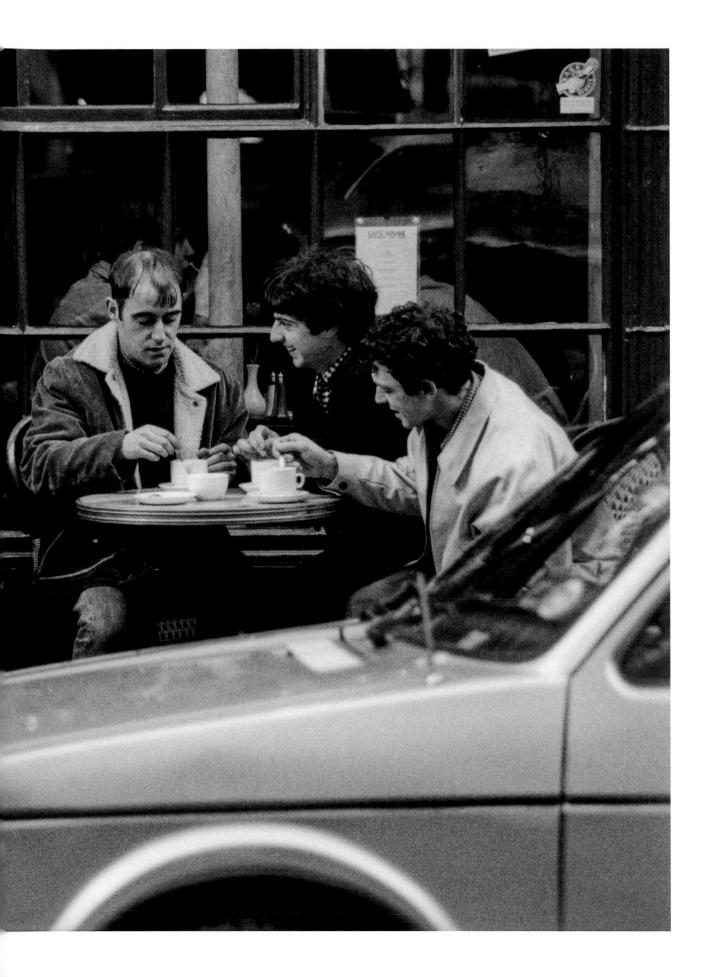

In Conversation
Noel Gallagher, Oasis

It's 25 years since Britpop – how do you look back on that time? Has it aged well?

Looking back on it now, I think Charles Dickens might well have summed it up best in 1859 when he wrote: "It was the best of times, it was the worst of times". Has it aged well? Yes and no. The attitude of the main players was correct and even some of the music still stands up, but sadly the cartoonish element of it has been allowed to survive.

Did it feel like you were all part of a scene?

Oasis wasn't part of any scene, not even in Manchester. The "scene" had already taken root a few years before. Blur and Suede had their foot in the door long before what came to be known as Britpop was even a thing.

Did you feel any kinship with other indie artistes of the time?

Absolutely not. In fact, it wasn't until Pulp entered the room that we found anyone remotely like us.

What did you think was the catalyst for the crossover from indie to mainstream?

Oasis. Pure and simple. Blur and Suede were having hits and were quite successful, but we literally smashed it wide open. The *NME* had to invent a collective so that every other fucker could ride on our coat-tails.

Do you feel that lumping bands together under the Britpop label was enhancing or demeaning for you and for the other bands?

I thought it was a bit demeaning for us but, like I said, the *NME* had to lump everyone together or we would have put everyone out of business. I couldn't give a fuck about the rest of the bands. Well, I certainly didn't then anyway.

The first Oasis *NME* cover featured Liam under "The Oasis Bar" sign rather than the other shots

I'd taken earlier in the week of the two of you together in City shirts. Did that sort of thing cause any tension between you and Liam, or the rest of the band?

I don't recall. Maybe. I most definitely would have been pissed off at having to do the shoot and then it not being used. I had better things to do than spend two fucking hours posing for a magazine. Life is way too short for that shit. Saying that it was the right cover – I'm not very photogenic and the pretty boy still had great hair then, so…

Oasis was the last great rock 'n' roll band of the analogue era. Do you feel that if you got back together, even for one show, that you could ever capture that magic again?

Musically, yes absolutely. The music still stands up so how could we not? The audience though would be vastly different. Camera phones, people filming it, snowflakes, all the woke people at the back tut-tutting, the tourists. It's best left in the past where it belongs.

Did you feel you were flying the flag for Britain and British music?

Erm…no.

Was Oasis just a bunch of lads having a good time?

Four of them were, yeah.

Do you see yourself as a Manchester band, part of the fabric of the city?

Now that is a tricky one. You see the likes of Paul Morley and the old Russell Club arty types would almost certainly say no. People like them are not people like us, but fortunately they don't own that town. The people do, and whether they or you like it or not we *are* a part of its musical furniture. And we sold more records than all of the other "Manchester bands" put together. Still do. Always will. So…fuck 'em all is what I say.

Do you think that being associated with Manchester is restrictive?

Very early on, most likely before anyone had actually heard "Supersonic", when it was asked "Where are they from?" and our people would say Manchester, there would be a rolling of the eyes as Manchester bands at that time tended to have a certain sound. But, on the whole, no, not at all. Why would it?

Did you feel uncomfortable with the way you were portrayed in the media?

I didn't really give a flying fuck about anything until my forties, so no.

Once the tabloids got hold of Britpop, do you think Oasis played up to the cartoon image of working-class lads with wads of disposable cash? If so, do you have any regrets about it?

Not at all – that's who we were! If you're just being yourself, then nothing can touch you, nothing can hurt you. The songs, the gigs, the interviews transcended everything. We were bigger and more important than the media. Like I said, I didn't give a fuck about anything – and I mean anything – until I was in my forties.

Did you feel there was a real rivalry between you and Blur or was it a media invention?

Not initially no, but…you know. Me and Damon were *very* competitive back then and things were said in interviews while we were drunk and high. The press jumped on it and it went from there.

Loaded **magazine's template of birds, booze, drugs, rock 'n' roll and football set the zeitgeist for the mid-1990s. If you didn't fit in, you were ignored. How did you feel about the hijacking of Britpop by tabloids and lads' mags? Did you feel you had to embrace it?**

Is that a serious question? That was our life in the first place! And in any case the lads' mags were all run by divvy cockneys, or even worse divvy wannabe cockneys, or even worse than that student wannabe lads. Some fucking idiot from *Loaded* came to a party at Supernova Heights and was trying way too hard to "have it large" – and left in an ambulance. Bellends, the lot of them. I wasn't arsed about Britpop. It meant nothing to me. My only concern was Oasis, drugs and City, and that's not even a joke.

What do you feel the legacy of that era is, looking back on it today?

I really – and I mean *really* – enjoyed it. As for the legacy? I truly couldn't care less. Let's put it this way, youth was not wasted on us. We fucking smashed it…repeatedly. The legacy of Oasis lives on in the music. As for the rest of it, well, it must have meant something as people are still writing and talking about it.

Do you think the era is forever tainted by the nationalistic use of the terms "Britpop" and "Cool Britannia", or do you think it was able to reclaim the Union Flag and celebrate a great period for British music?

Ask Paul Morley.*

Most eras of music are remembered for songs that live on forever. Do you think Britpop has this too?

Of course. Not as many as the preceding decades but more than the following.

Give me five songs that would always be on your playlist from this era.

"Live Forever", "Don't Look Back in Anger", "Champagne Supernova", "Common People", "Girls and Boys".

What do you think is Britpop's defining image?

There isn't one…is there?

* See page 255.

"I've always thought it was a good cover... I remember buzzing off it and showing it to me mates and that. That's where I'm meant to be – on front covers."

Liam Gallagher on the 4 June 1994 *NME* cover,
NME, 29 September 2012

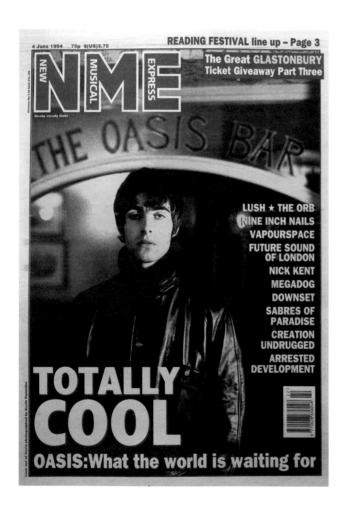

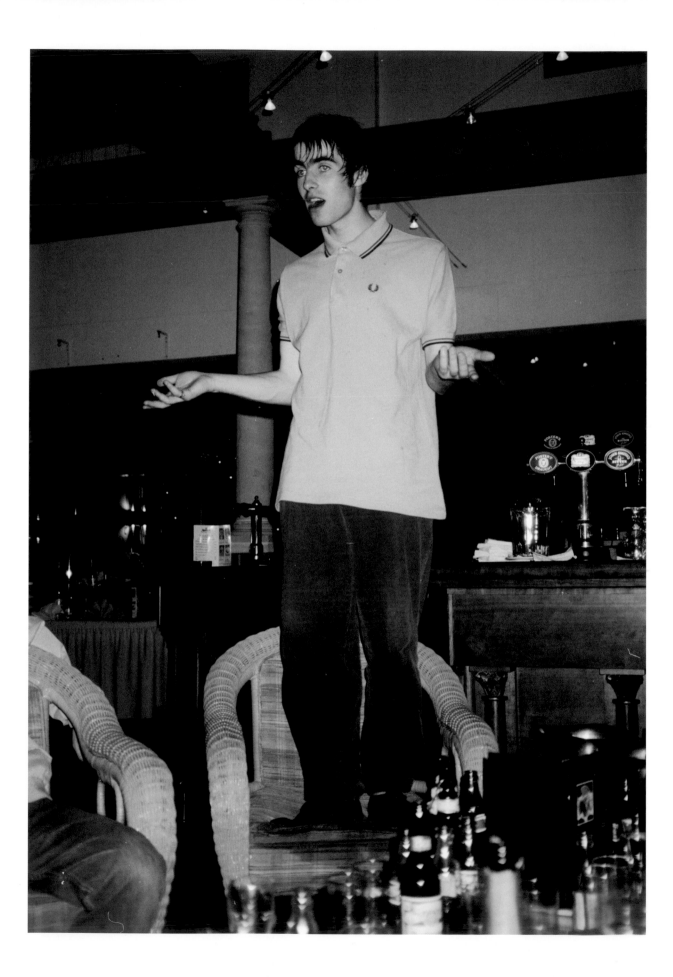

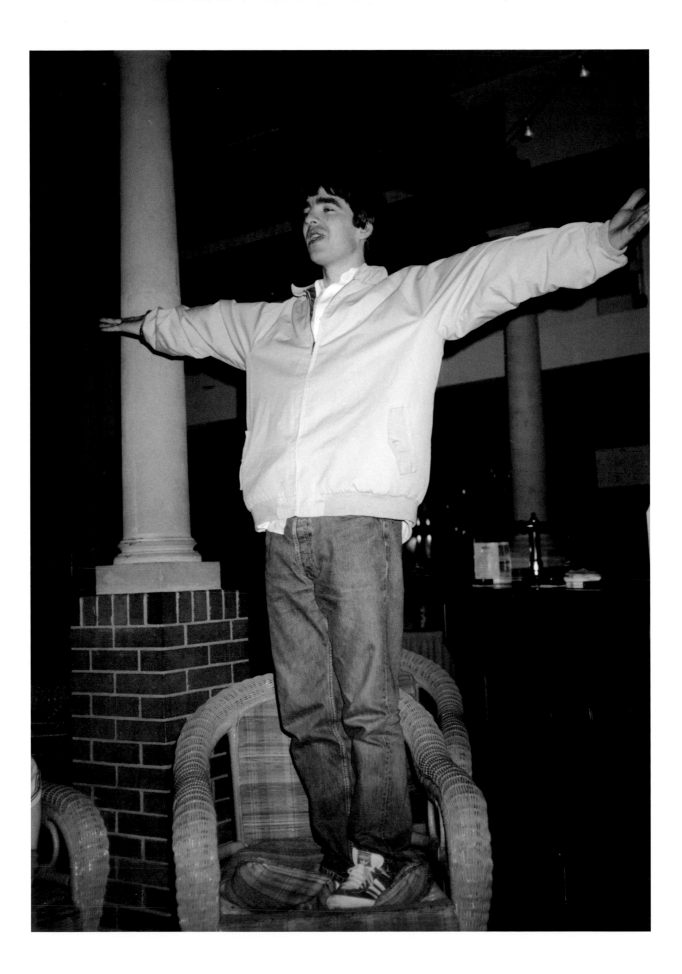

"I worry that someone is gonna throw a bottle at Our Kid [on stage] one night and he's gonna casually move out of the way and let it smack me right in the mouth."

Noel Gallagher, Oasis, *NME*, 4 June 1994

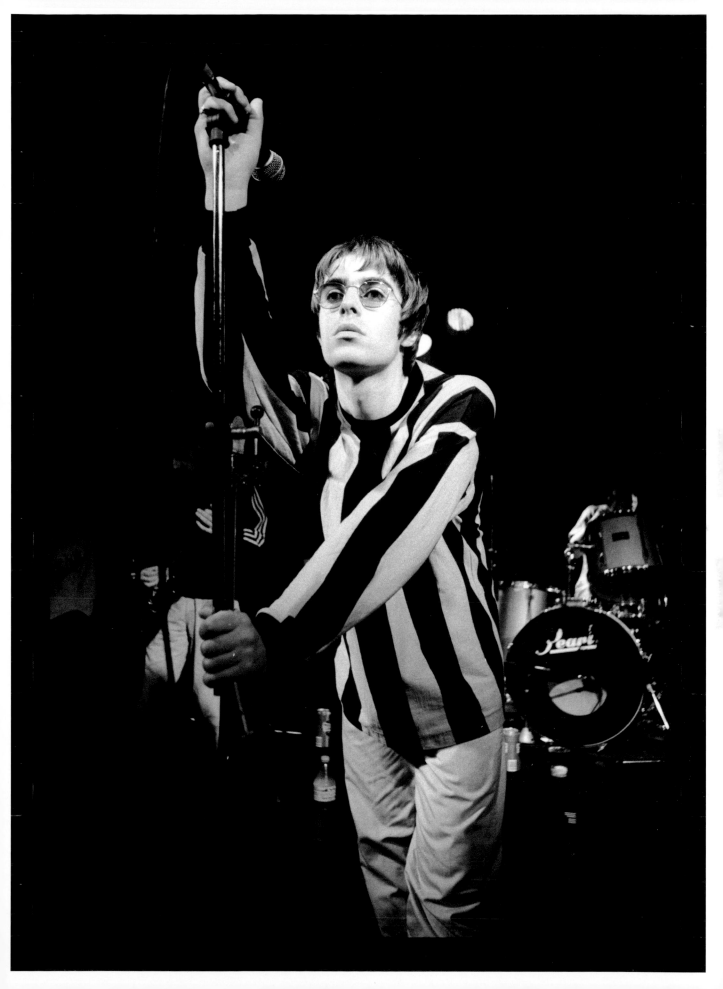

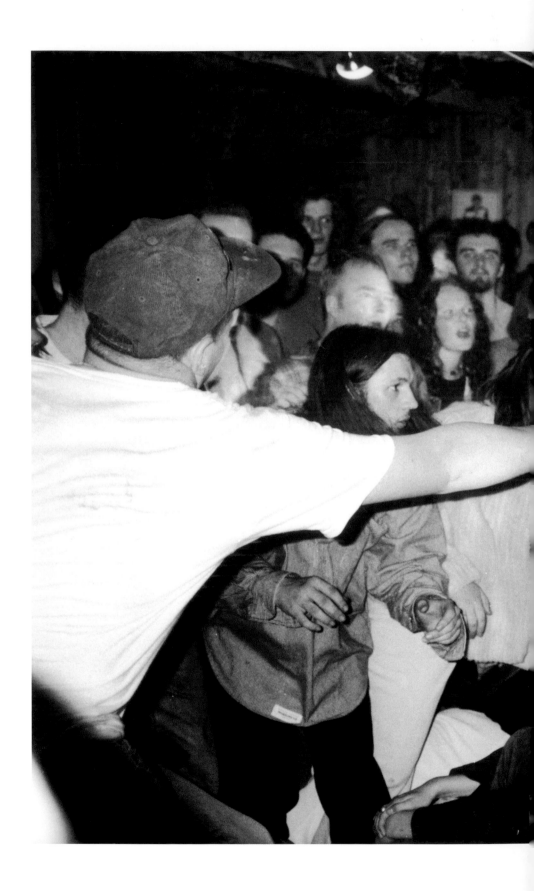

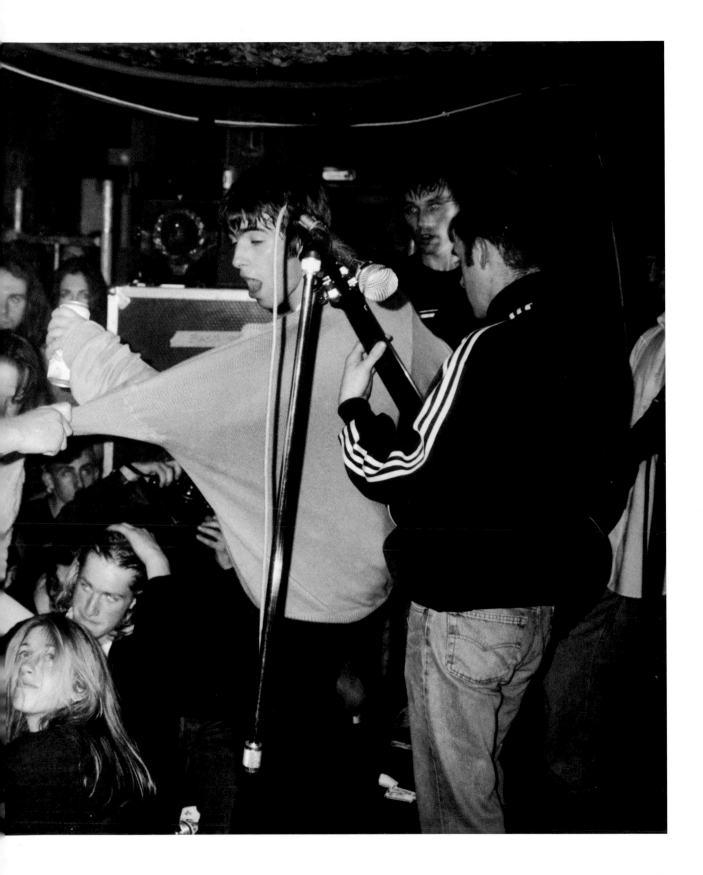

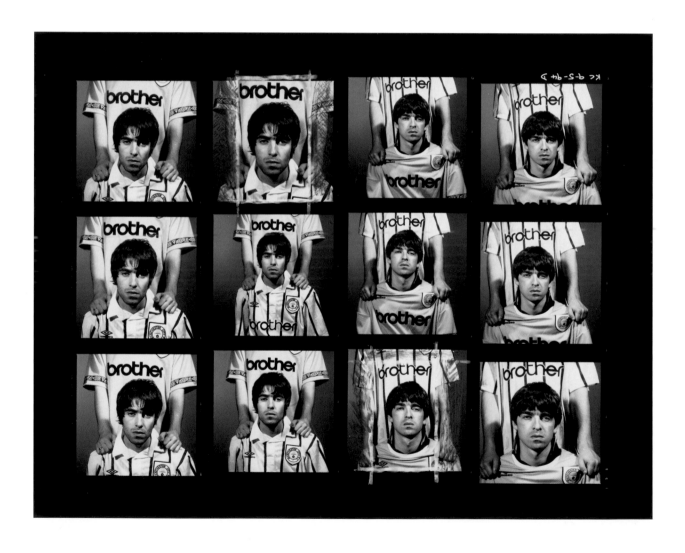

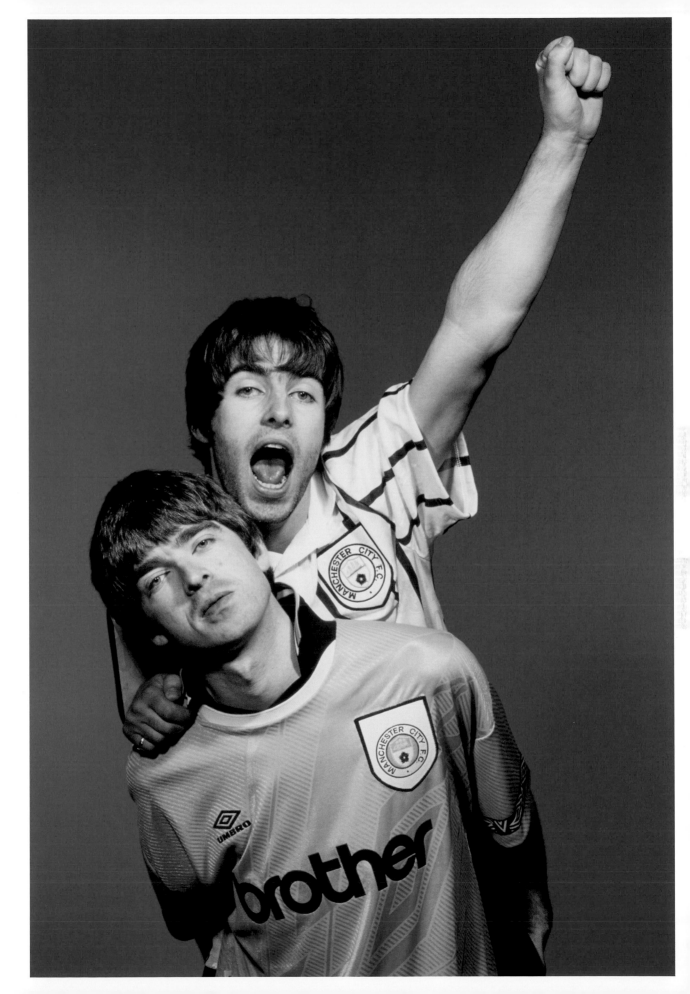

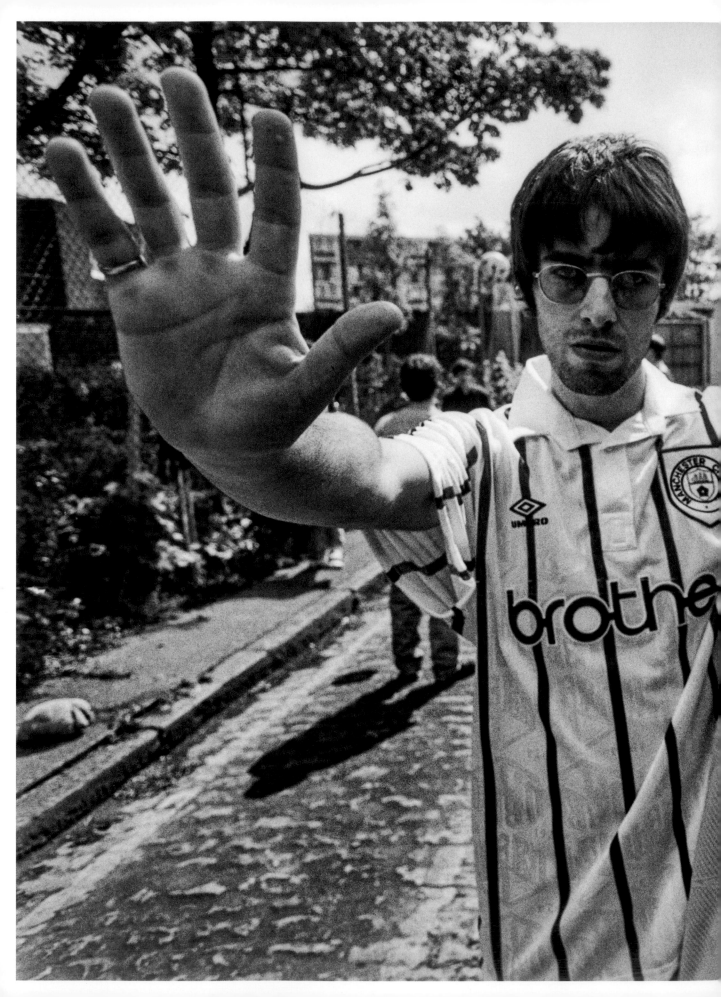

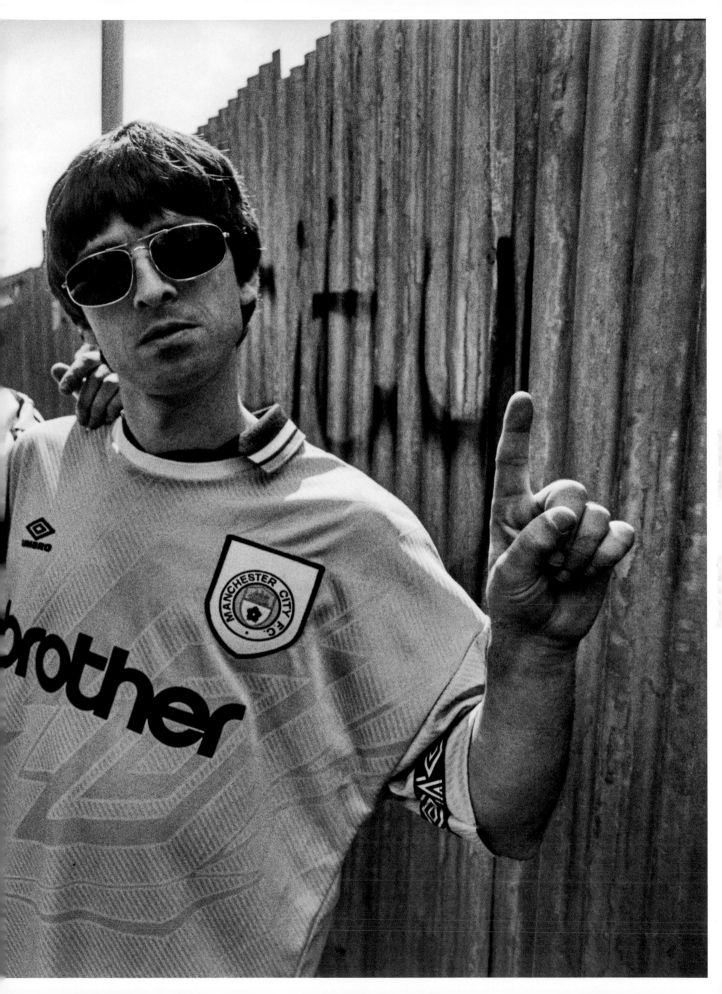

Oasis, Manchester, July

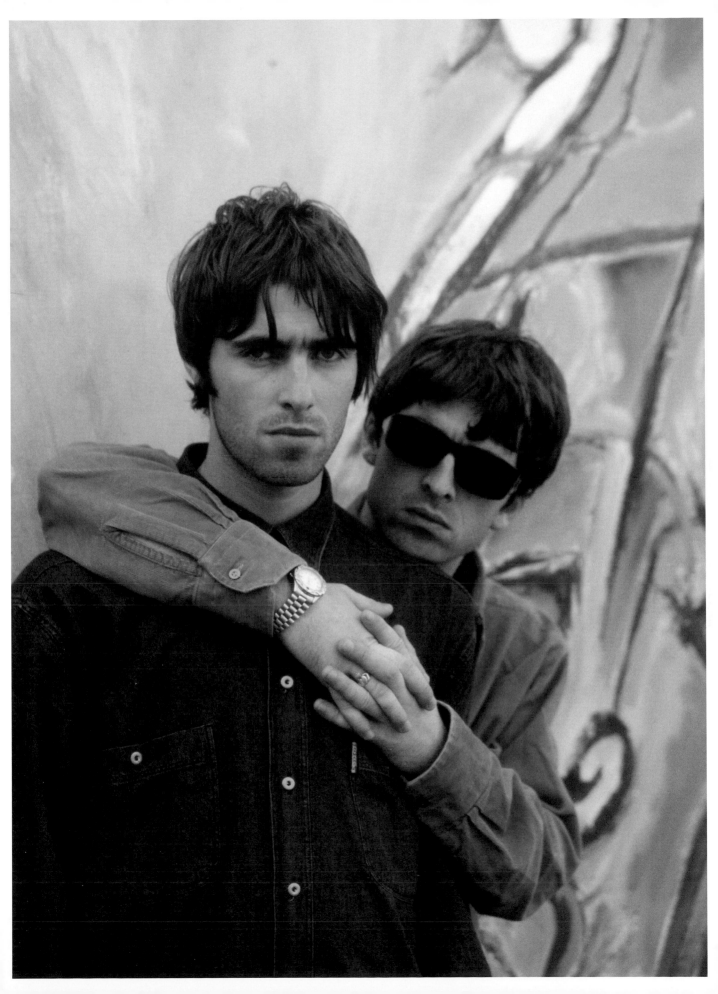

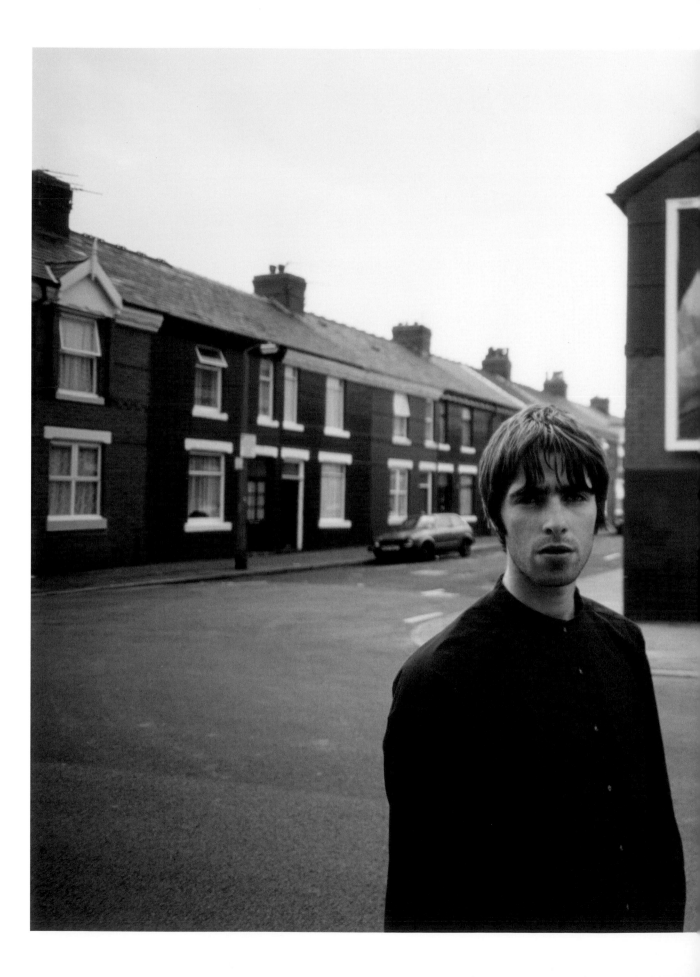

Sonya Aurora Madan/Echobelly, Studio, August

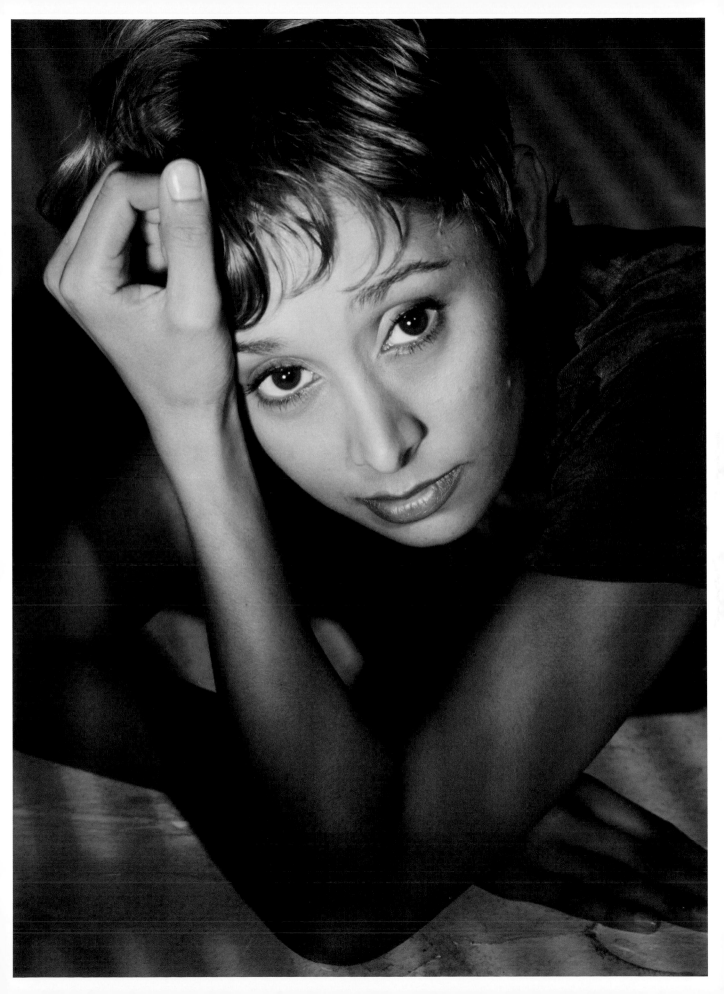

In Conversation
Sonya Aurora Madan, Echobelly

It's 25 years since Britpop – how do you look back on that time?

Sometimes I look back with an air of ambivalence and guarded nostalgia, and then I get asked about it and I return momentarily to the gloriousness of it. I accept that it is an era that I am associated with, although it seems at times to be like a past-life memory.

Has it aged well?

You could argue this point either way. I get the impression that, for some who are trying to make sense of it now, there is a kind of guilty pleasure because the current populist level of political correctness sits uncomfortably with how some view the Britpop era. We're judging it through the perspective of the present.

Did it feel like you were all part of a scene?

Yes, it was a scene and I suppose we were part of it. It had all the classic hallmarks: music, fashion, art, journalism, photography, hedonism, self-identity, smugness. The icons and the iconoclasts. Like being back at school, we were tiered into the most popular and the not so popular.

What did you think was the catalyst for the crossover from indie to mainstream?

The catalyst was the genuine grassroots appreciation for Britpop. It wasn't just media-made. A generation of fans embraced it as part of their identity, a soundtrack to the journey of their youth.

Do you feel that lumping bands together under the Britpop label was enhancing or demeaning for bands?

I think it more pertinent to say that if you were not included, you were excluded. It was a case of, if you wanted attention for your music, you had to be lumped in. The music press at the time was very powerful and had a self-perpetuating agenda of its own. Echobelly sat a little more awkwardly with the official tenets of Britpop.

How did it feel to be female at the heart of Britpop – a very male-dominated scene?

Britpop is always described as a male-dominated scene, but there were strong female characters there. I came into my own through the liberating experience of fronting Echobelly, being able to explore lyrics freely and the connection with our fans. I was quite shy and the experience empowered me. It is interesting to look back and see how we subverted traditional gender roles, exploring androgyny and the accepted image of a rock star. That said, It did become a little tedious to be lumped in with acts I felt we had little in common with, other than having female singers fronting them.

Britpop was very white. How did the prevalence of the Union Flag make you feel as a woman of colour?

As my mother once said, "white is a colour too." There isn't time here to explore the deep profoundness of that statement. I think the Union Flag is a thing of iconic beauty, powerful and full of fascinating history. It is the hijacking and underpinning of negative meaning behind an image that can bring it into question. I don't align with the one-dimensional fear-based belief that automatically views it as racist. Guitar-led music has been more popular with white audiences for a good few decades, and so it would be natural to see a predominately white audience. Music has always been a uniting force and is available for all people to appreciate. Ultimately, by concentrating on the ethnicity of a scene you do it a disservice.

Did you feel you were flying the flag for Britain and British music?

I'm not sure. Echobelly was a little too maverick and under the radar. We weren't handed that role by the press or the industry. Britpop made an impression in certain countries more than others. It was viewed as quintessentially British in the way that British culture was appreciated in the 1960s: charming, witty and a little twee. In reality, it didn't

make much sense in the States and was a drop in the ocean compared with British rock bands from the past.

How comfortable were you with the misogyny of *Loaded* and ladette culture? Was it something you felt you had to embrace in order to grow as a band?

Not very comfortable. The only time I remember *Loaded* asking me to be in the magazine was if I wore a bikini. It was a very successful magazine for a while, the bachelor's coffee-table staple of the time. The truth is that art and commerce will always have a complicated relationship. Artists seek recognition and fame, and the media knows what gets the public's attention. I think there is a song somewhere about selling your soul to the devil…

Echobelly was perceived as you and a male backing band. I realize I was guilty of perpetuating this by photographing you for the bulk of the session and then taking a few band shots to keep everyone happy. Did this cause problems or internal rivalry at the time?

There must have been envy. Echobelly's original line-up was a magical force. Everyone brought something unique to the table, and together we felt we were doing something special. Early on, touring in the States, I was kept in New York for a day of interviews while the band was driven out to rehearsal, and when I joined them, exhausted from the interviews, there was a real coldness from one particular band member. I think I was pretty hurt by it, but from his point of view he was feeling less relevant and jealous of the attention I was getting. Later on we had some problems again from another band member who seemed to always need to suck the attention out of the room. You could write a whole book on the dynamics of being in a band!

How did you feel about the hijacking of Britpop by tabloids and lads' mags?

I don't presume that they hijacked it, only because they were an integral part of it. The media made you or ignored you. The only frustrating thing is that it was never really about the depth of a song's content. On the contrary, the sensationalist element prevailed. Tabloids encouraged rivalry, narcissism and a shallowness to the exclusion of a deeper appreciation of the artistic merit of its exponents. Cocaine culture, the right press agent and who you were sleeping with were of paramount interest. Interviews were edited to propagate their own agenda.

Loaded magazine's template of birds, booze, drugs, rock 'n' roll and football set the zeitgeist for the mid-

1990s. If you didn't fit in, you were ignored. Did you feel you had to embrace it?

Luckily, I think Echobelly managed to carve out its own niche and loyal fans. Drugs and alcohol were absolutely everywhere and made for some interesting times. There were always enablers hovering around. I remember one dealer saying she was off to the BBC to supply her clients there. I also remember some of the bands from the pre-1993 scene complaining that they couldn't get any press attention anymore. They were considered to be from the previous scene and therefore irrelevant.

What do you feel the legacy of that era is, looking back on it today?

Out of all the bands, one thing I consciously acknowledged in its legacy was the genuine connection between mainly working-class boys identifying with Oasis. It was like they had been ostracized and here was a bunch of "rockstars" they could relate to their own sense of self.

Do you think the era is tainted by the nationalistic use of the terms "Britpop" and "Cool Britannia", or do you think it was able to reclaim the Union Flag and celebrate a great period for British music?

Perhaps over-intellectualizing it will miss the point and veer the scene's legacy into the realms of a post-graduate thesis. The seeping-in of shame when it comes to nationalist pride is a modern day obsession. If it's done with positive appreciation for one's culture, why shouldn't it be exuberant? The idea of Britishness is sold via film, TV and music to the rest of the world because our supposed identity is of interest to others, as theirs is to us.

Was Britpop the epitome of white male privilege?

This is a loaded question, if you excuse the pun. To feel obliged to denigrate a musical scene because of the politics of the current climate means you limit your appreciation of all the good things it had to offer. There was an exuberance and joy that Britpop championed. None of the male artists I knew set out to champion white male privilege. You only had to read the lyrics of the Britpop classics to appreciate that many artists were questioning privilege, class and British identity.

Did you ever consider Britpop as a backlash against all the great social advancements up to that point?

Not from the bands of that era. On the contrary, if there was one phrase I'd use to describe Britpop's over-riding message, it would be the exploration of identity.

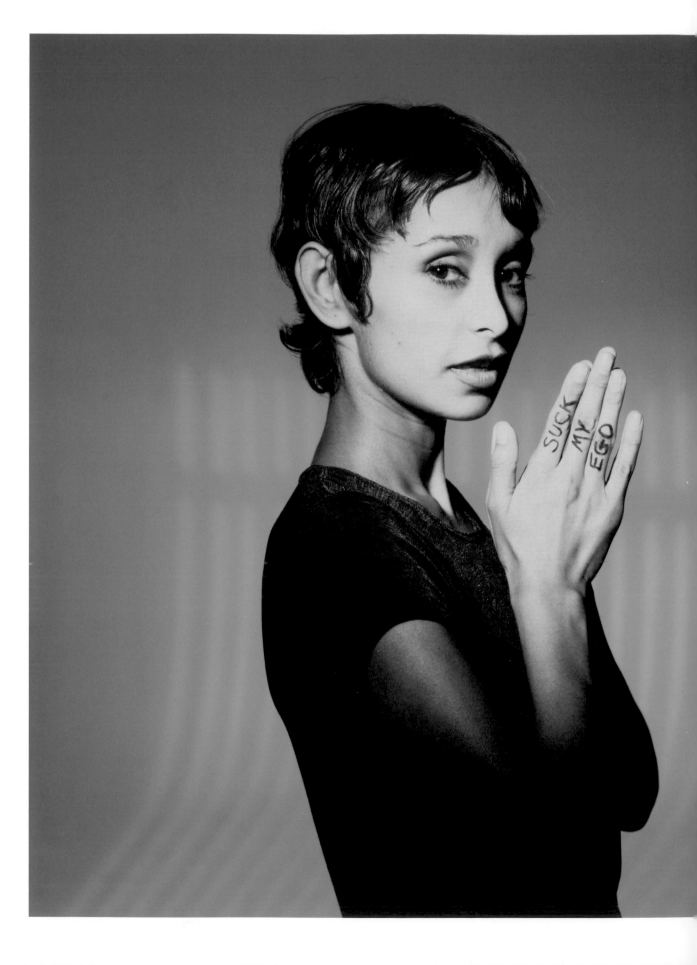

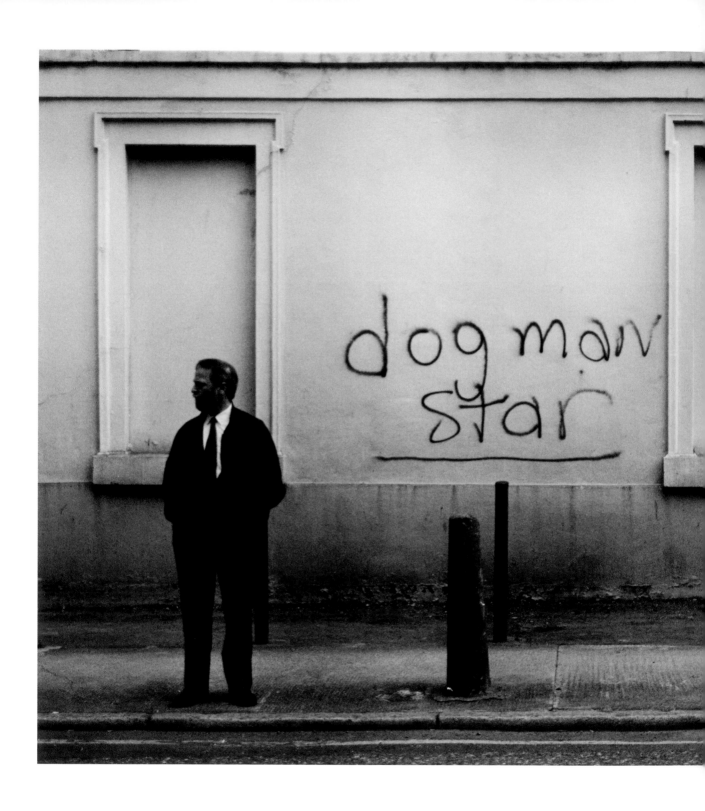

Stamford Street, London, August

Radiohead, Gloucester, August

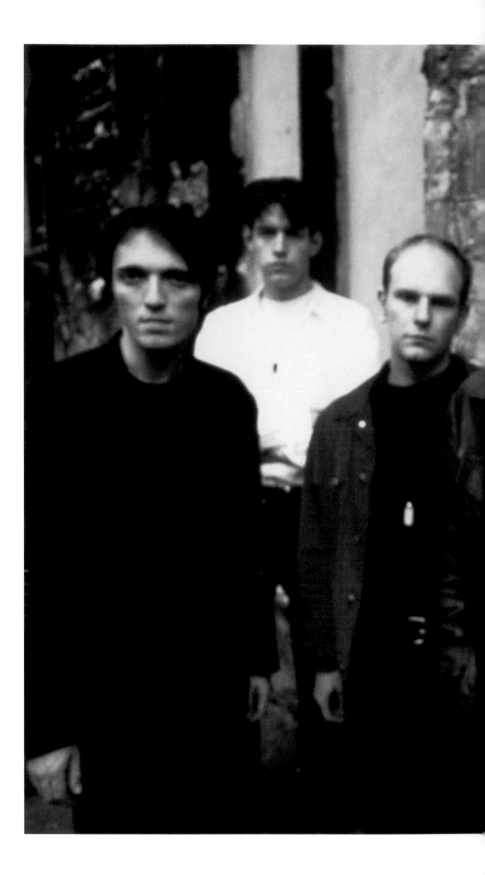

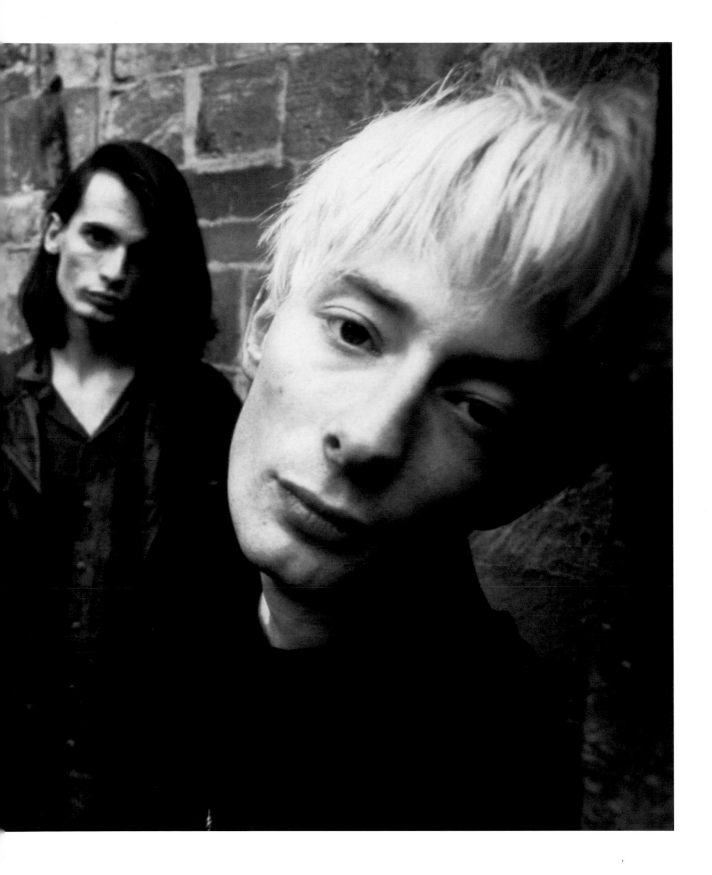

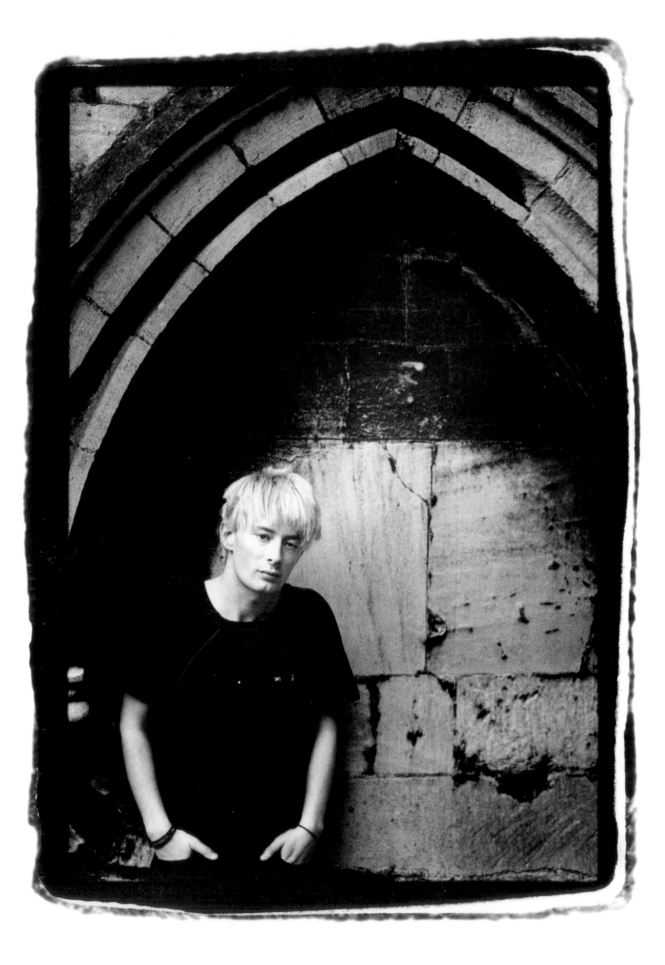

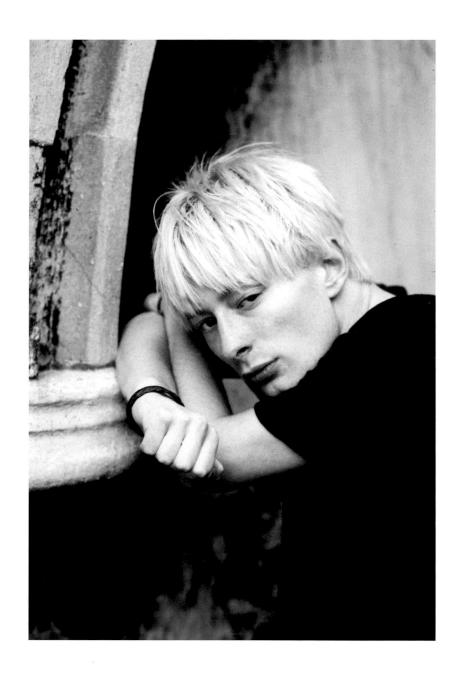

Oasis and Evan Dando, Virgin Megastore,
London, August

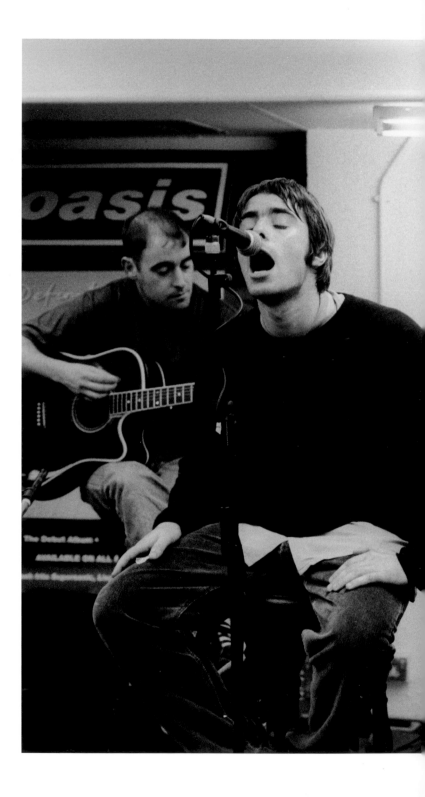

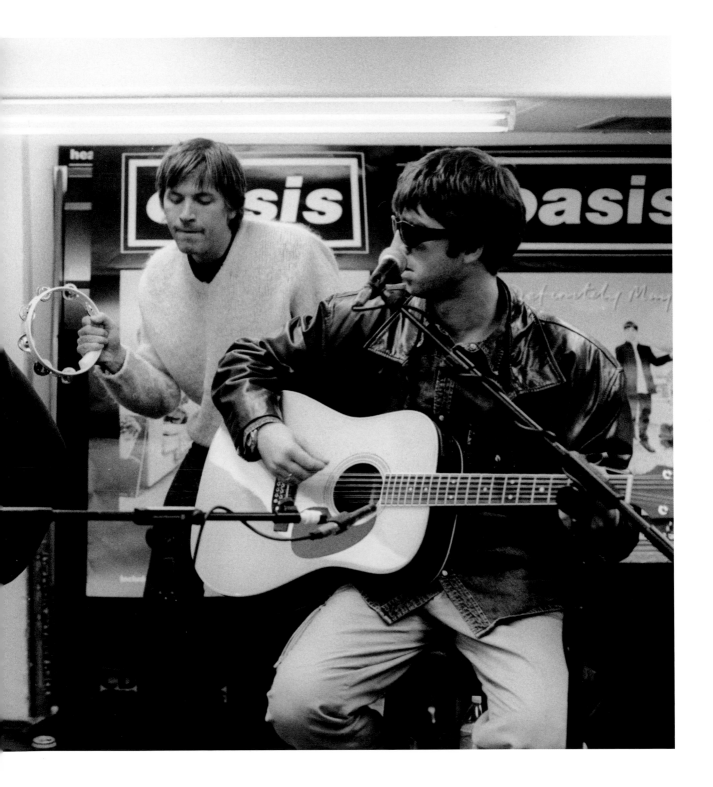

"I think a lot of kids find Suede too intellectual, while with Blur they don't understand that stuff about sugary tea."

Noel Gallagher, Oasis, *NME*, 4 June 1994

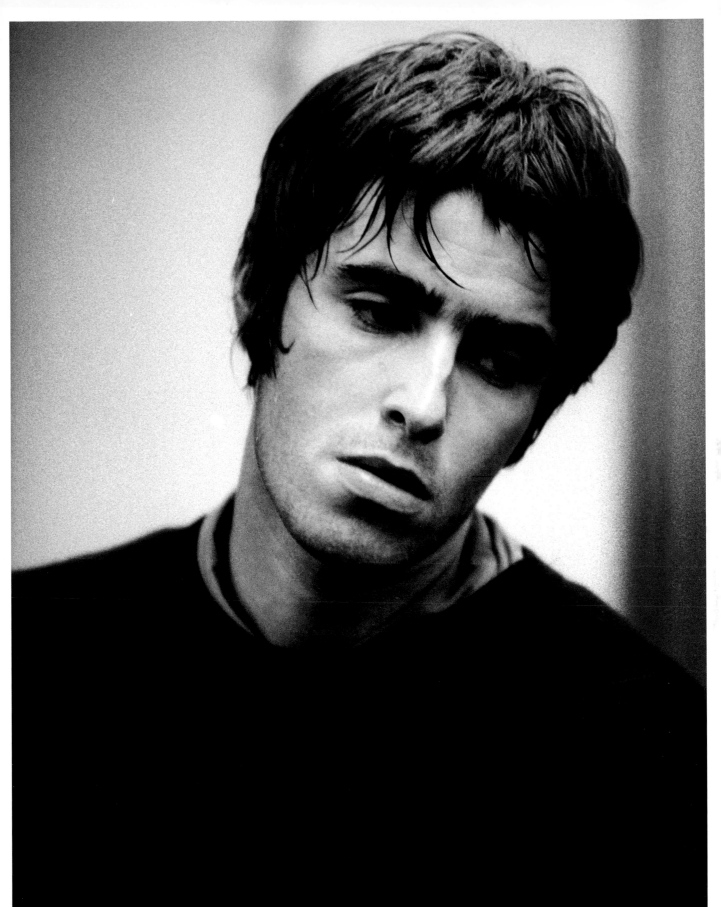

Damon Albarn/Blur, Los Angeles, September

"I didn't feel the need to be a caricature of Britishness."

Damon Albarn, Blur, *NME*, 16 September 1995

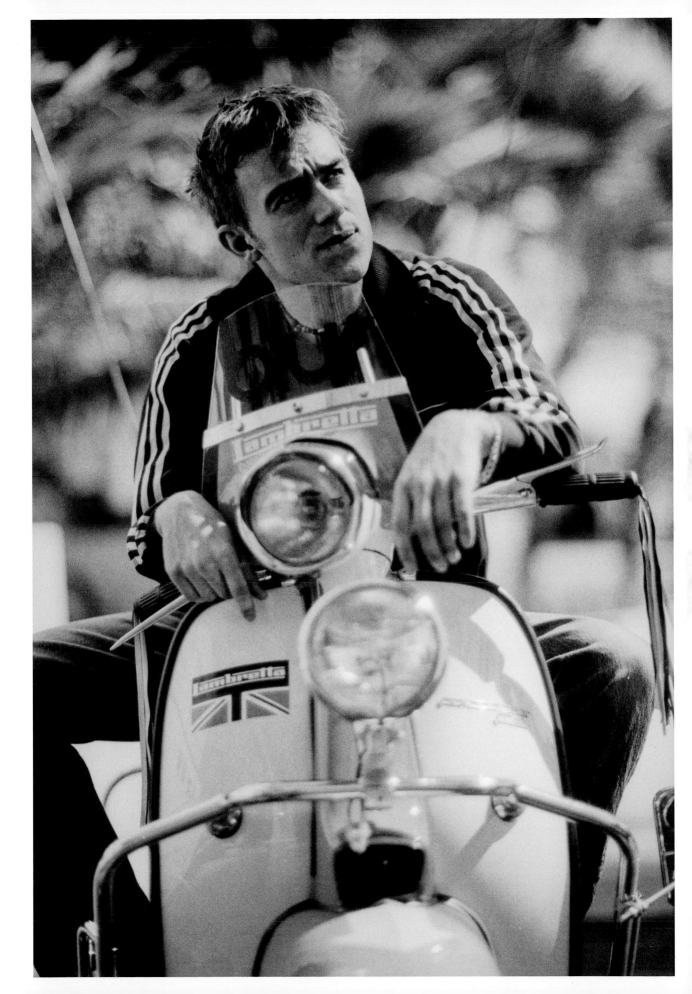

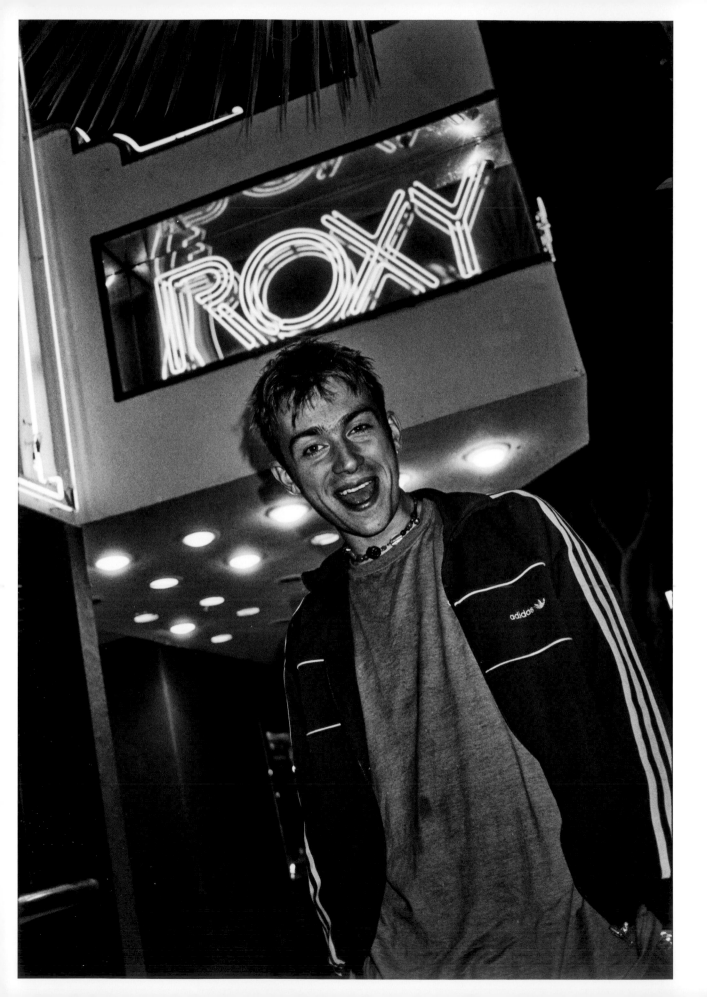

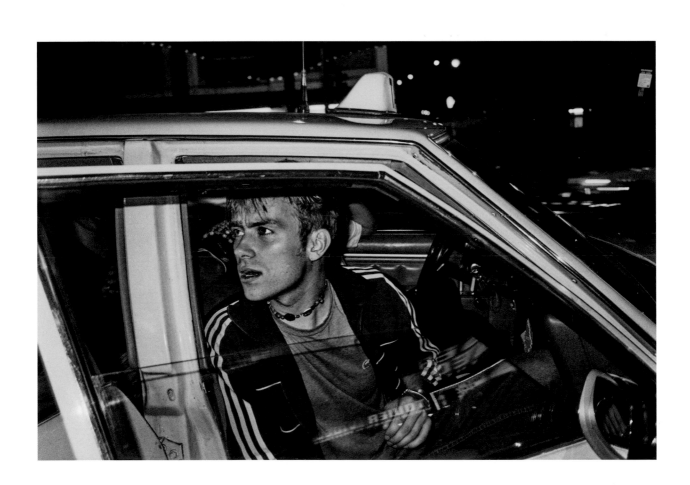

Gene, London, October

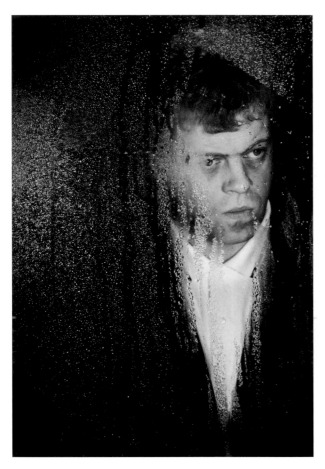 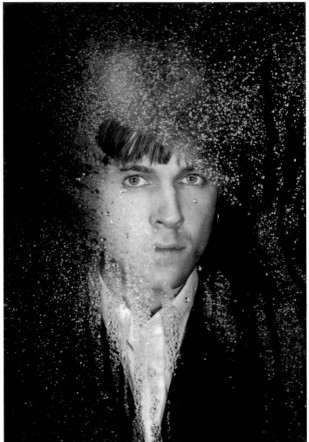

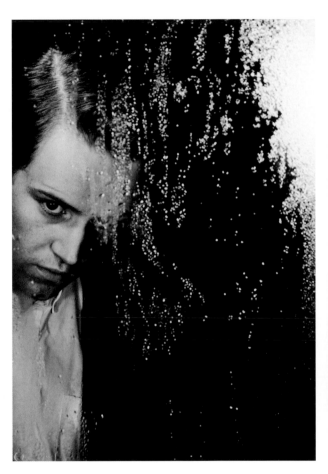
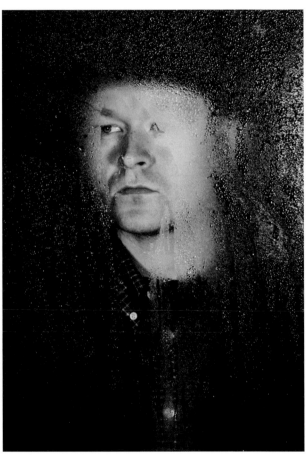

Suede, YMCA Tottenham Court Road, London, October

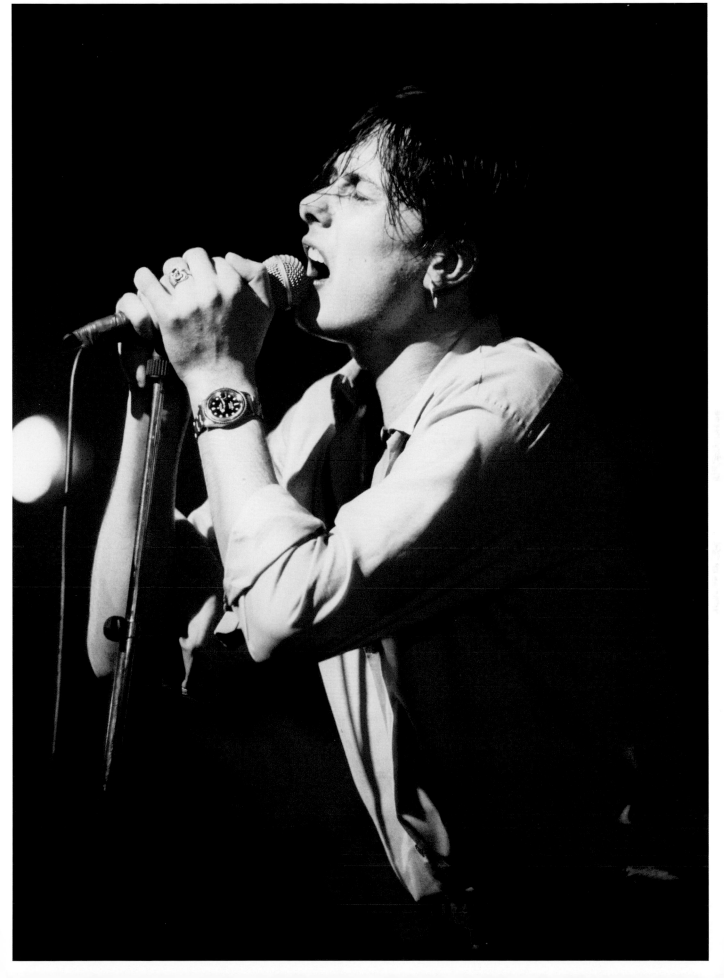

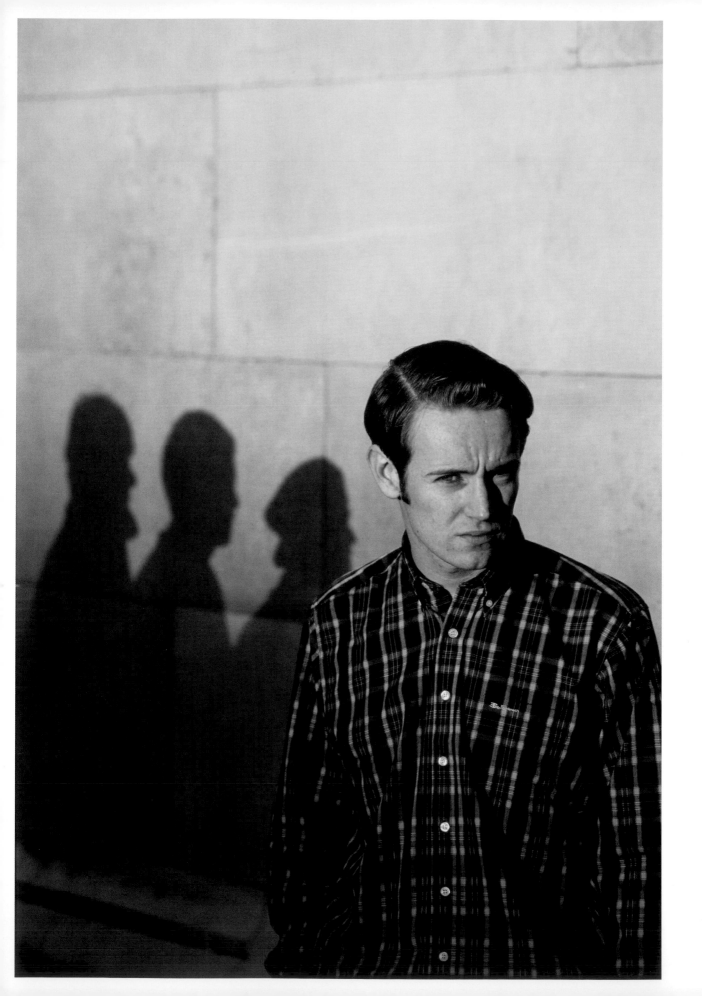

"I think people expect me to stop our show halfway through and read Byron or something of that ilk. I think people are surprised about how rock we are, expecting me to be some sort of fey, winsome, slip-on shoe-wearing fop."

Martin Rossiter, Gene, *NME*, 7 January 1995

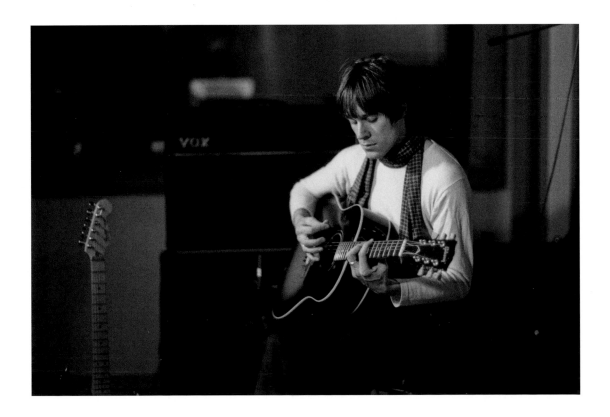

Brett Anderson/Suede, London, December

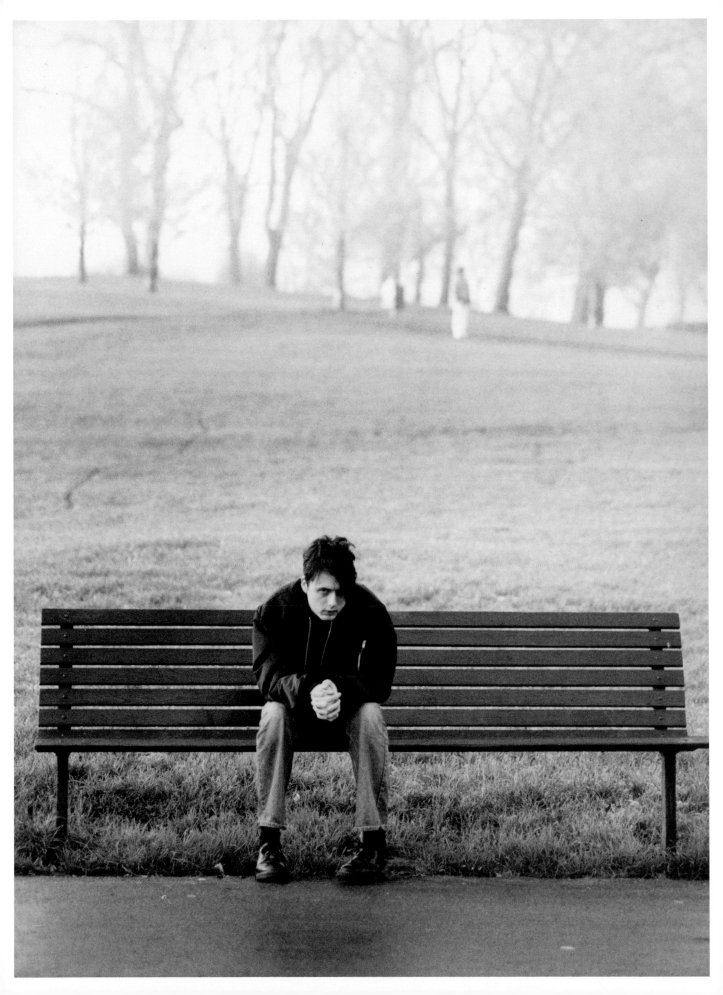

1995

Menswear, London, January

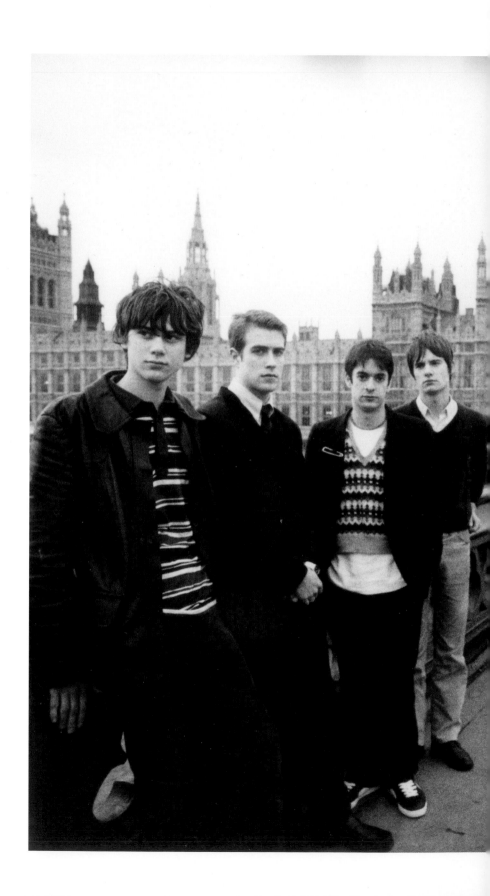

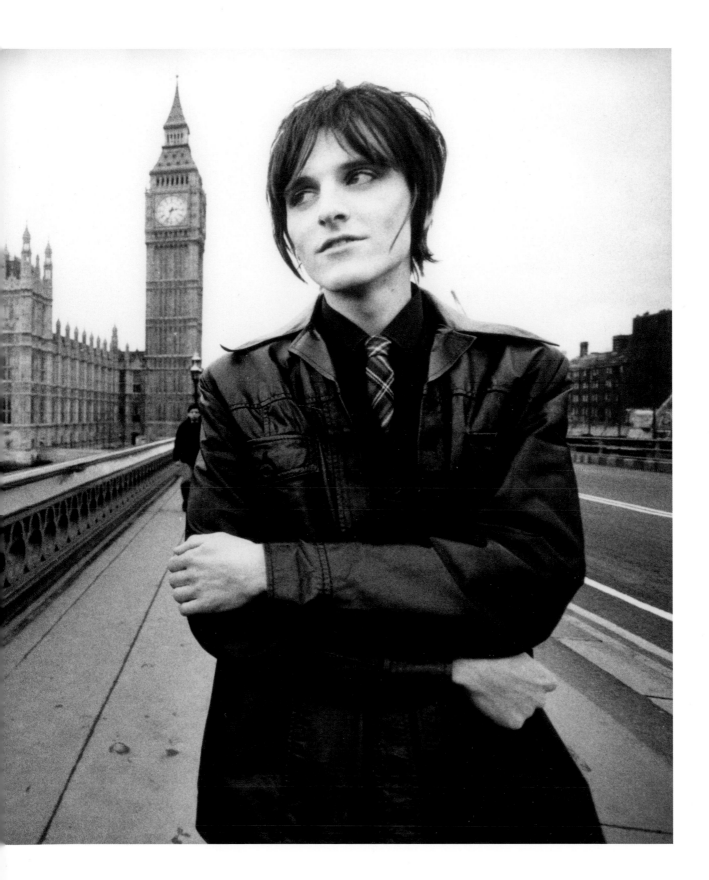

"I think Liam's an absolutely brilliant front man. If I was a 15 year old, I'd wanna be like Liam."

Damon Albarn, Blur, *NME*, 16 September 1995

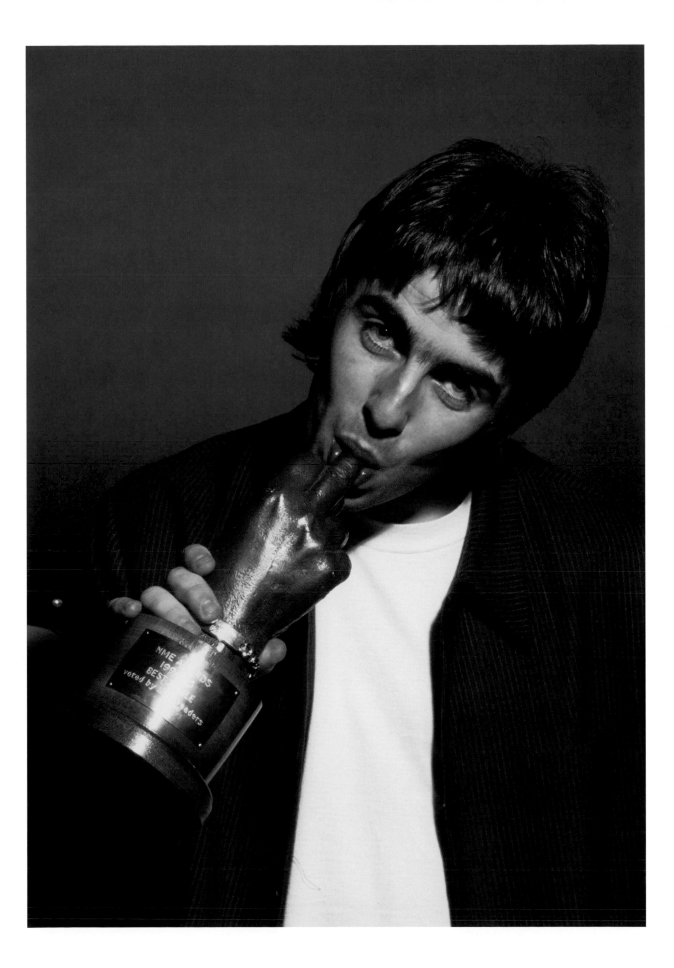

Jaime Harding/Marion, Manchester, January

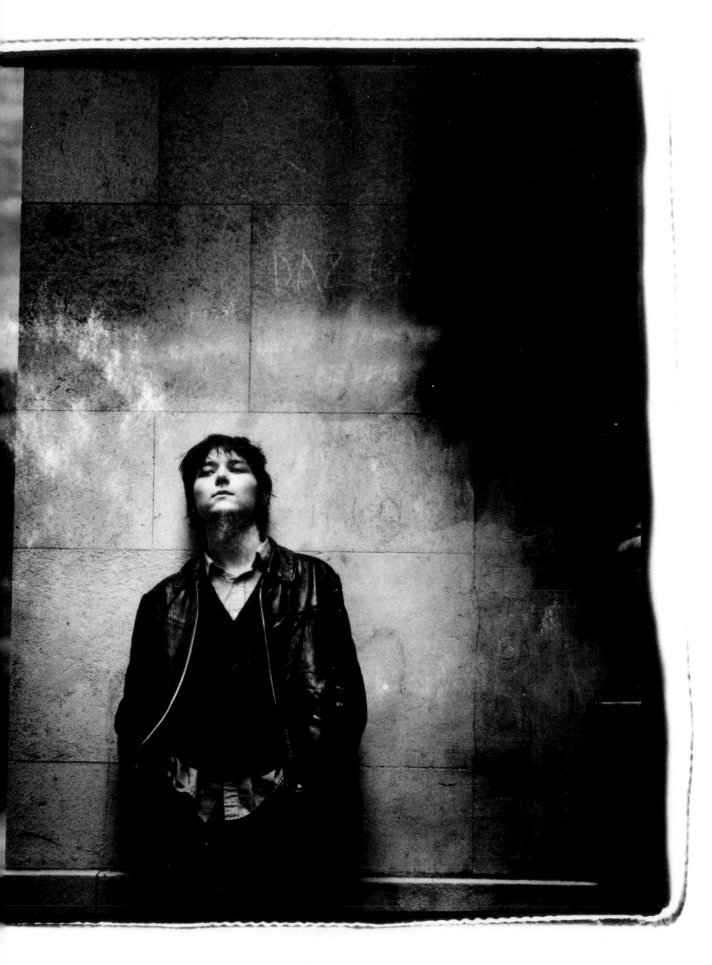

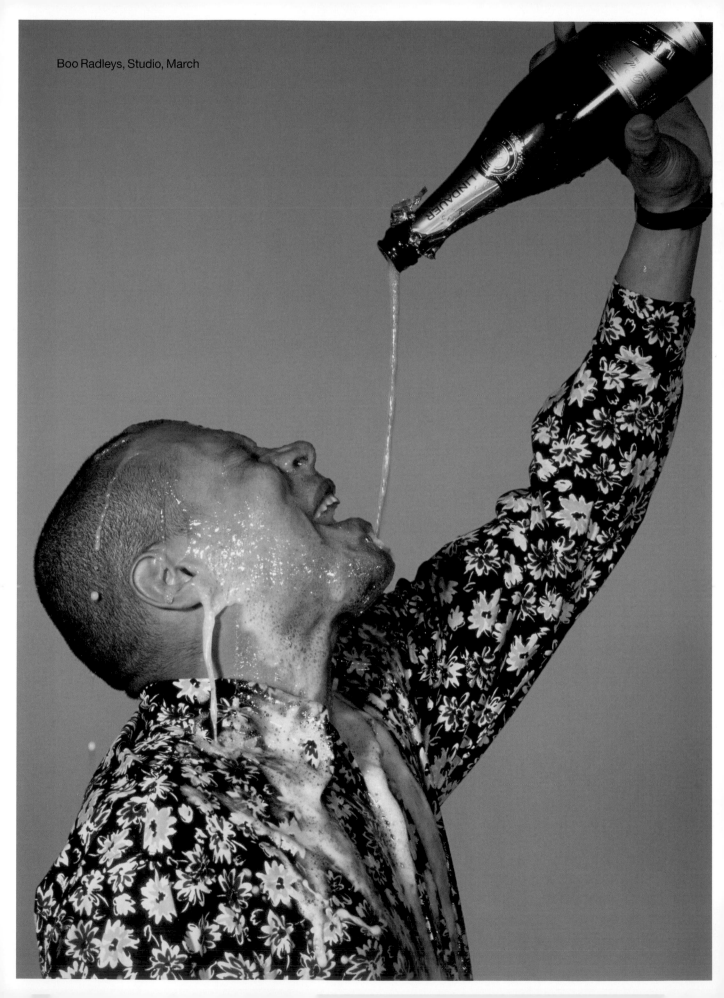

Boo Radleys, Studio, March

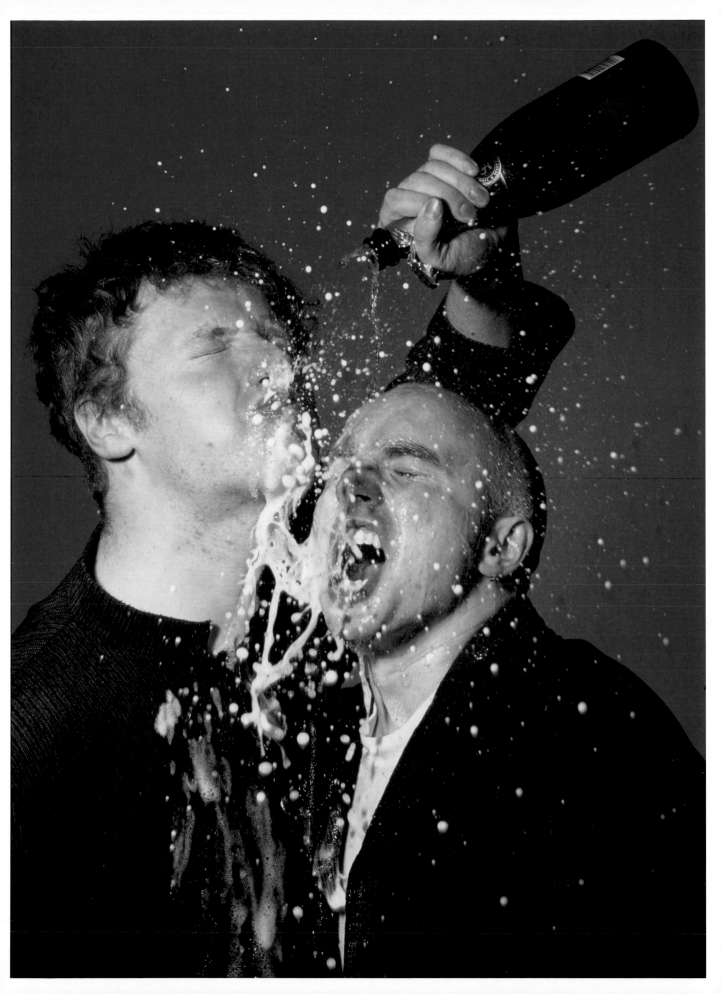

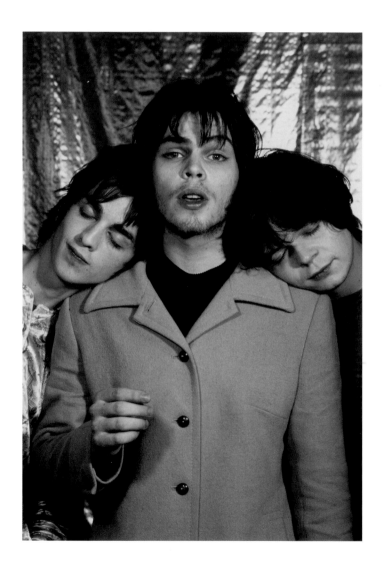

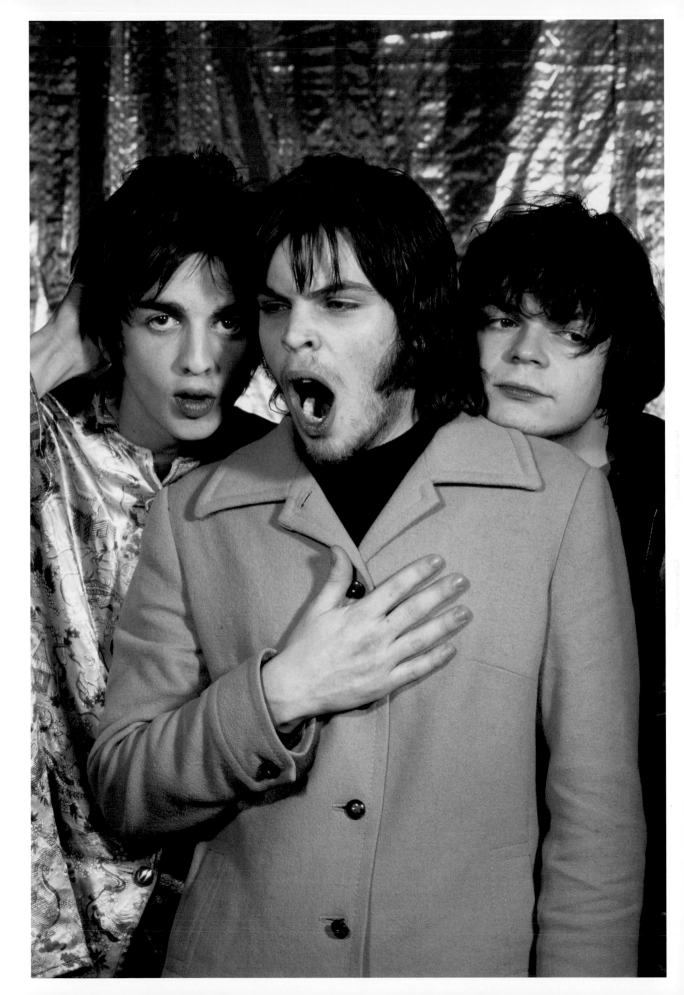

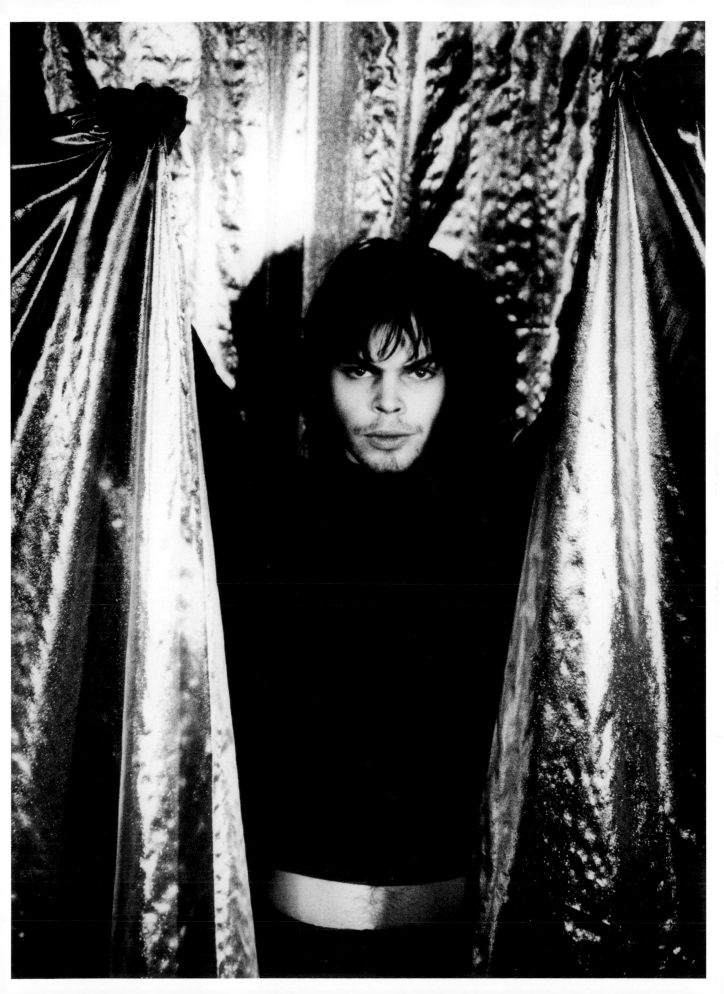

Shampoo, Tokyo, March

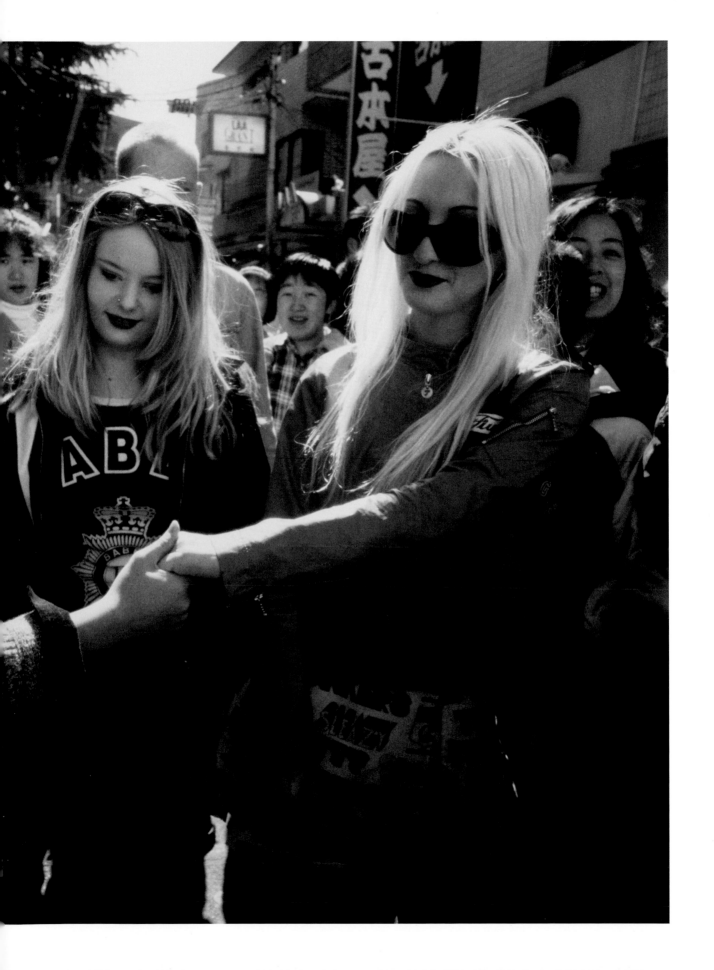

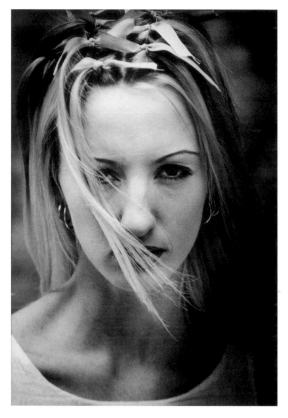
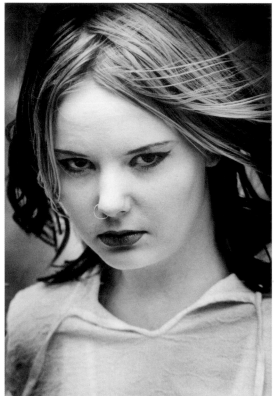

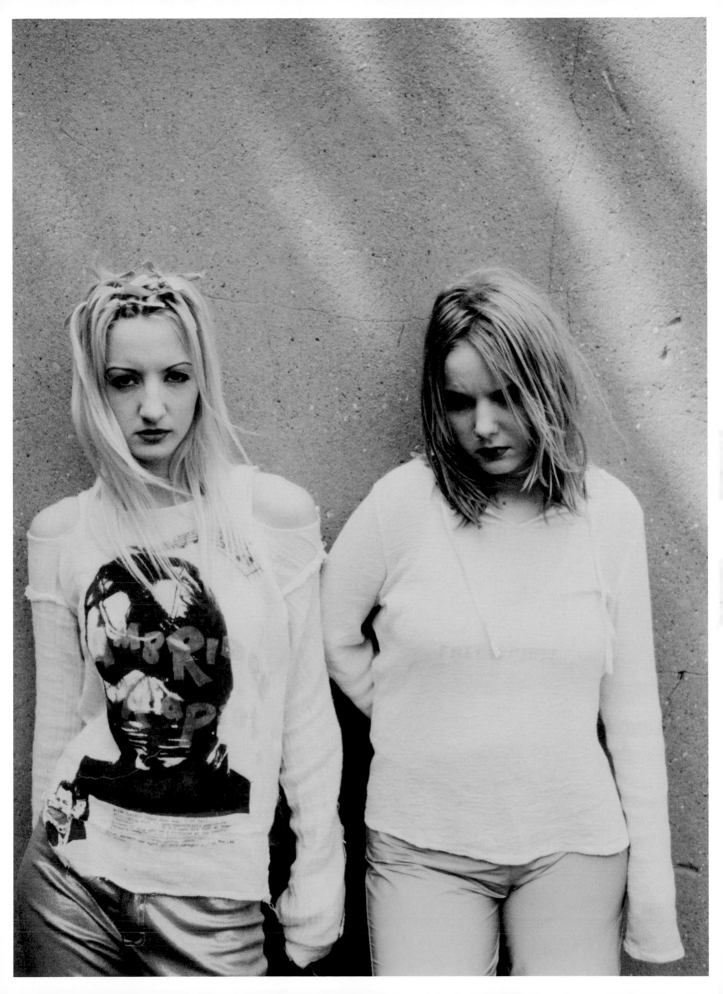

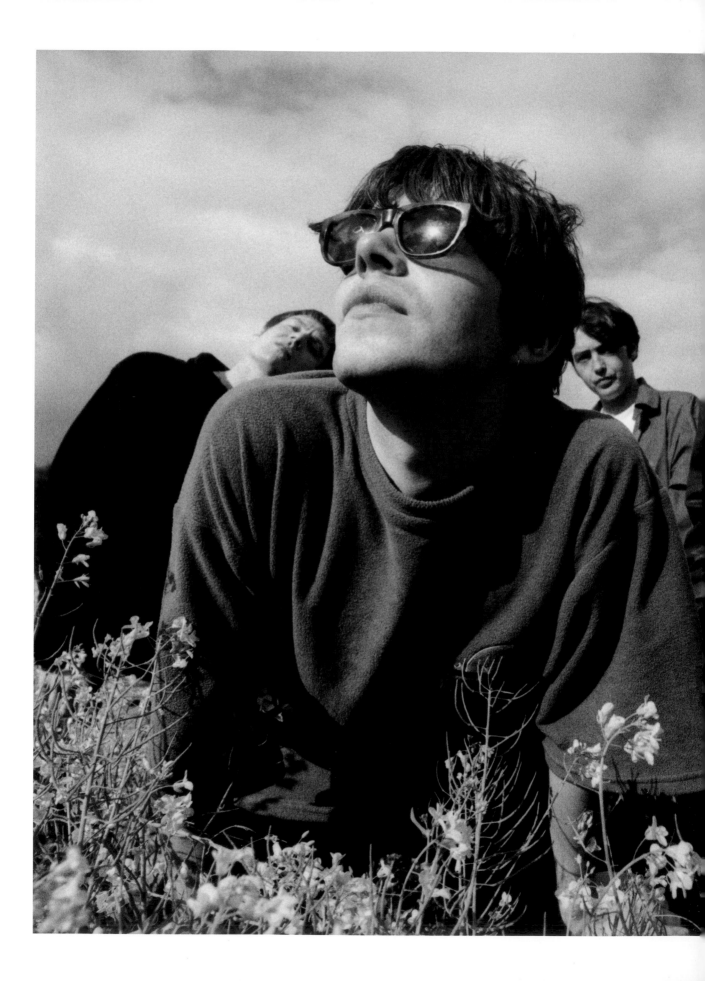

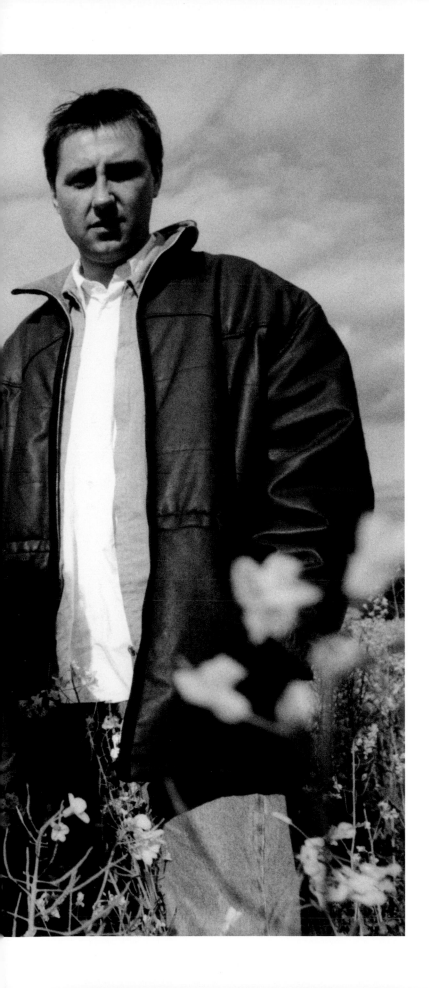

The Charlatans, Nottingham, May

Elastica, New York, May

"I think we're representative of 20-something women in Britain…I can imagine women in bands in America have to put up with seriously ignorant, sexist people."

Justine Frischmann, Elastica, *NME*, 10 June 1995

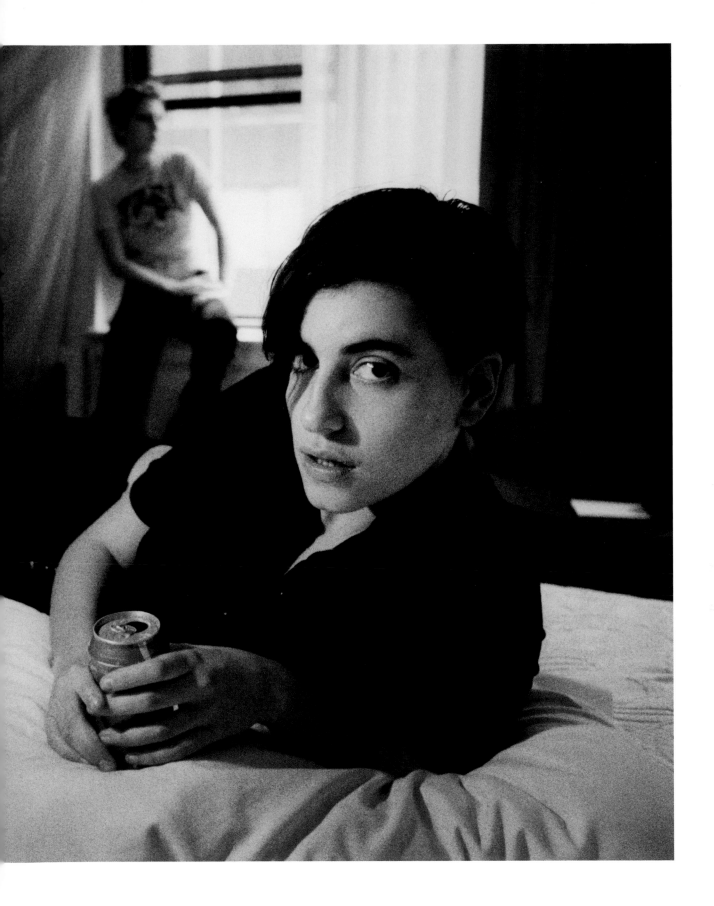

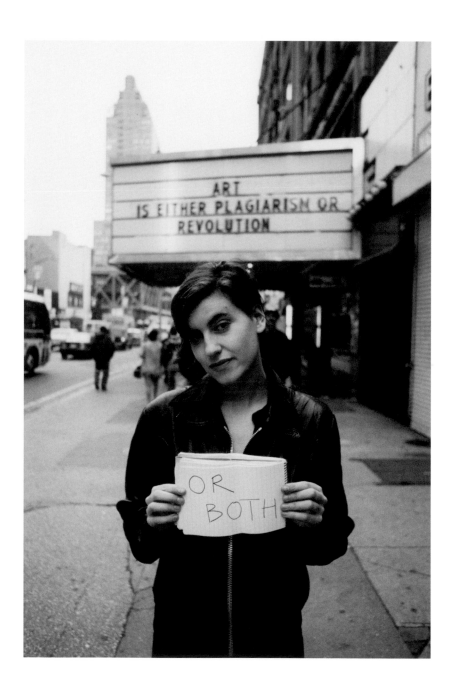

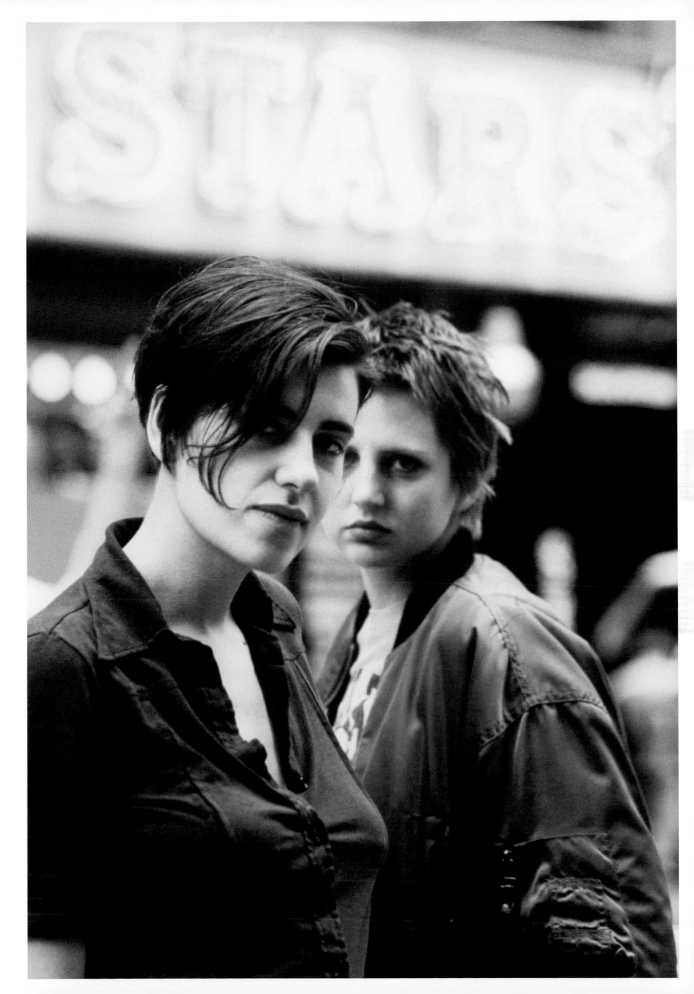

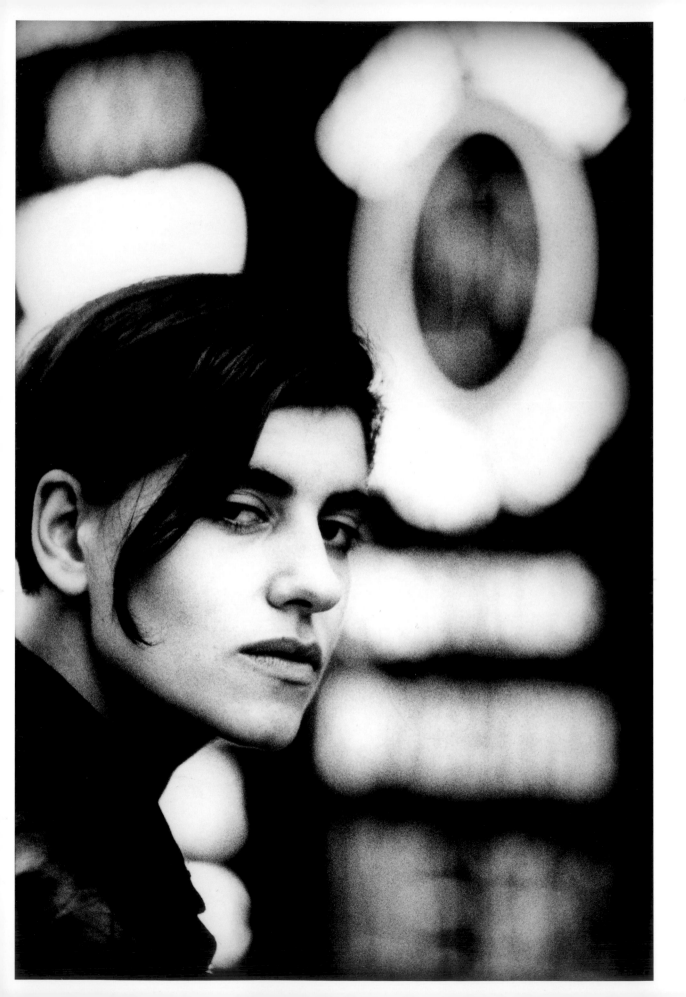

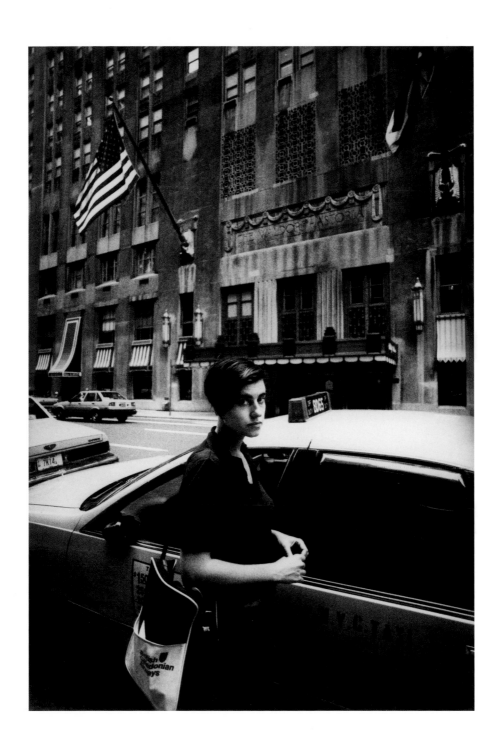

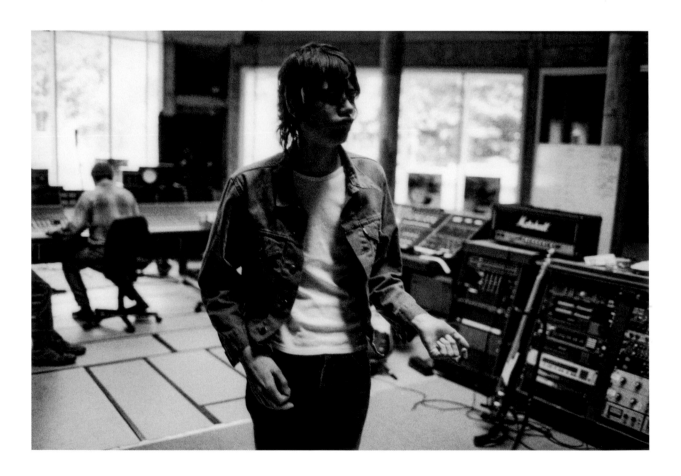

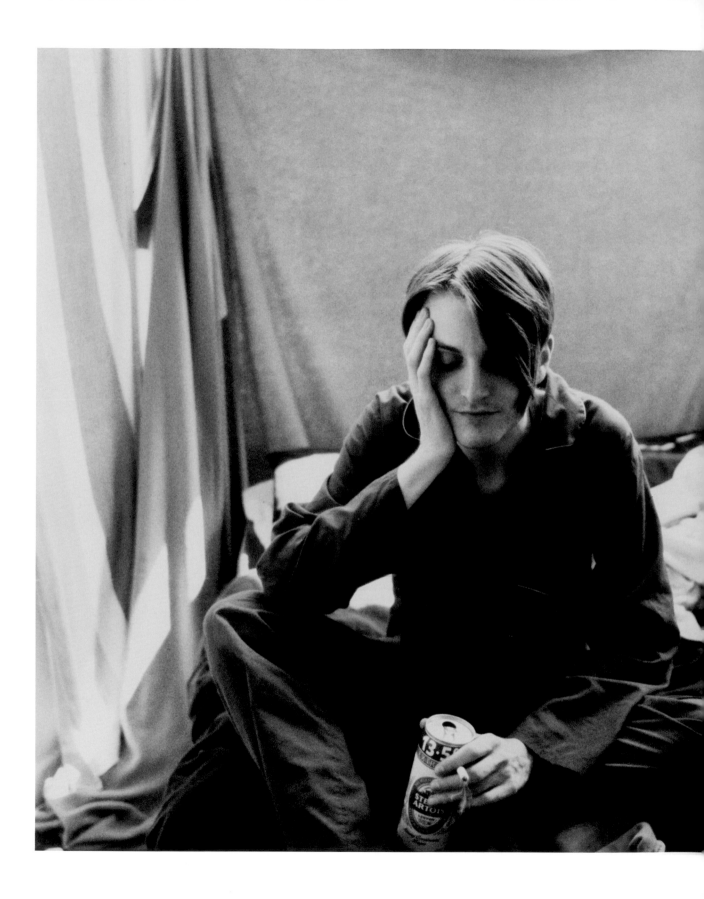

Blur, London, August

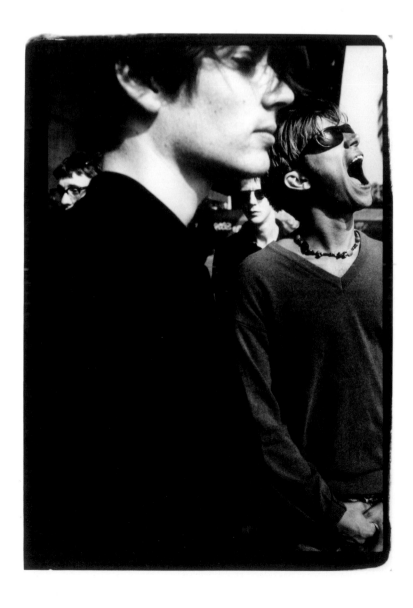

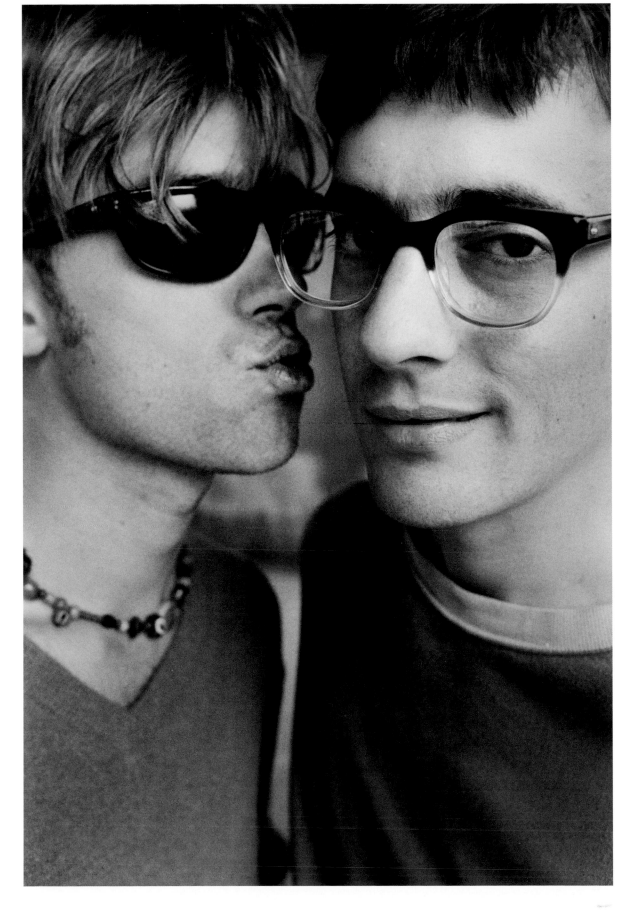
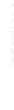

"I couldn't write something like 'Wonderwall'. I just can't bring myself to write simple stuff like that …why on earth would I want to?"

Damon Albarn, Blur, *NME*, 27 April 1996

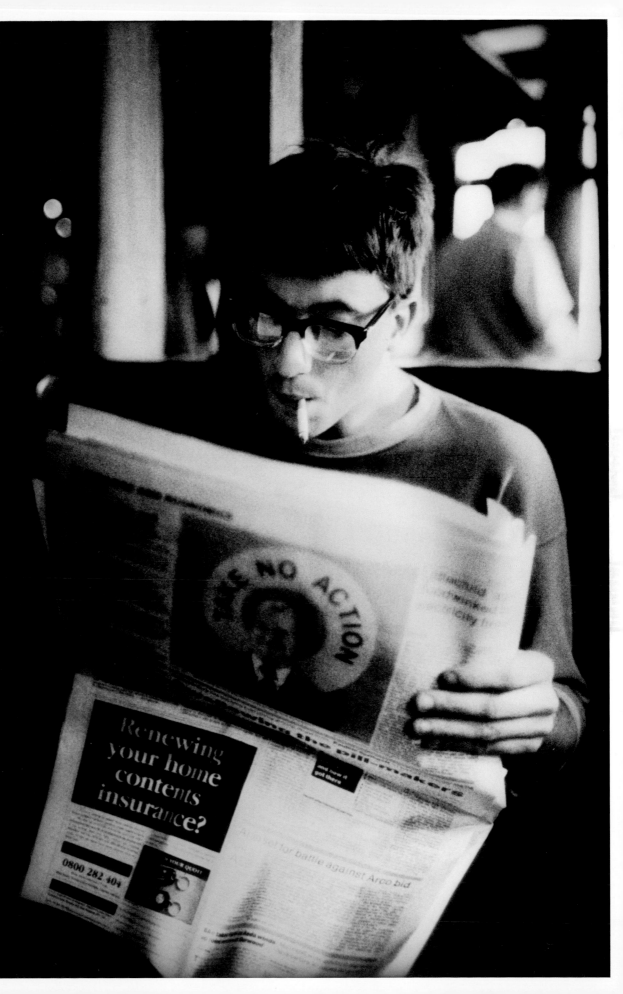

The Charlatans, Montreal and Toronto, October

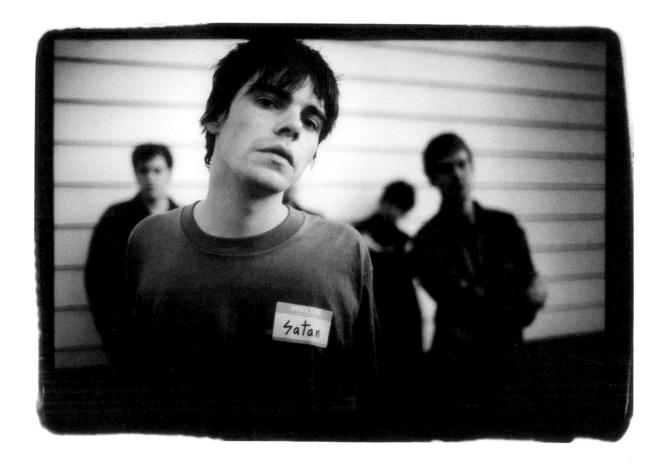

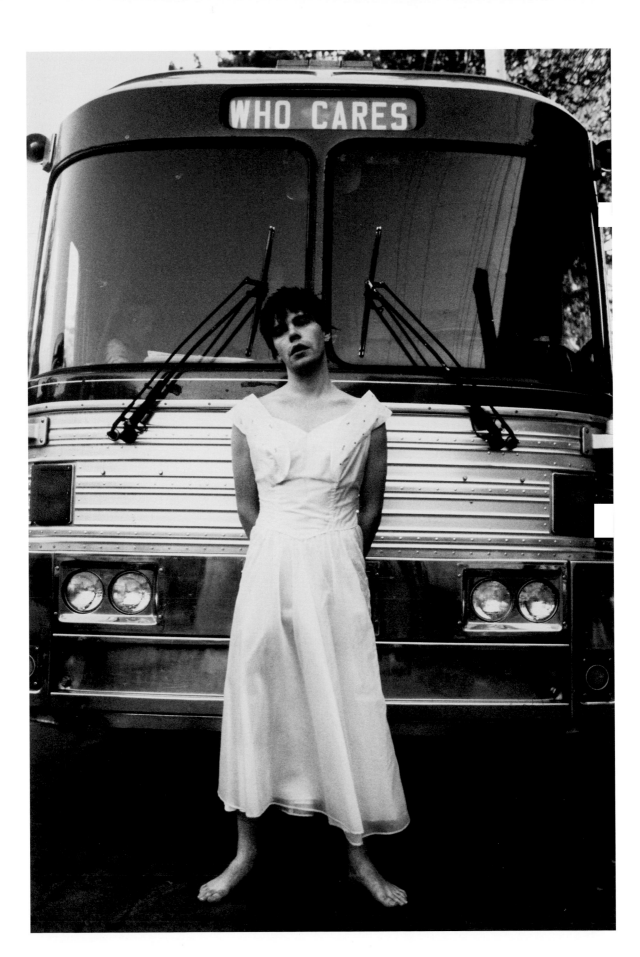

Radiohead, Cambridge, November

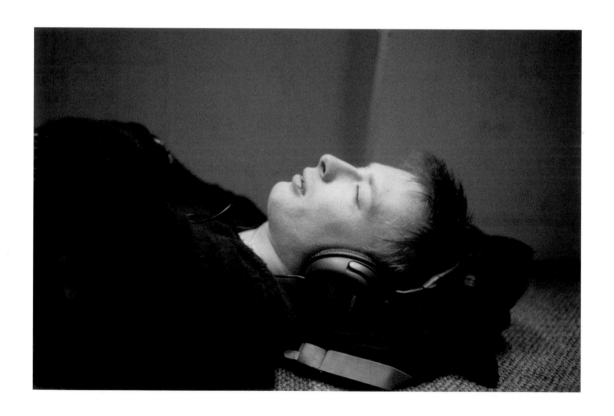

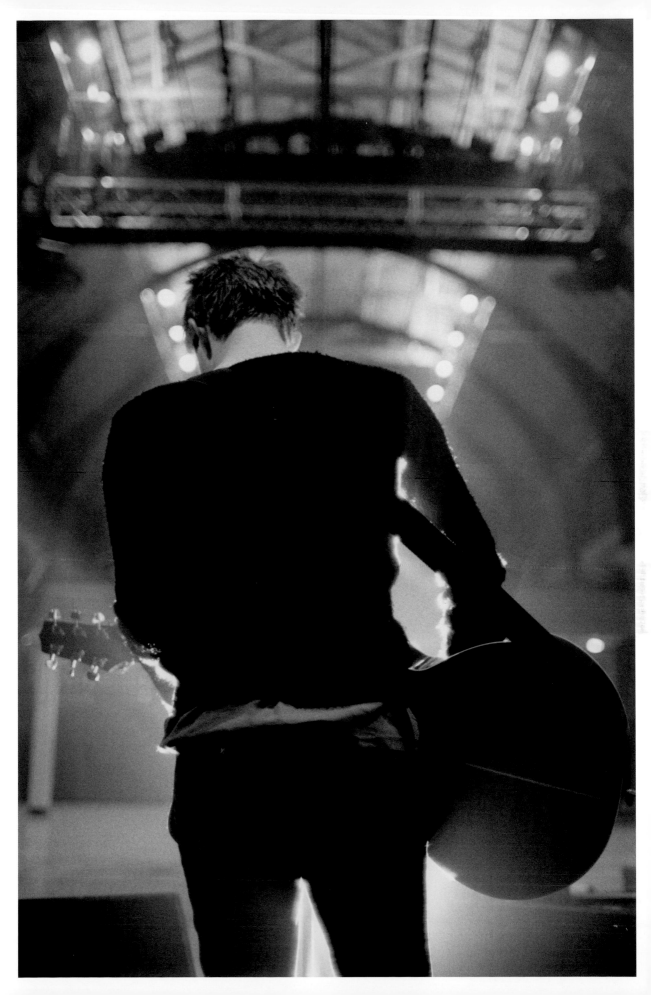

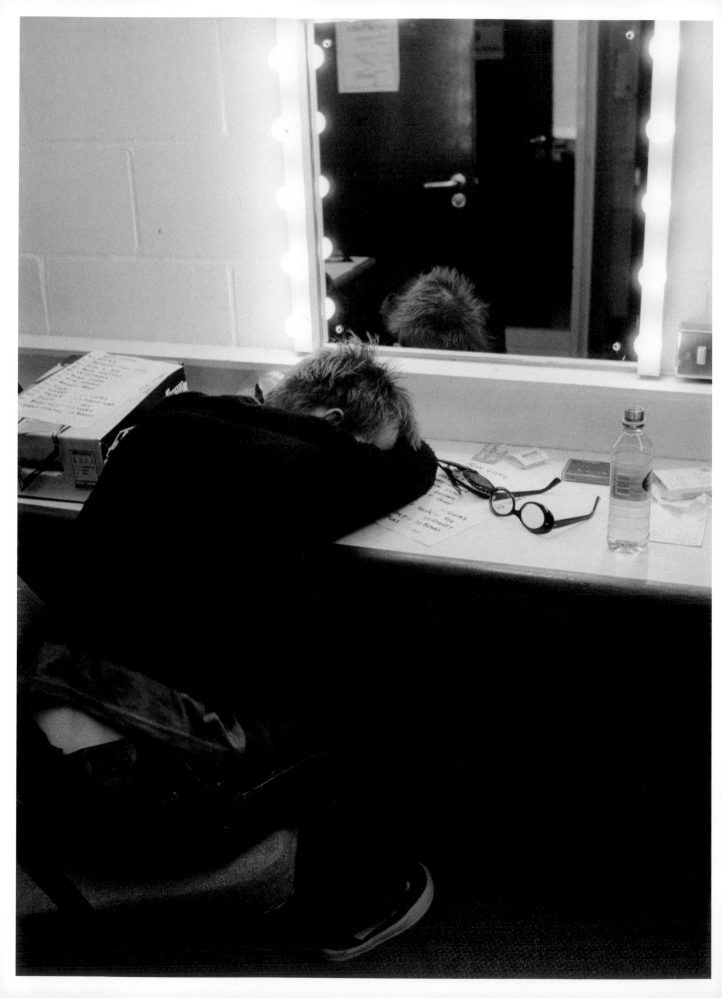

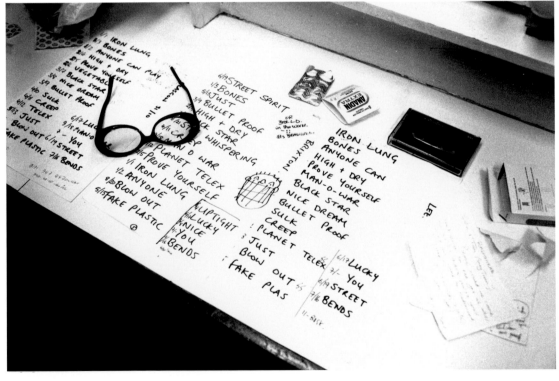

189

Radiohead, Madrid, November

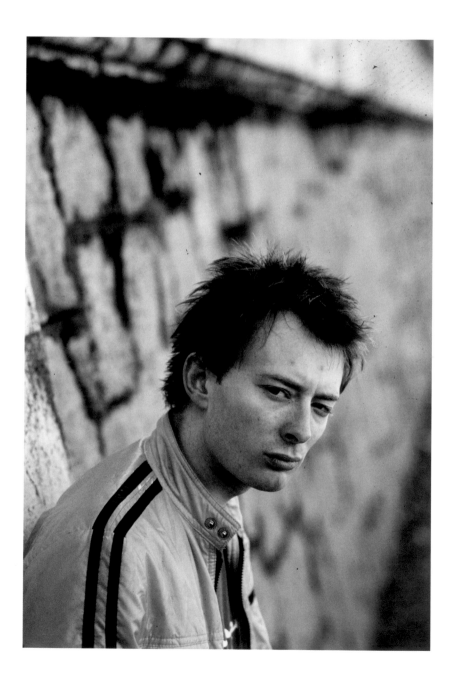

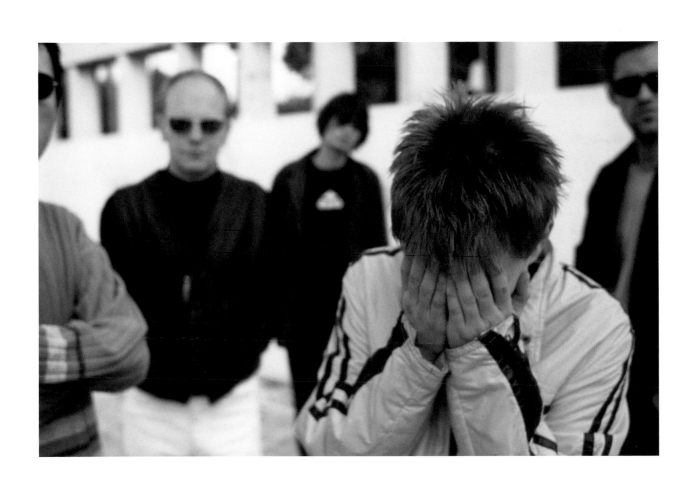

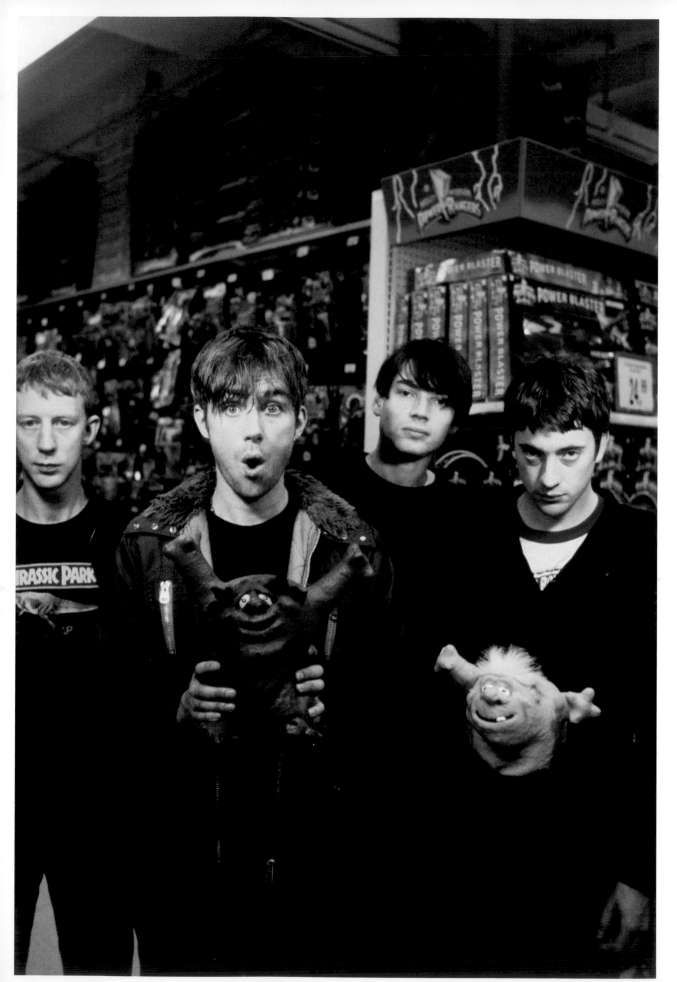

"I know it's a very flippant thing to say, but if Kurt Cobain had played football, he'd probably be alive today."

Damon Albarn, Blur, *NME*,
16 September 1995

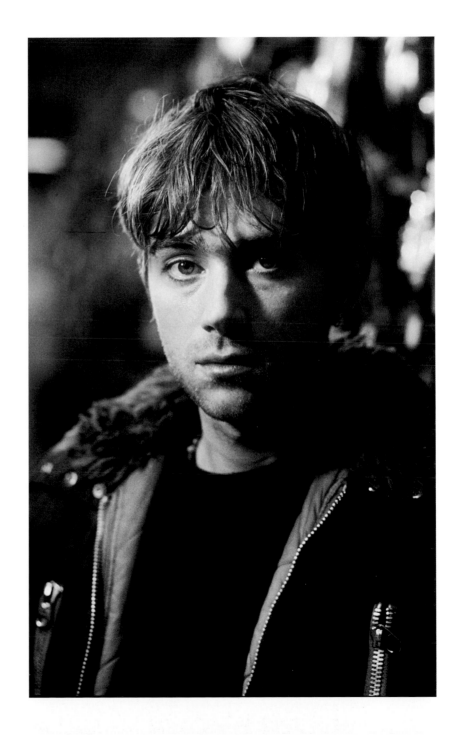

Phil Daniels and Damon Albarn,
Wembley Arena, London, December

For the final night on Blur's *Great
Escape* Tour, at Wembley Arena on
13 December 1995, Damon and
Phil Daniels decided to dress up as
pantomime dames for the encore. I
took the photos backstage, then, to
the bemusement of 15,000 punters,
they went onstage in drag to perform
"Parklife". I can only assume it had
been a long tour and cabin fever was
setting in.

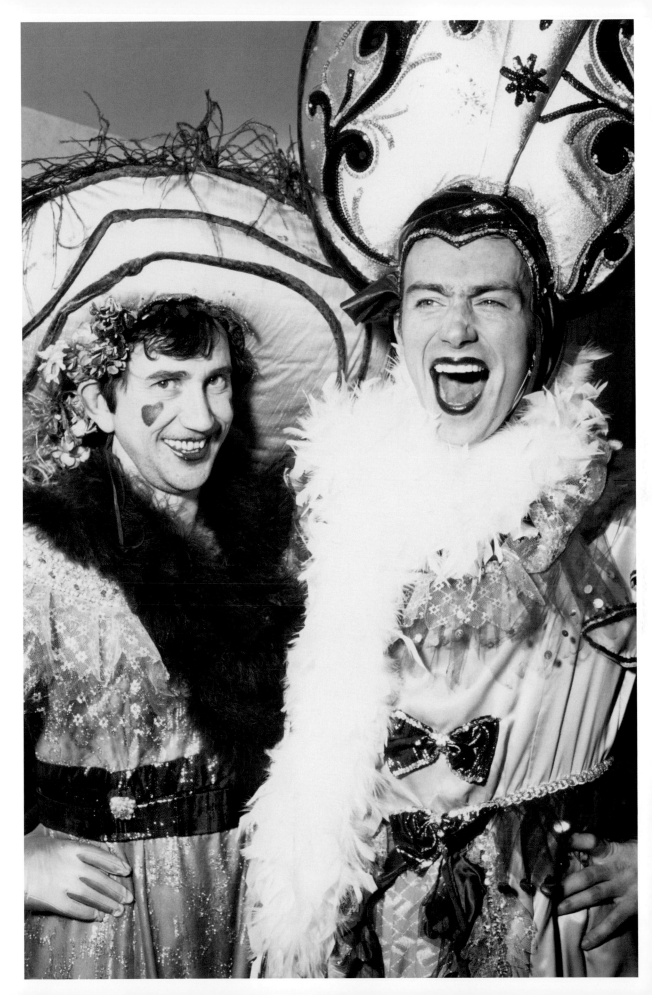

"There was a bit of rivalry between us and Oasis. It was very close, it went to extra time and penalties."

Alex James, Blur, *NME*, 4 February 1995

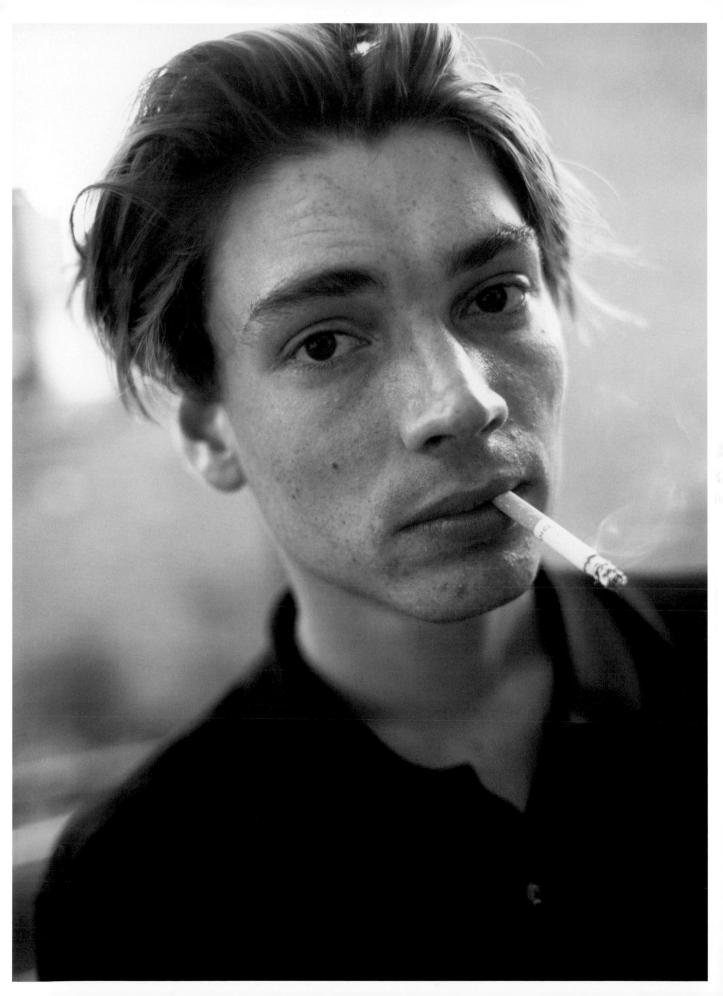

Louise Wener/Sleeper, Studio, date unknown

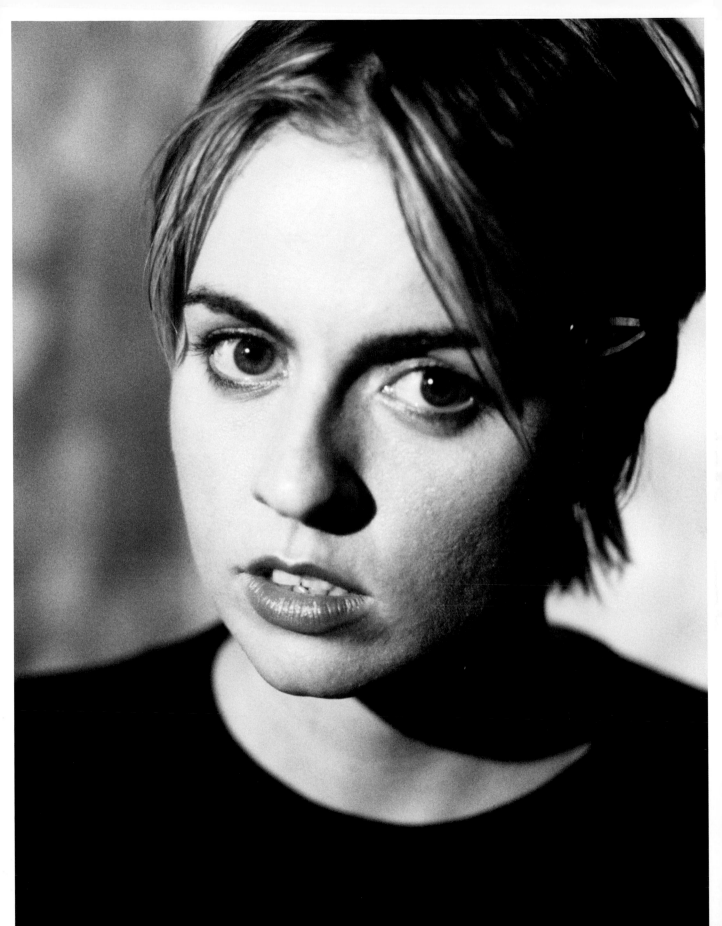

1996

Jarvis Cocker/Pulp, Studio, January

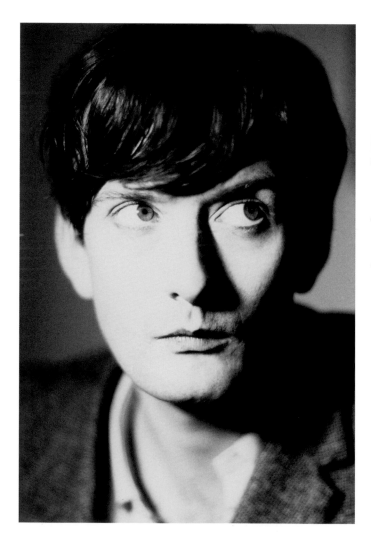

"When I've talked about Britpop – which I think is a horrible name – I think about it being like Merseybeat, in that The Beatles came out of Merseybeat, but others fell by the wayside."

Jarvis Cocker, Pulp, *Vox*, February 1996

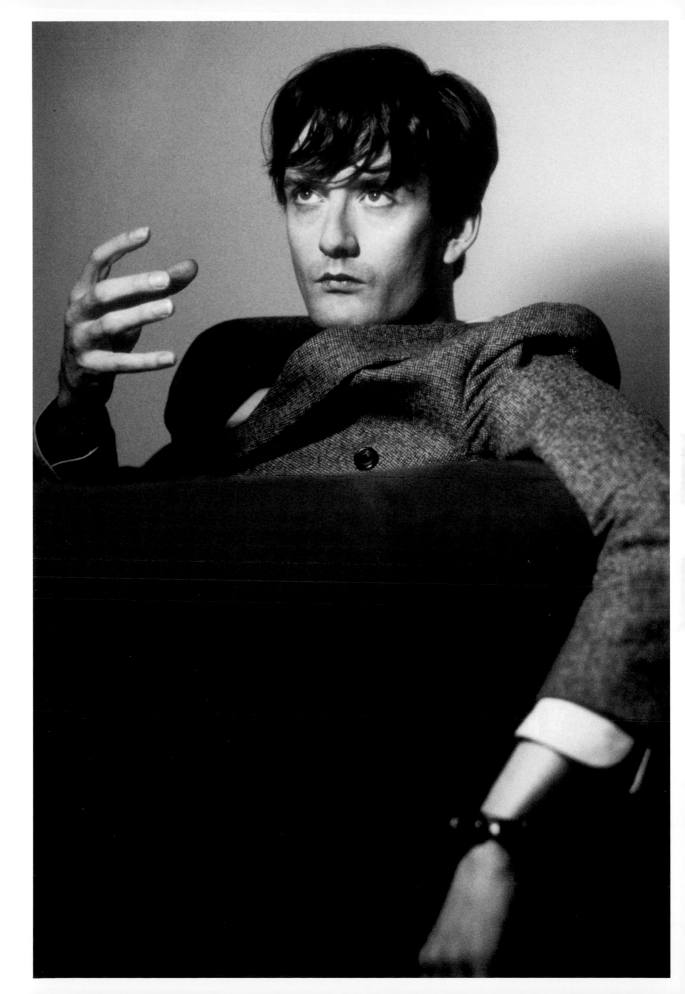

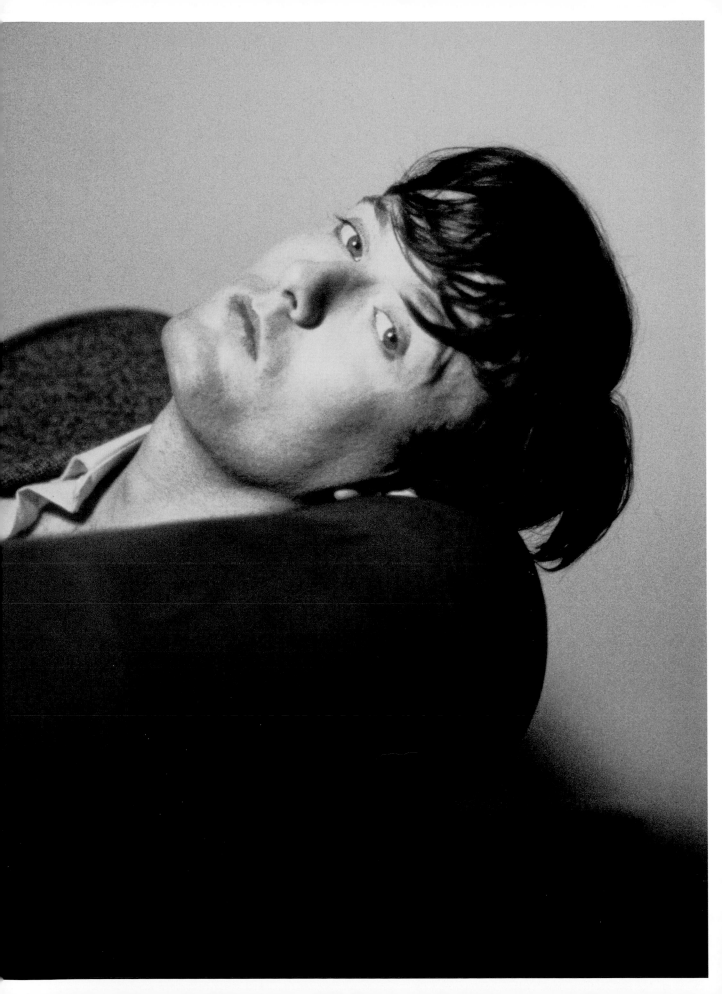

Lush, London, February

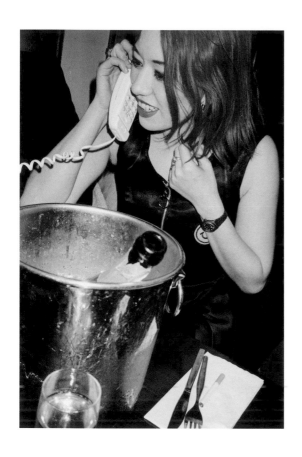

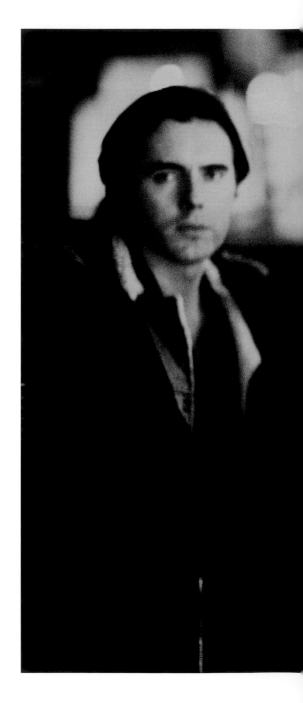

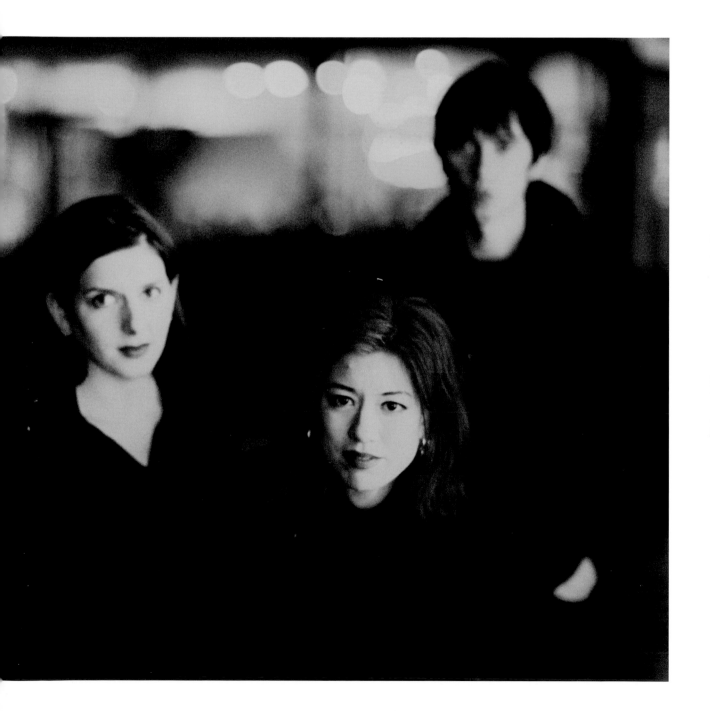

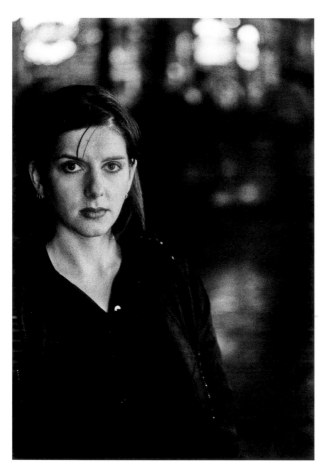
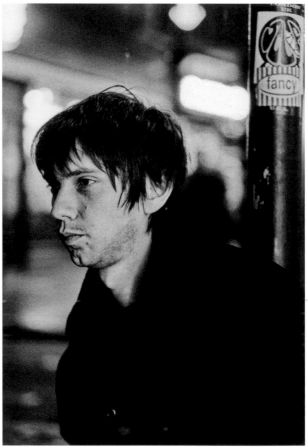

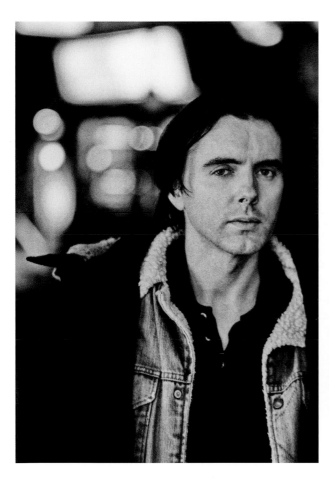
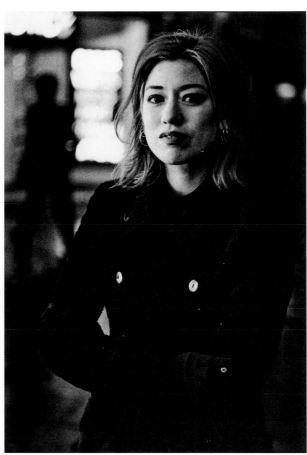

The Bluetones, Studio, March

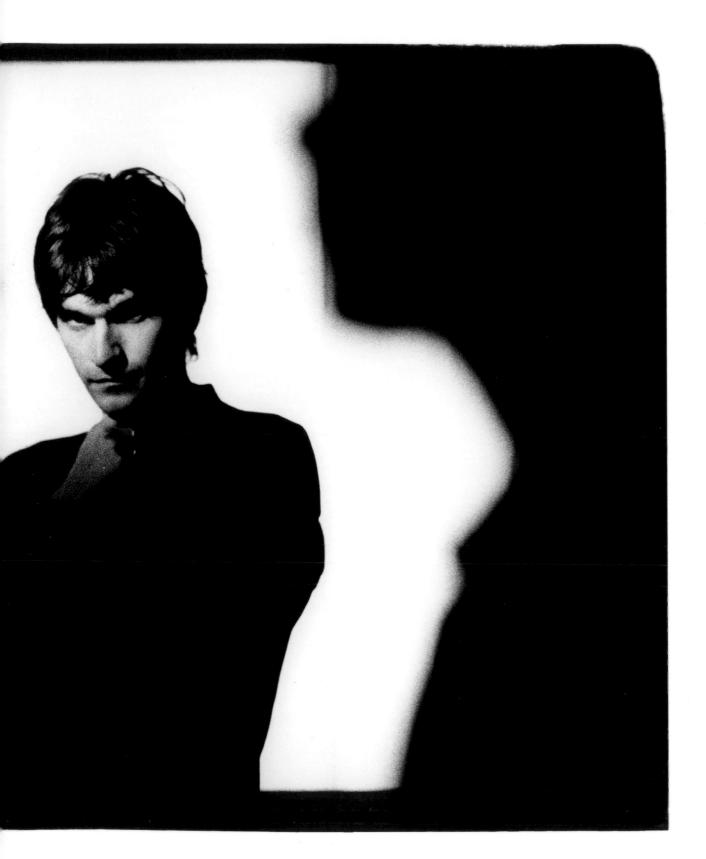

Damon Albarn/Blur, Grindavik and
Reykjavik, April

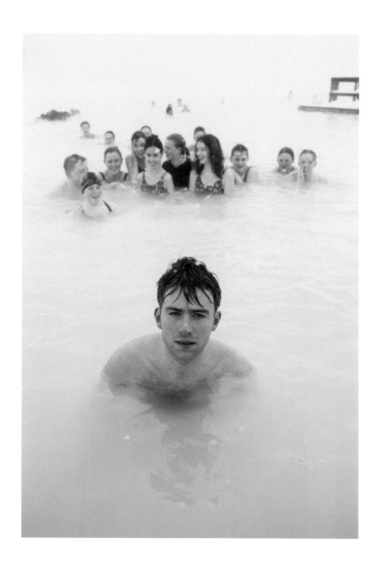

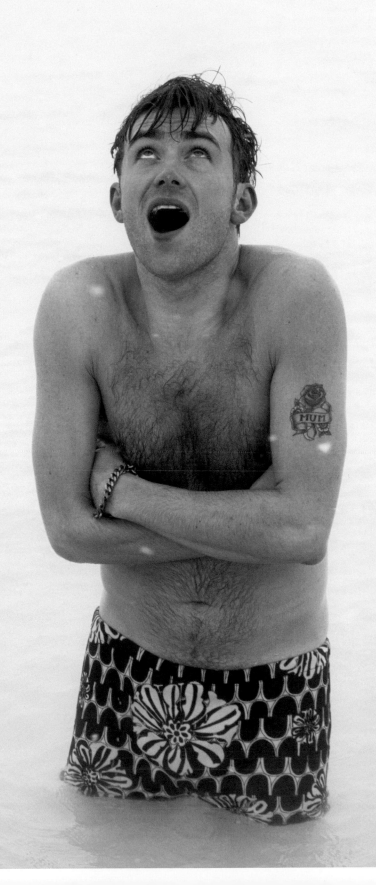

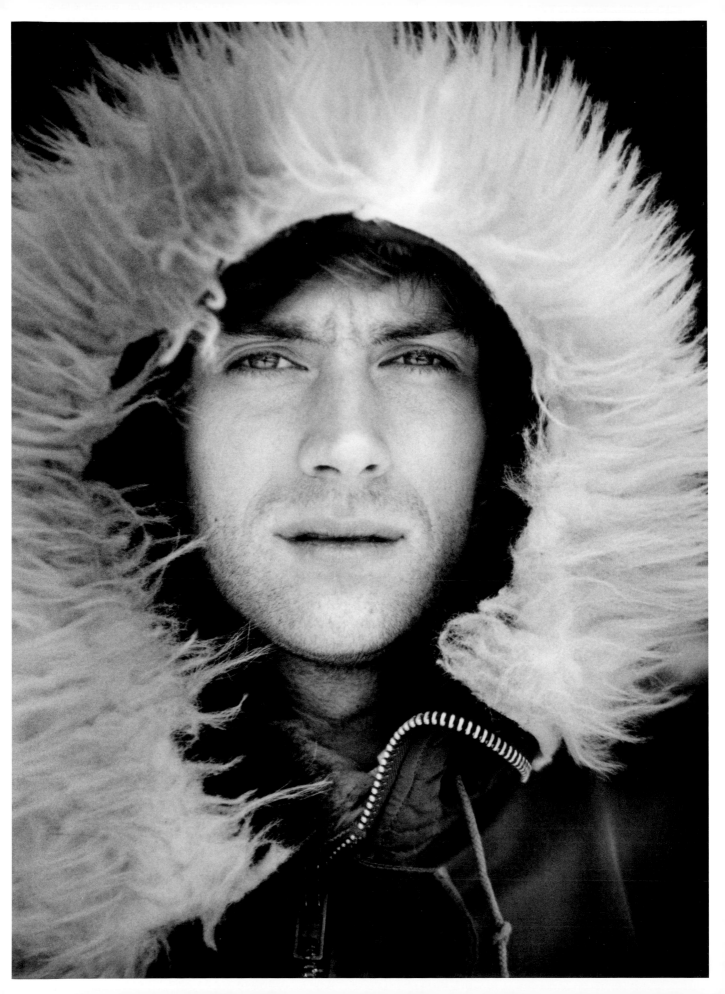

Oasis, Maine Road, Manchester, April

"You wanna write about shagging and taking drugs and being in a band. You don't wanna write about going down the supermarket or anything like that."

Noel Gallagher, Oasis, *NME*, 4 June 1994

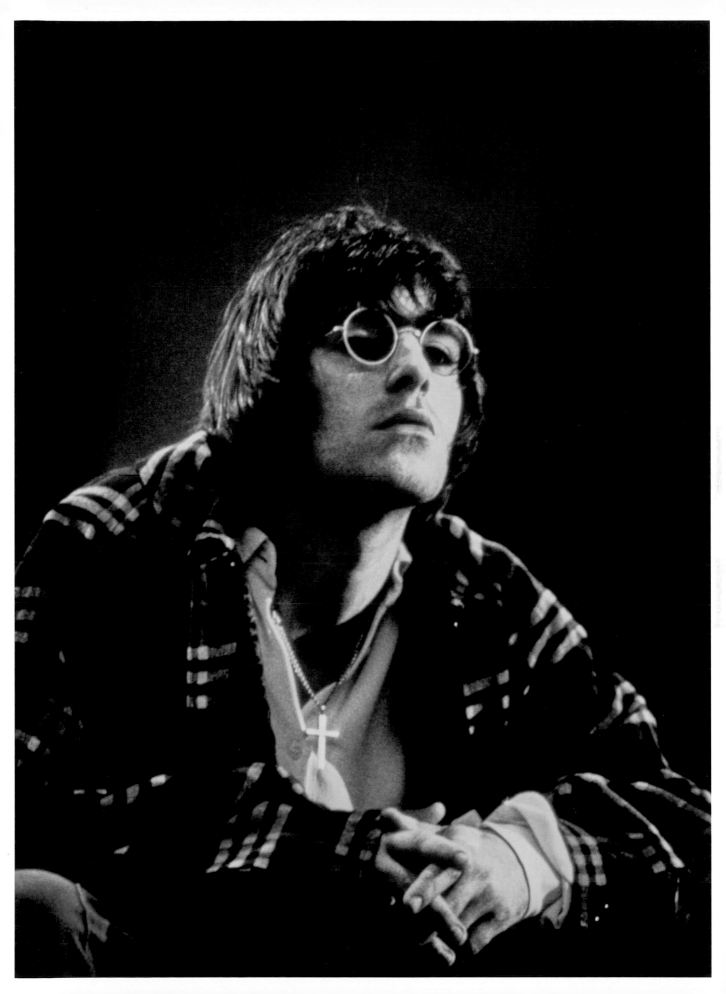

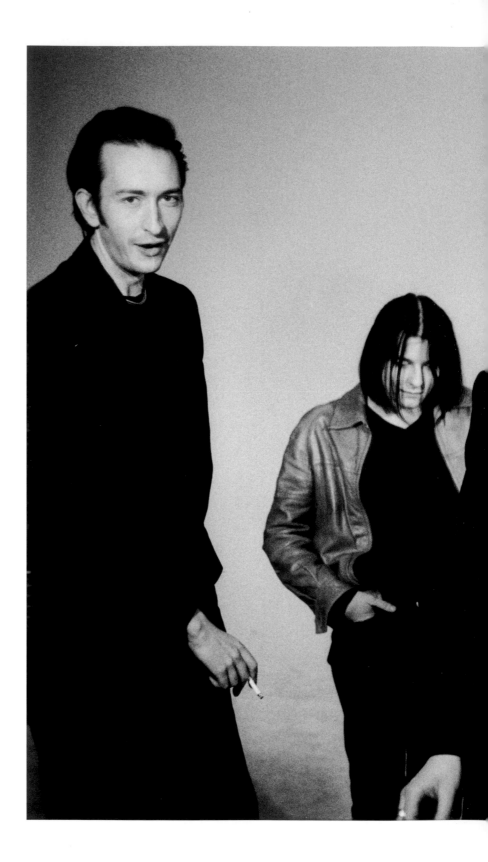

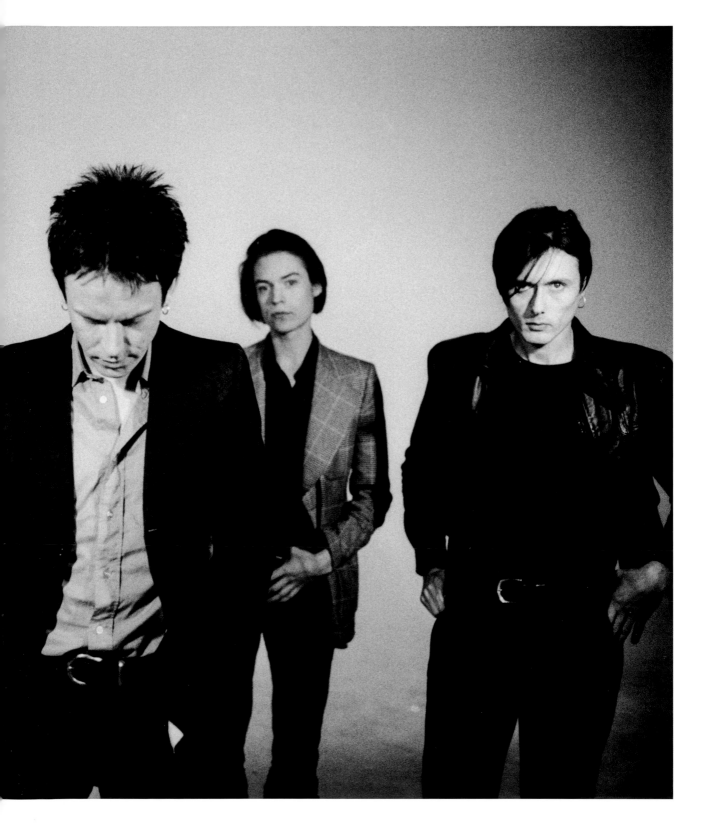

"I know I'm a whipping boy for people who drink down the Good Mixer [in Camden], because I don't go there and I've got no interest in any of that…we don't fit in."

Brett Anderson, Suede, *NME*, 14 January 1995

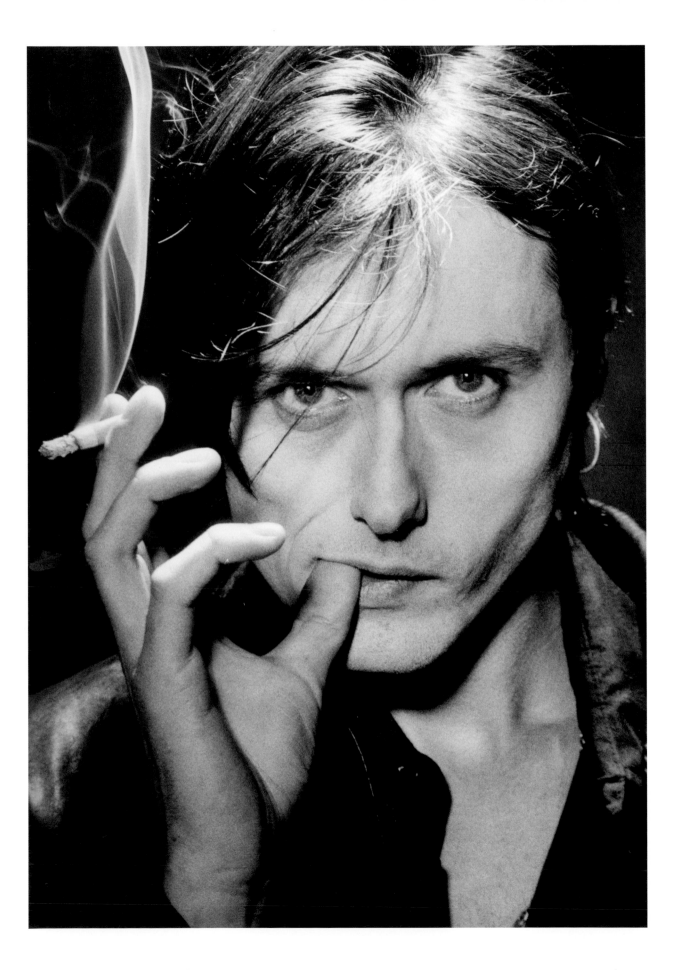

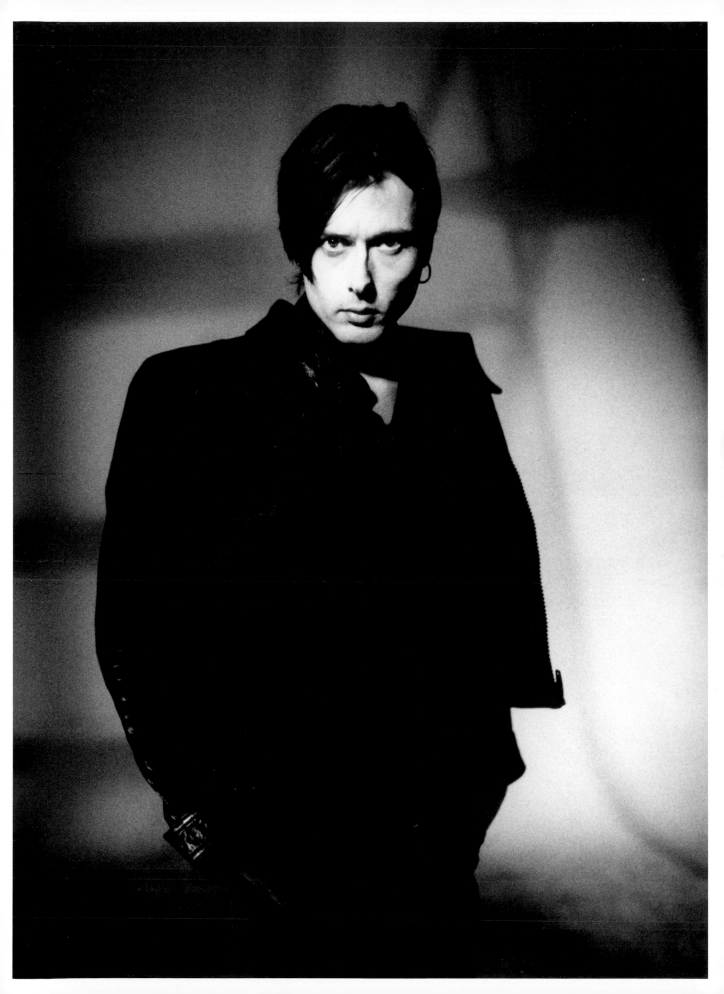

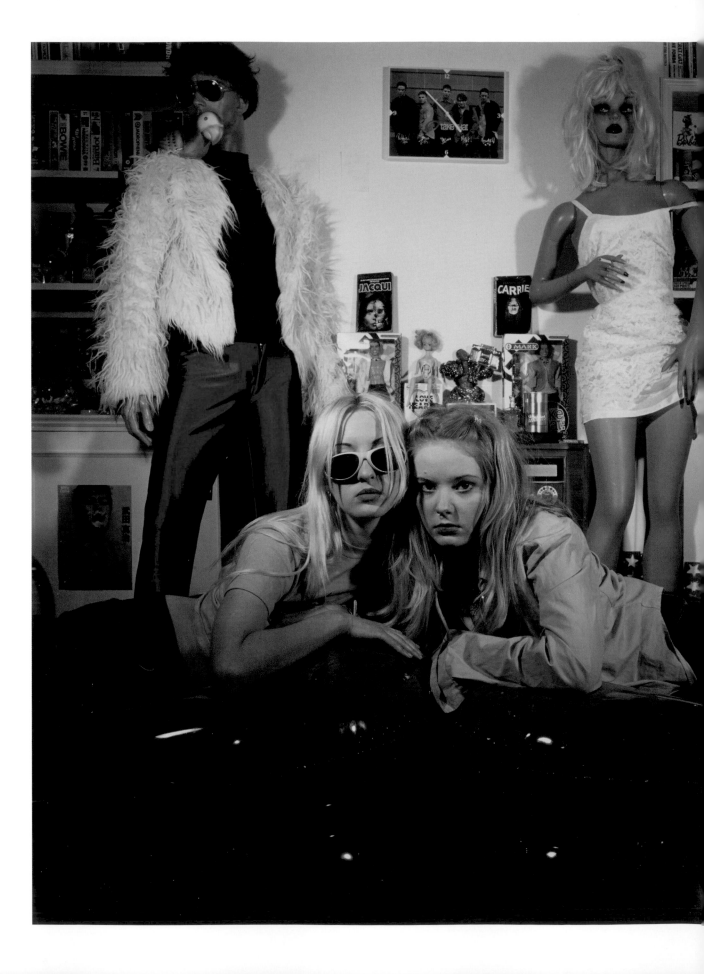

Kula Shaker, Studio, September

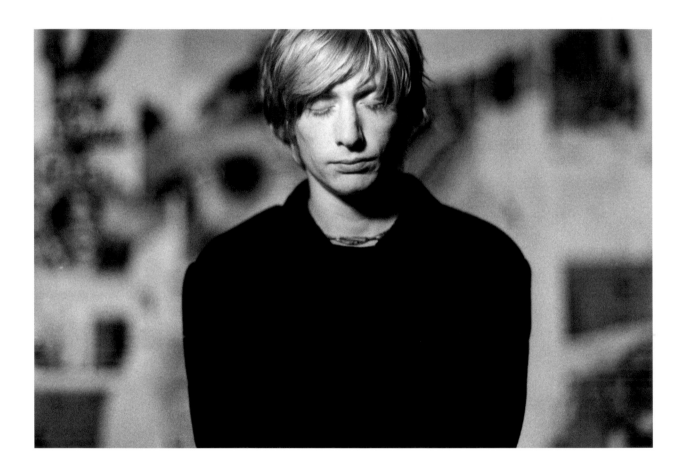

"I think [Noel] saw an interview we did in America where I said Oasis were nihilism and we were idealism. He took offence to that because he's Lord Noel, Starmaker."

Crispian Mills, Kula Shaker, *NME*, 4 April 1998

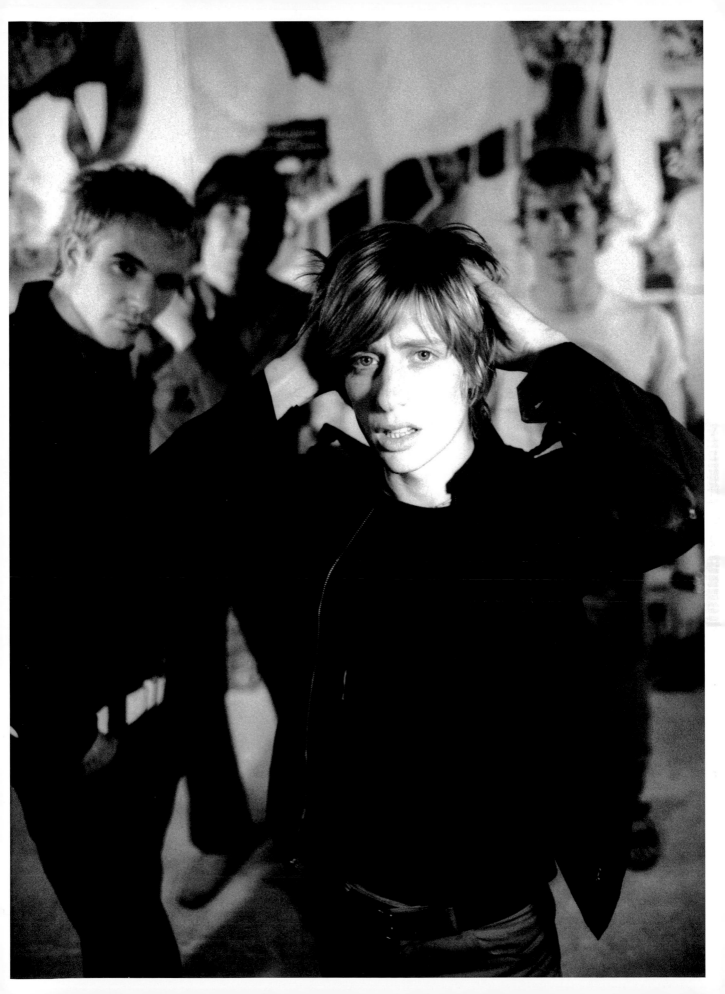

Ian Broudie/The Lightning Seeds,
Wembley Stadium, London, October

"We got lumped in on the edges of the Britpop thing but I think we're totally different to all that stuff, although I guess there are tunes and I'm definitely influenced a lot by the 60s."

Ian Broudie, The Lightning Seeds, *NME*, 26 October 1996

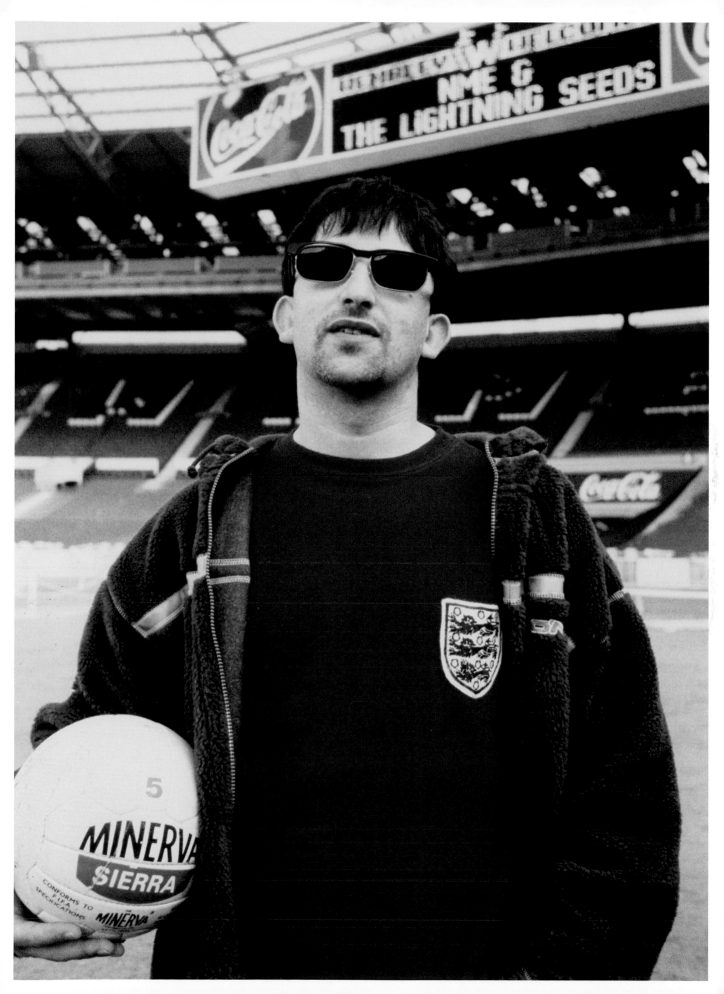

Damon Albarn and Justine Frischmann,
Oxo Tower, London, October

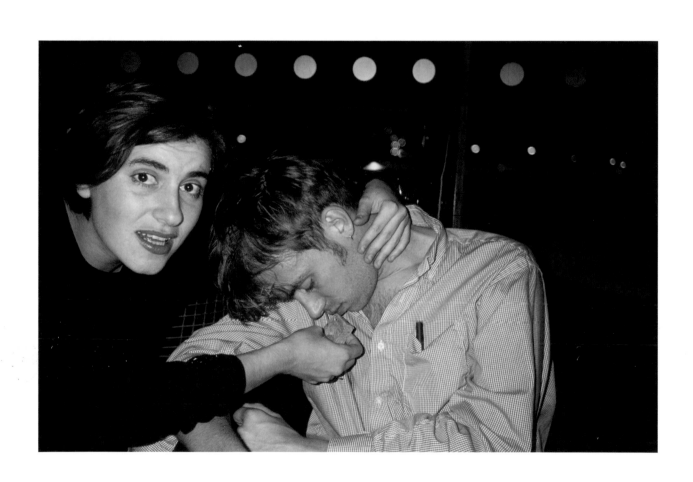

Mansun, London, November

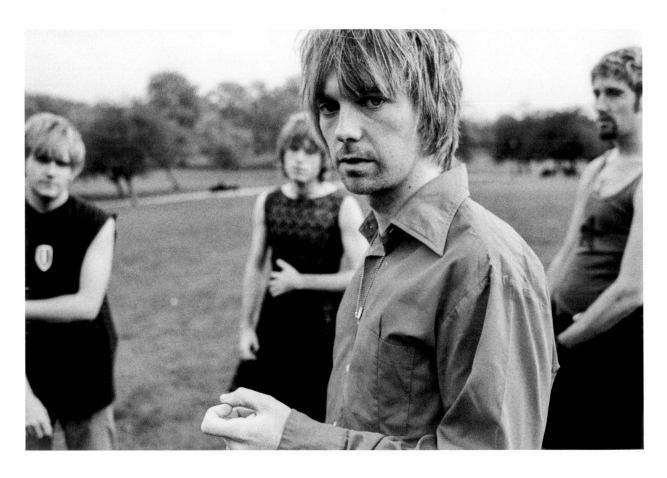

"We're a rock band, and rock is a dirty word in this country."

Paul Draper, Mansun, *Vox*, January 1997

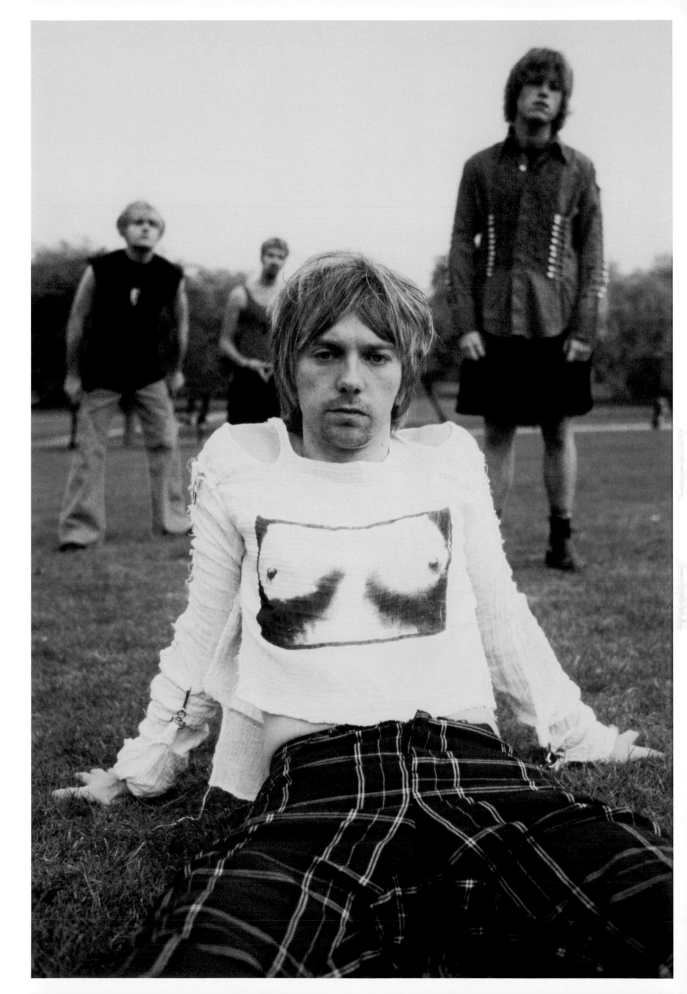

Tim Burgess/The Charlatans, Studio, December

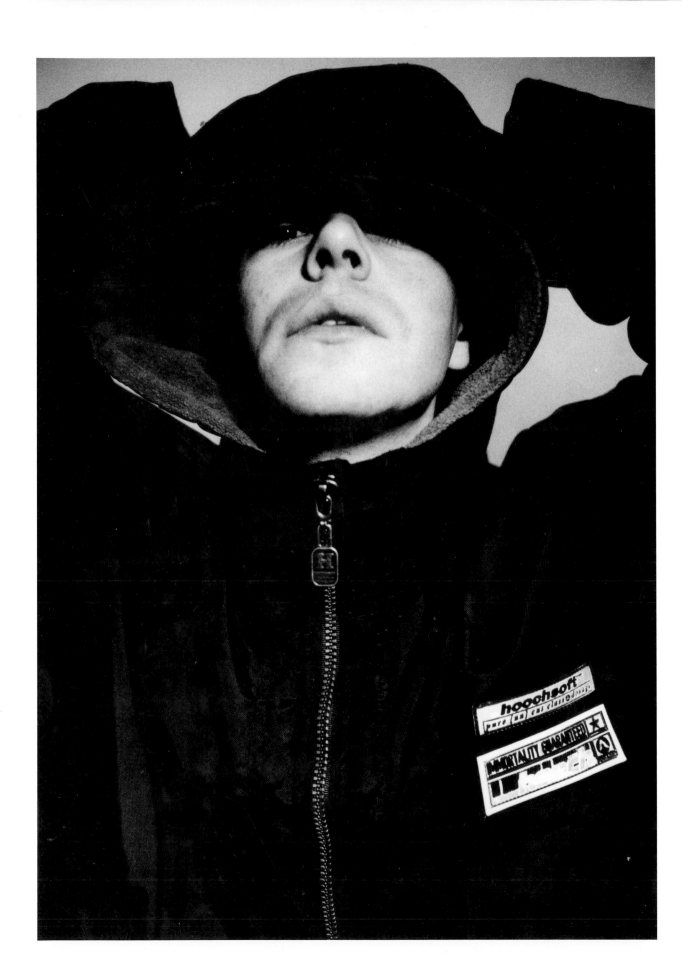

1997

Damon Albarn/Blur, London, January

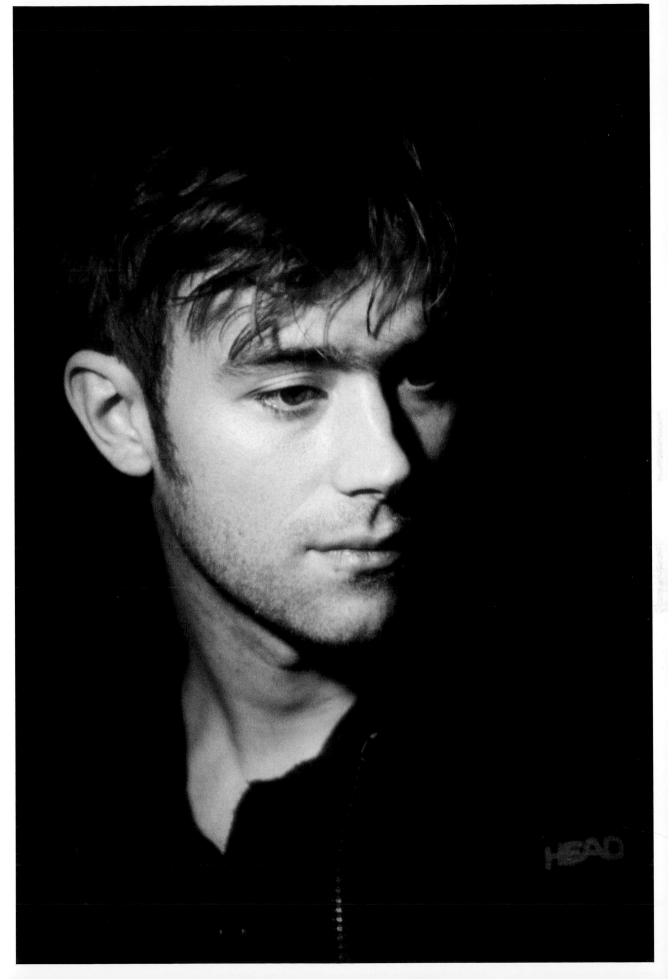

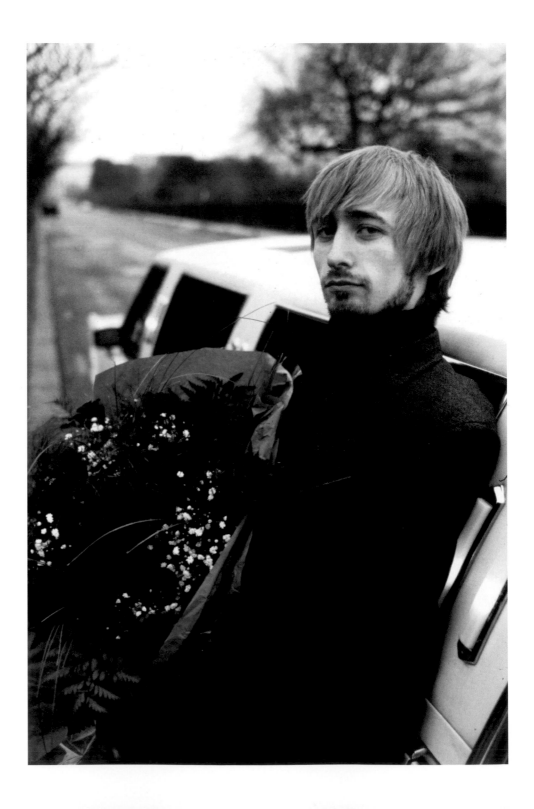

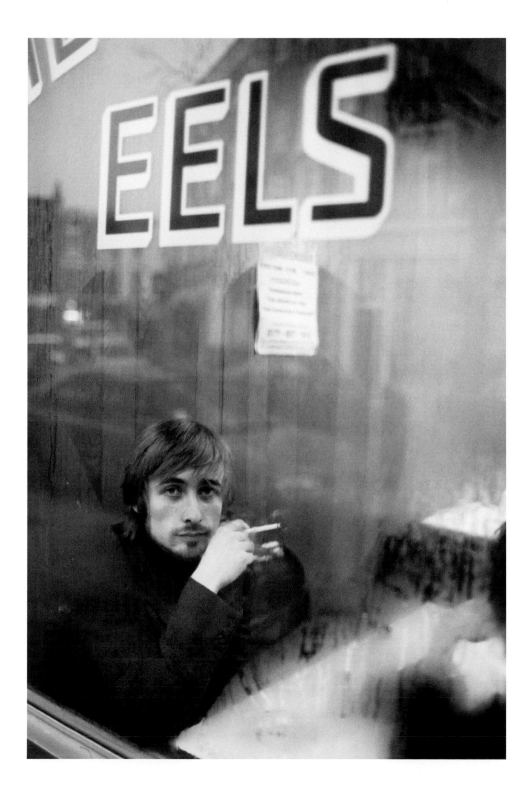

Gene, London, February

"I enjoy camp humour, I don't deny it. If it encourages Morrissey comparisons, then so be it. It's not something that'll worry me greatly."

Martin Rossiter, Gene, *NME*, 7 January 1995

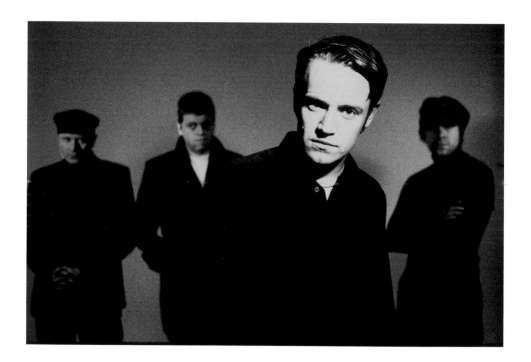

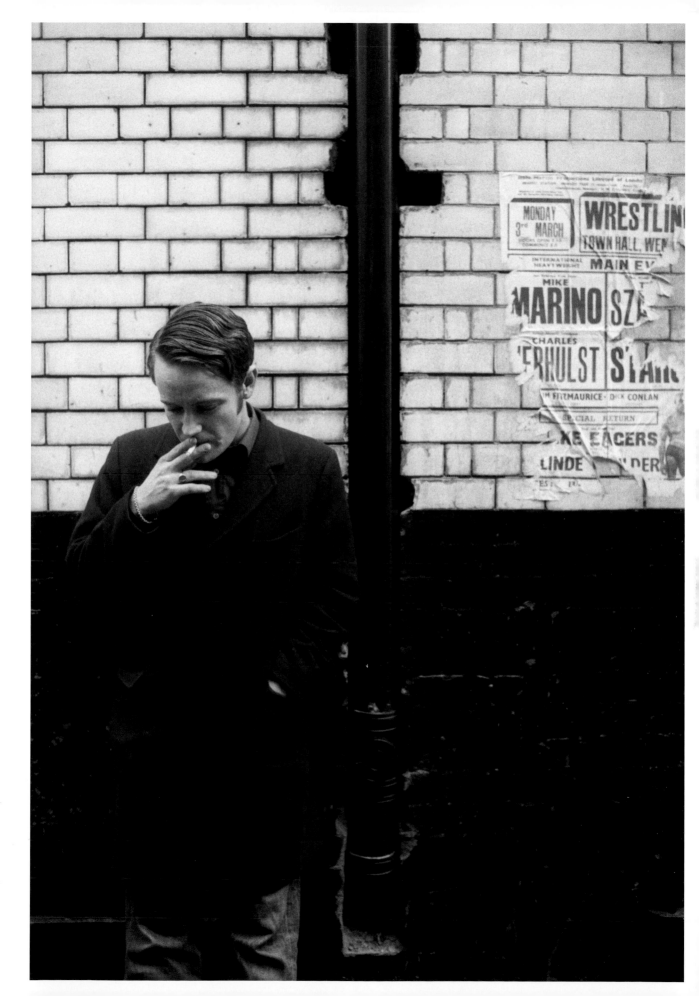

Gaz Coombes/Supergrass, Studio, February

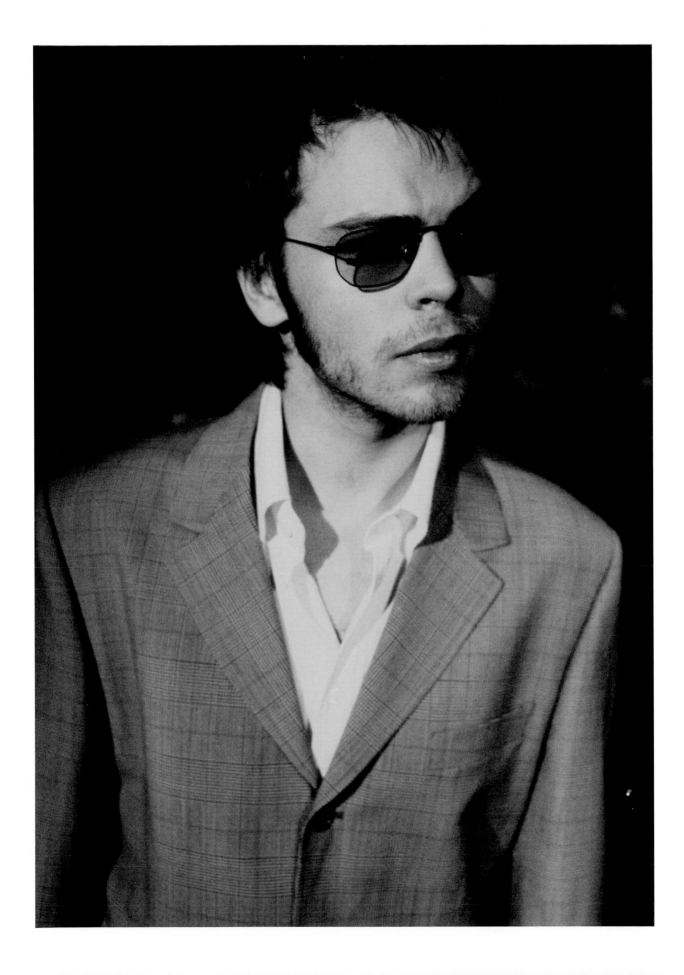

The Seahorses, York, April

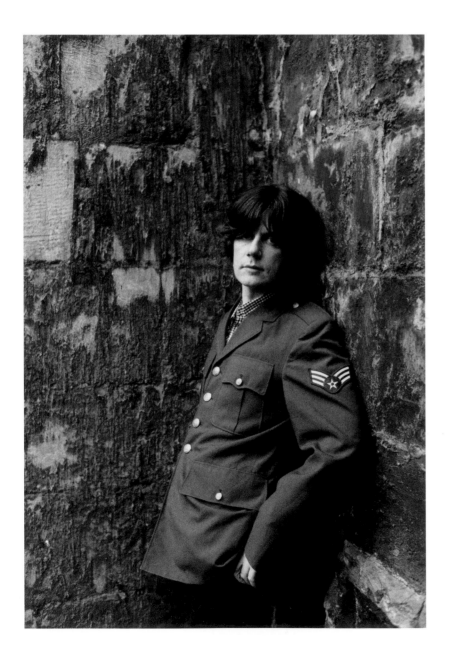

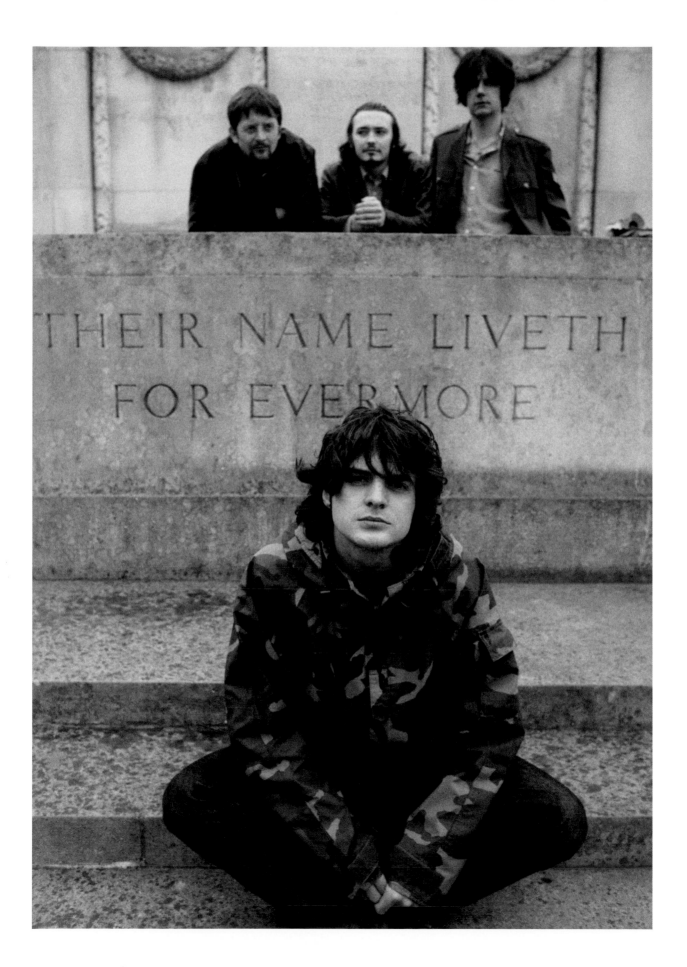

Kenickie, Studio, April

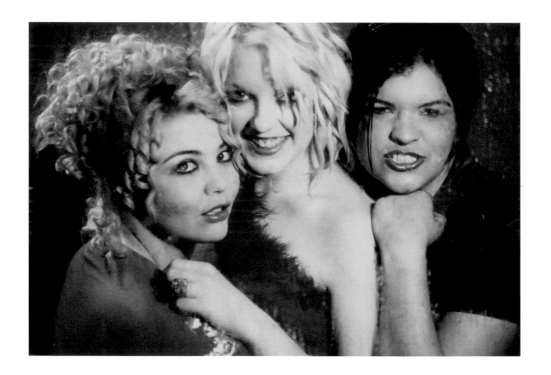

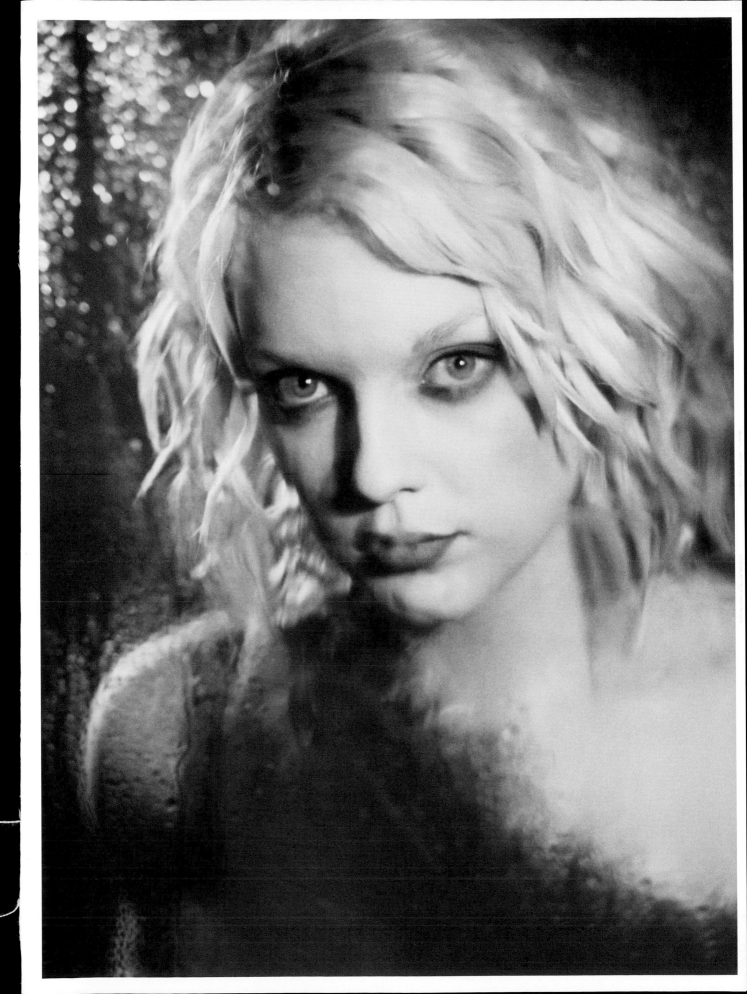

1998

Shed Seven, London, month unknown

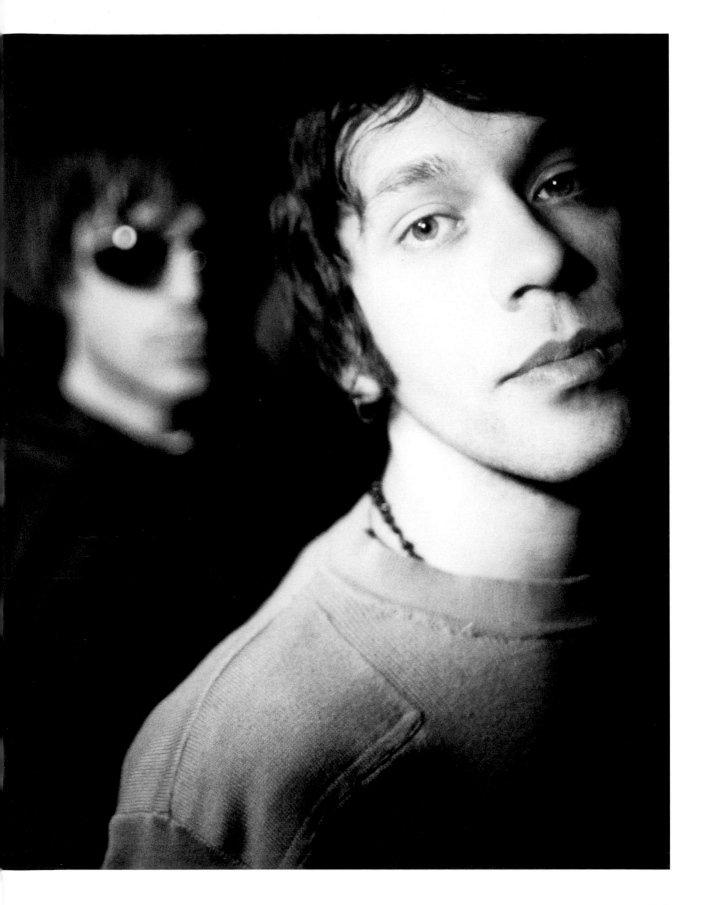

Jarvis Cocker/Pulp, Studio, December

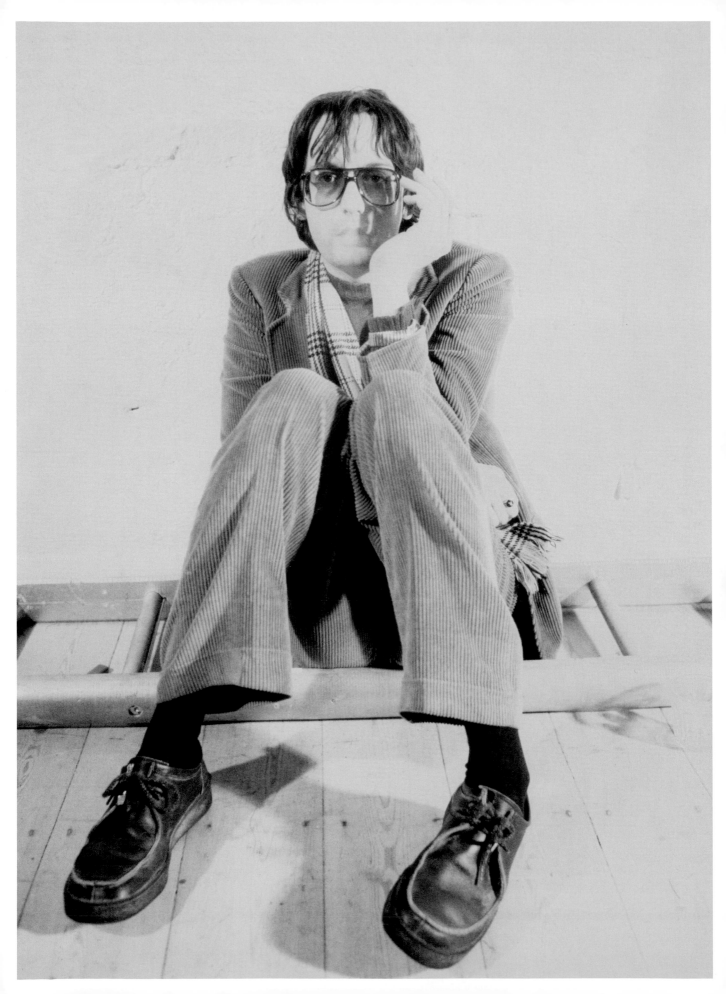

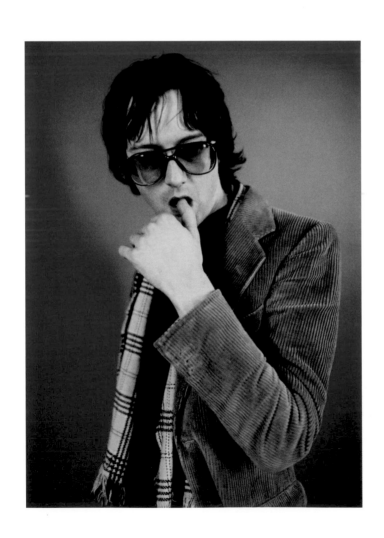

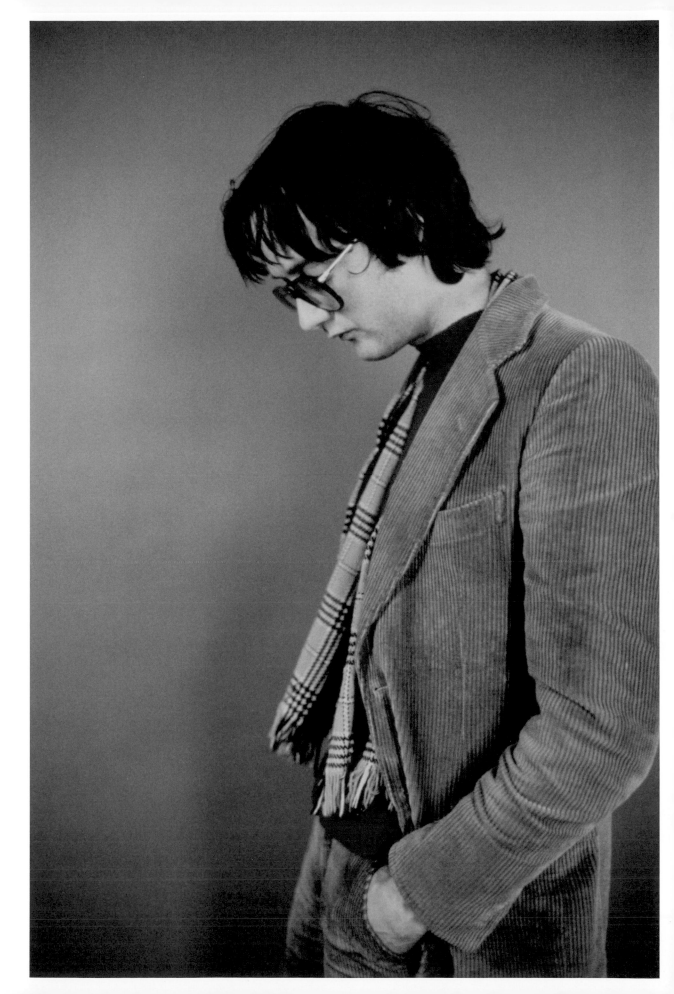

Acknowledgements

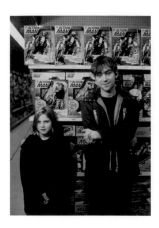 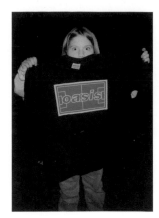

An Hachette UK Company

www.hachette.co.uk

First published in Great Britain in 2020 by Cassell, a division
of Octopus Publishing Group Ltd
Carmelite House, 50 Victoria Embankment, London EC4Y 0DZ
www.octopusbooks.co.uk

Distributed in the US by Hachette Book Group
1290 Avenue of the Americas, 4th and 5th Floors,
New York, NY 10104

Distributed in Canada by Canadian Manda Group
664 Annette St., Toronto, Ontario, Canada M6S 2C8

ISBN 978-1-78840-220-0

A CIP catalogue record for this book is available from the
British Library.

Printed and bound in China

10 9 8 7 6 5 4 3 2 1

Senior Commissioning Editor: Joe Cottington
Senior Editor: Pauline Bache
Copyeditor: Emma Bastow
Creative Director: Jonathan Christie
Production Controller: Emily Noto

To my daughter, Ella, who'll now know why I always hang
on to family snapshots. "If Damon wants his picture with
me, I'll be stood over here", is still a line that makes me
laugh 25 years later.

It's virtually impossible to put a book together without
the support of a great team and I'm really lucky to have
one on my side.

My regular meetings with my agent, Carrie Kania, in The
French House encourage and support the vicissitudes of
book editing – at least up to 7pm…

Joe, Pauline and Jonathan at my publisher, Octopus,
for their patience at my indecision over the inclusion
of certain photos and my constant agonizing over
border sizes.

Special thanks to my wonderwall, Gail Crowther, who
bestows enormous clarity when I'm working on all my
books and is a well of support 24 hours a day.

To all my friends for their usual support, especially Sally
Williams who curbs my enthusiasm for excessive use of
the comma. Mick Mulligan: thank you for the music and
John Kelsey for dragging me away from my desk to watch
endless films. And the rest of the MCSCLB Arts Council:
you know who you are…

Thanks also to Natalie Faccenda and Ben Stanley for
lending me part of their priceless badge collections and
to John Robinson at *Uncut* for smoothing the path to the
NME archives.

To Noel Gallagher for his candid interview and for
allowing me to use a line from "Champagne Supernova"
for the title. Also thanks to Brett, Sonya and Martin for
their interviews and finally to Paul Morley for answering
the question Noel wouldn't.

KC: Do you think the era is forever tainted by the nationalistic use of the terms "Britpop" and "Cool Britannia", or do you think it was able to reclaim the Union Flag and celebrate a great period for British music?
NG: Ask Paul Morley.

* * *

Thanks for asking, Noel. The "Brit" in Britpop, Cool Britannia and the waving of the Union Flag are not ageing well. To some extent, the nostalgic British reclamation of lively, optimistic, creative '60s pop – a backlash against nihilistic American grunge and synthetically faceless rave, as much as anything – helped open the channels for Brexit, which taints it. The rose-coloured and/or malignant British nationalism can swamp the pure and enchanting pop part of the name. There was a sense that the yearning for when British pop ruled the world was a version of the later, wider, more complicated cultural yearning for when Britain ruled the waves. The music, symbols and personalities of The Beatles, Stones, The Who, The Kinks, Small Faces, Syd Barrett, David Bowie, Marc Bolan, etc. were a kind of reassuring replacement for a lost empire that led pop to a last-gasp end-of-century celebration, which was embraced – even manufactured – and inevitably hyped by a desperate media as a distinct and special cultural explosion.

Every era, every generation, wants their own Beatles, a Stones, a Pistols – a sense they are part of something brand new, that they have their very own sense of cool. The "Brit" was wrapped around the pop music by a media needing marketing labels and cultural excitement, which turned it into a movement. But the "Brit" and definitely the flag wasn't the intention of the groups themselves, and, whatever the movement was, it quickly became a cul-de-sac. The musicians and groups became trapped by the "Brit" and only those who actually made great pop songs – for them the whole point, part of their positive curating of a response to the innovations and adventures of the 1960s and 1970s – have come out of it well, more pop than Britpop now, and then even more art than pop.

The Britpop era was perhaps the last time such a collective shot-in-the-arm display of idealism will ever happen, so it is definitely something worth chronicling. Seeing as how it was also about a love for the sound, vibe and magical tangibility of vinyl records, it might not seem so tarnished if it was called something like Vinylpop. Or Superpop. Parkpop. Elasticpop. As a final authentic blast of spirited, youthful guitar-based pop – Youngpop. Or, lets face it, Wonderpop.

Paul Morley

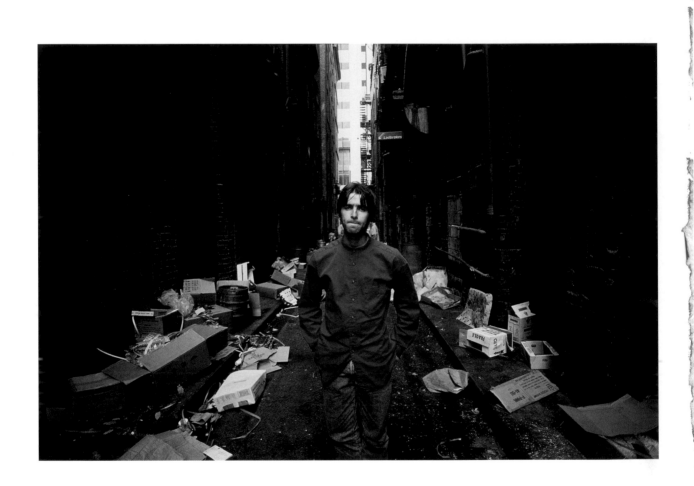